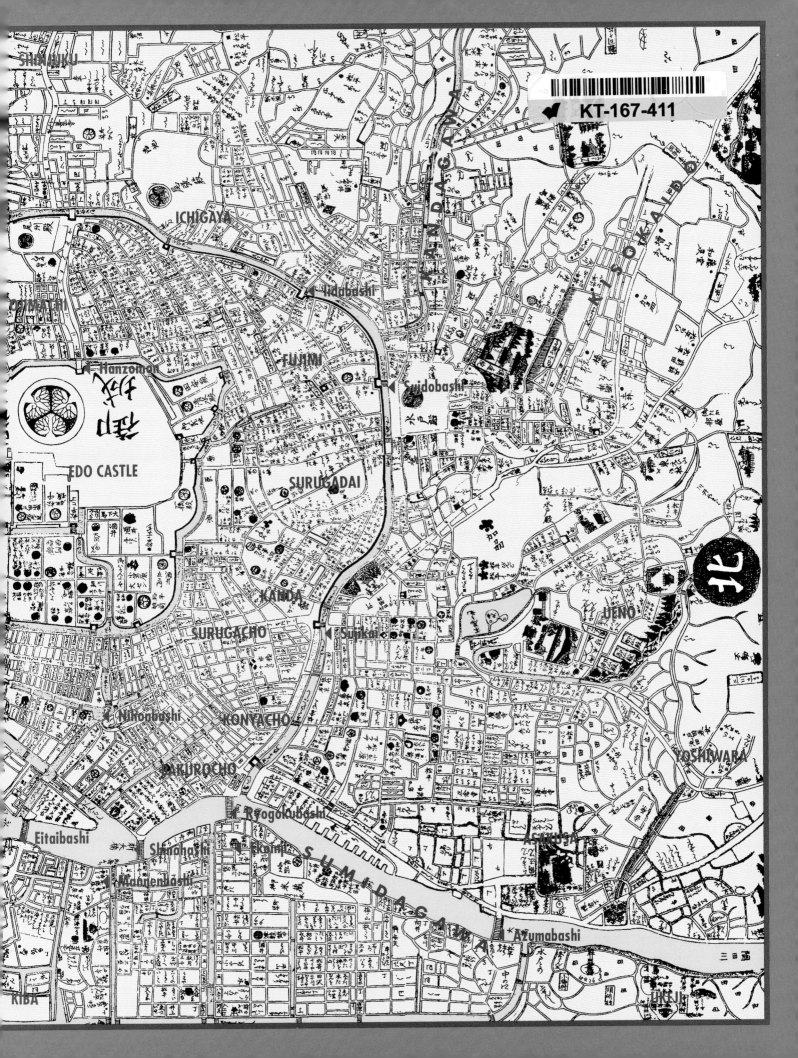

SHINJUKU

ICHIGAYA

KAN-DAGAWA

NISOKAIDO

Iidabashi

KOJIMACHI

FUJIMI

Hanzomon

Suidobashi

EDO CASTLE

SURUGADAI

KANDA

UENO

SURUGACHO

Sujikai

Nihonbashi

KONYACHO

YOSHIWARA

BAKUROCHO

ASAKUSA

Ryogokubashi

Eitaibashi

Shinohashi

Ikashi

SUMIDAGAWA

Mannenbashi

Azumabashi

KIBA

UKEJI

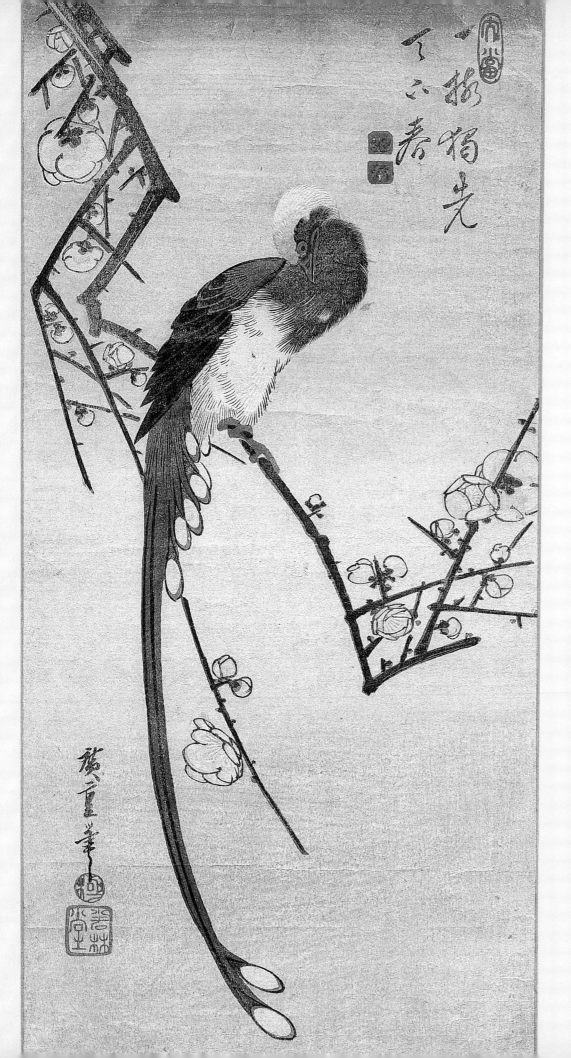

**For Titus**

*"One solitary
early plum
blossom
And the whole
world is
spring."*

"White Plum Blossom
and a Black Paradise
Flycatcher." *A print of the
early 1830s with an
unsigned* kambun *poem.
This extremely elegant
design is executed with a
number of special
printing and graphic
techniques to achieve a
particularly painterly
effect; the use of a
carefully balanced range
of colors, the delicacy of
the shading in the
background, the
precision of the cutting,
and the use of embossing
in the bird's plummage.
Brocade print, o-tanzaku
size. By Courtesy of the
Board of Trustees of the
Victoria & Albert
Museum, London.*

PAINTERS & PLACES

# HIROSHIGE IN TOKYO

## The Floating World of Edo

## Julian Bicknell

POMEGRANATE ARTBOOKS

SAN FRANCISCO

First published 1994 by Pomegranate Artbooks
Box 6099, Rohnert Park, California 94927

Conceived, designed, and produced by
New England Editions Limited
25 Oakford Road
London NW5 1AJ, England

ISBN 1-56640-803-2
Library of Congress Catalog Card Number 93-87360

Editor: CHARLES PERKINS
Art Director: TRELD PELKEY BICKNELL
Typography & Maps by GLYNN PICKERILL
Special Photography by ALEX SAUNDERSON
Typeset in Garamond Light by THE R & B PARTNERSHIP
Printed in Singapore by IMAGO PUBLISHING

# Contents

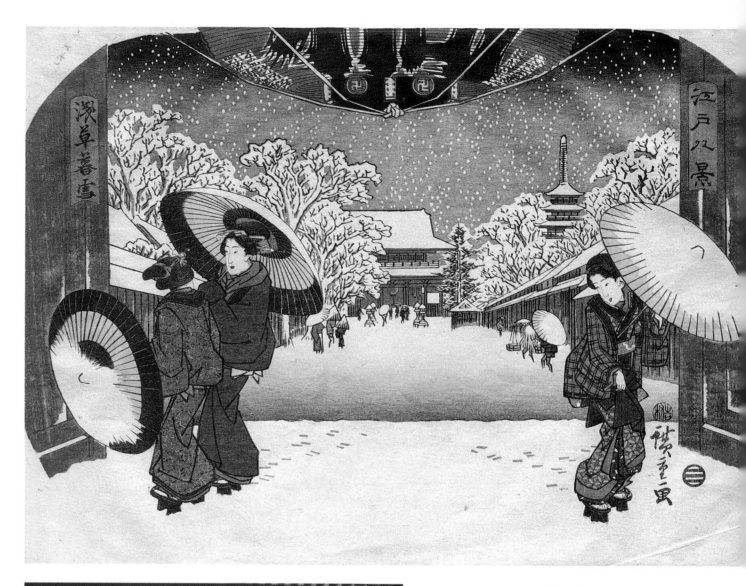

浅草暮雪

江戸八景

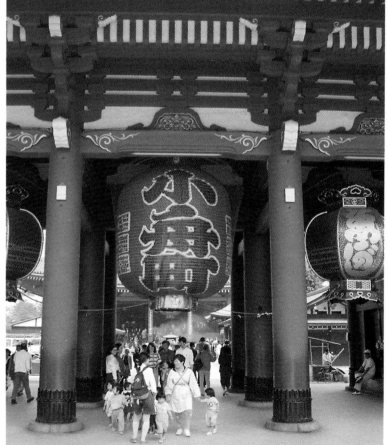

"Evening Snow at Asakusa (above)," *from the series of* Eight Famous Views of Edo (Toto Hakkei), 1839. *On the right, a courtesan, and on the left, a* geisha *and her assistant, at the Thunder Gate (Kaminarimon) of the Asakusa temple complex. Brocade print for a non-folding fan (aiban size). By Courtesy of the Board of Trustees of the Victoria & Albert Museum, London. (left) The Thunder Gate is still a favorite gathering place for visitors to Asakusa.*

# PREFACE

When I first visited Tokyo, only a few years ago, it was not as a tourist or even as a student of Japanese culture but as an architect, with the awesome prospect of designing buildings for a place and a people of which I knew very little. My knowledge of the traditional culture of Japan was limited to what I had gleaned from museums, exhibitions, films, and books, and from occasional foreign tours by the *kabuki* and *Noh* theater troupes. Like many Westerners before me, I had been entranced by the color, the abstraction, the craftsmanship, the discipline, the sense of detail, and the overall strangeness of things Japanese.

Modern Japan appeared at first sight to be very different. However, closer examination has revealed that many aspects of traditional Japanese culture do survive, and not only as carefully sustained tourist attractions. The temples and shrines, festivals and theaters, traditional restaurants and inns, and traditional costumes and music are still there—and remain a part (even if not the entirety) of everyday life for many Japanese. For the roots of Japanese culture—the language, society, and background of history and geography—are unchanged.

Cultures *do* change, but by a process of gradual growth and development. The history of Europe can be seen as a continuum stretching back through Greece and Rome to the civilizations of Egypt and Mesopotamia, with identifiable connections to India and beyond. It is also apparent that cultures change as a result of interaction with their neighbors, with the effect that it is now possible to recognize elements of common cultural roots all over the world.

But Japan and its culture—both traditional and contemporary—have remained clearly distinct. Many of the fundamental activities of culture and civilization are paralleled: the provision of food and shelter; the ordering of agriculture, hunting, and commerce; the eternal quest for truth and beauty, reflected in philosophy, religion, art, and literature. But in Japan the forms and patterns that these fundamentals have adopted over the years are quite unlike those in other parts of the world. In every aspect of their lives and culture—in their diet, their family structure, their social organization; in writing, painting, clothing, theater, history, music, philosophy, building techniques, aesthetic sensibility; in *everything*—the Japanese are different,

*"What we call culture or civilization is based on man's capacity to be a maker, to invent unexpected uses, and to create artificial substitutes."*

ERNST GOMBRICH

9

or certainly were until the opening of Japan to the rest of the world in the 1850s and 1860s. But, significantly, every aspect of Japanese culture was as highly sophisticated in every field of human endeavor as in any other culture in human history.

Modern Japan retains that sophistication. It also remains profoundly different from most of the world, despite the many superficial similarities—the motor cars, the transistors, the fashion photographs, and all the rest of it. The experience of living (however briefly) in modern Tokyo and working (however carefully sustained by others) with Japanese colleagues has given me the opportunity to understand and explore both the strangeness and the sophistication of contemporary Japanese life. In so doing, I have come to understand much more of the traditional culture.

I am, therefore, deeply indebted to the many friends and acquaintances in Japan who have helped me to understand so many aspects of their country and its traditions, that were at first so mysterious. I have in mind a number of occasions spent in "traditional" environments in Tokyo, Chiba, and Kyoto, where the surroundings, the food, the entertainment, and the conversation had surely at least a little in common with the Floating World of Hiroshige's day. I shall not embarrass them by naming them here, but I owe them all—hosts, colleagues, fellow guests, and staff alike— a deep and abiding debt.

It is in the nature of Hiroshige's work that it is widely available. It has been my good fortune to be able to examine his prints in museums and print shops in the most unlikely corners of the world—some of them surprisingly close to my home. I am particularly indebted to the staff of The Department of Japanese Antiquities of the British Museum, the Far Eastern Gallery of the Victoria and Albert Museum, and The Whitworth Art Gallery, University of Manchester, for their help and patience, as well as for their permission to reproduce work from their collections.

It is inevitable in our age of the copiously illustrated book and computer-aided scholarship that much of what is assembled here is based on the work of others. The literature on Hiroshige and his period is extensive, and I cannot claim to have read it all. I, therefore, must thank those scholars whose firsthand knowledge of the many excellent Japanese authorities is incorporated in the books referred to in the Select Bibliography.

However, my task has not been to provide an exhaustive and final account of Hiroshige's life and work; rather it has been to share with others my curiosity and admiration for Japanese culture and the discoveries about Hiroshige and Edo Japan that have engaged me so instructively during the last few years. I have, therefore, followed my own sense of wonder and tried to record the delight of a newcomer to this field. At the same time I have tried to relate these discoveries to my own experience, first as an architect and teacher and second as an amateur artist and photographer.

When this project began, I intended to limit myself to research into the city of Edo as Hiroshige recorded it in his last great series, *One Hundred Famous Views of Edo*. The fact that my inquiry has developed into a more comprehensive study is due to one person, who combines the support and patience of a wife with the enthusiasm of an indefatigable and inspired publisher.

I am also deeply grateful to many others who have opened up a new world of the imagination to me during the last few years—not least my newfound friend, Hiroshige.

Julian Bicknell, 1994

Note: The Japanese are inured to the fact that their language cannot be transliterated directly in the Roman alphabet—just as many Western languages cannot be rendered accurately in Japanese writing. Throughout this book, Japanese words, names, and phrases have been transliterated in the simplest possible way—without double vowels or the long accent that indicates them. The Japanese words and names used in the text are further explained in the Glossary on pages 150-153.

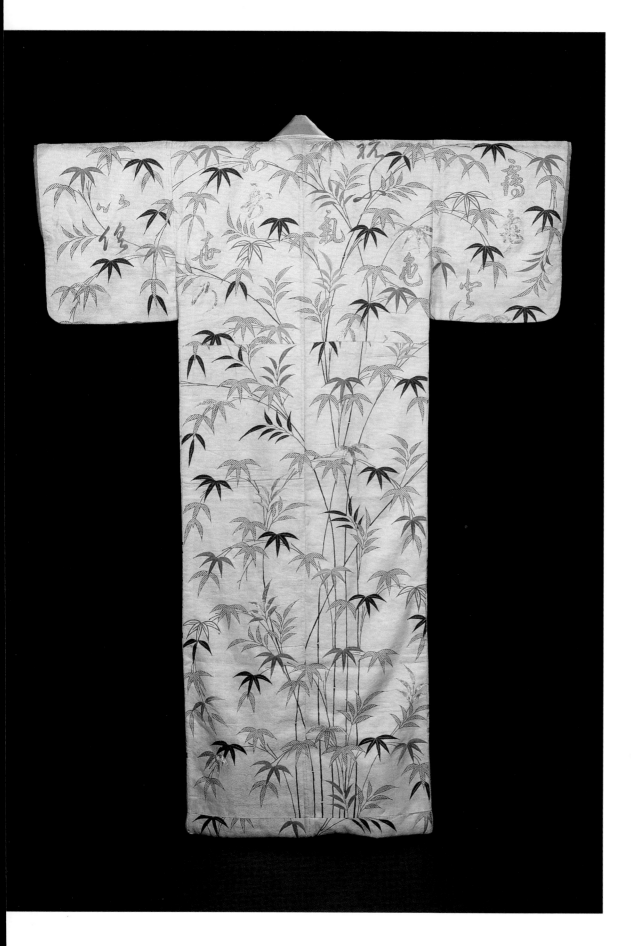

*A white silk satin girl's* kimono, *embroidered, painted, and dyed with a design of bamboo and calligraphic characters* (kanji), *late eighteenth century. By Courtesy of the Board of Trustees of the Victoria & Albert Museum, London.*

# INTRODUCTION:
## The Cherry Blossom and the Sword

In its heyday, the city of Edo was one of the largest, most populous, and most cultivated cities of the world, giving its name to an era of 250 years of Japanese history, a period marked by a unique social and artistic continuity and by unbroken peace from 1600 to 1868.

Today the same city is known as Tokyo—the name given to it after the social and political revolution that accompanied the opening of Japan to the rest of the world in the 1850s and 1860s. Whether known as Tokyo or Edo, it remains among the great cities of the world. But the nature of the city and the culture that it now celebrates has changed. Once a city of myriad one- and two-storied timber buildings interlaced with narrow streets and canals, it is now a metropolis of gleaming steel and glass towers, fed by the most sophisticated of elevated highways and underground railways. An economy dominated by manual labor and pedestrian or waterborne transport has been replaced by an economy of mass production and mass transit with all the trappings of the post-industrial age.

However, the language and the underlying philosophy, the basic ingredients of Japanese culture, are in many ways unchanged. The exquisite craftsmanship and ingenuity that were devoted to the design and manufacture of fabulous kimonos, delicate porcelain, and the carving of miniature ivory toggles for clothing (called *netsuke*) are now devoted to the design and manufacture of miniature cameras, family cars, and the many other mass production artifacts of contemporary life.

The life of the artist Utagawa Hiroshige (1797–1858) spans the last years of the Edo period. His work provides one of the most engaging records of the life of the city, rich in the detailed observation of its physical appearance, of the lives of its inhabitants, and of their dreams and habits of mind, as well as their literature, religion, and philosophy.

A city is the repository of memories, a living museum of the lives and fancies of its people. In any city, every object is an artifact. It has been made by man, and in the making

*Small ivory toggle* (netsuke) *used to hold the cord of a medicine case or purse* (inro) *in the belt of an Edo gentleman— this one carved as a pair of quails pecking at a millet stalk. By Courtesy of the Board of Trustees of the Victoria & Albert Museum, London.*

*"A lively cherry
In full bloom
Between the
two lives
Now made one."*

BASHO

it has been the subject of special care and thought, whether it be a building or a bridge, a boat or a barrow, a kimono worn by a girl walking in the street or the child's kite flying in the spring breeze. Each of the artifacts that make up this urban world acts as a record of the intent of its maker—be it a simple utilitarian question such as a shelter or a ship; the more sophisticated intellectual, philosophical, or artistic intent of a temple or garden; or, indeed, the imagery of a woodblock print, the chosen medium of Hiroshige, the master artist of Japanese landscapes and cityscapes.

The art of Hiroshige is also a repository of memory, containing an immeasurable diversity—like the city he celebrates. He observes and records, with only the slightest artistic editing, the enormous variety of the city and its population: the stately towers of the *shogun's* fortress; the streets and bridges burdened with traffic; the fleets of boats and barges on the rivers and canals; the gleaming white storehouses protecting the riches of the city; the sea of roofs covering its 300,000 dwellings; the jostling crowds in the fish market, shopping district, theater street, or Pleasure Quarters; the splendid processions of *daimyo* lords with their arrogant *samurai* retainers in matching costumes; the tradesmen in their shops and booths; the hawkers and porters in the street; the elegant wives strolling in the temple gardens; the stylish young men and their pretty companions in giggling boatloads on the river; and even the stray dogs and itinerant musicians on the street corners.

Hiroshige records these scenes in all their visual richness, but with a pictorial directness that is instantly accessible. Yet at the same time he incorporates a whole world of secondary significances—significances that only gradually become apparent, with the help of a little knowledge of the culture of which he and his images are part. For in his pictures he also includes references that a scene or sight might call up in the mind of his audience—the particular festival or event associated with a given location: perhaps a *sumo* wrestling festival at the Ekoin-ji, cherry blossom viewing in the gardens at Ueno, or the legendary origins of a place name or temple dedication. He may conjure up the delights of the culinary specialities of a certain restaurant or an afternoon at the *kabuki* theater, or the frisson of an assignation in the Pleasure Quarters. He is also a master of the effect of light and weather on a scene, evoking in his images the chill of a long journey at midwinter, the hazy oppression of

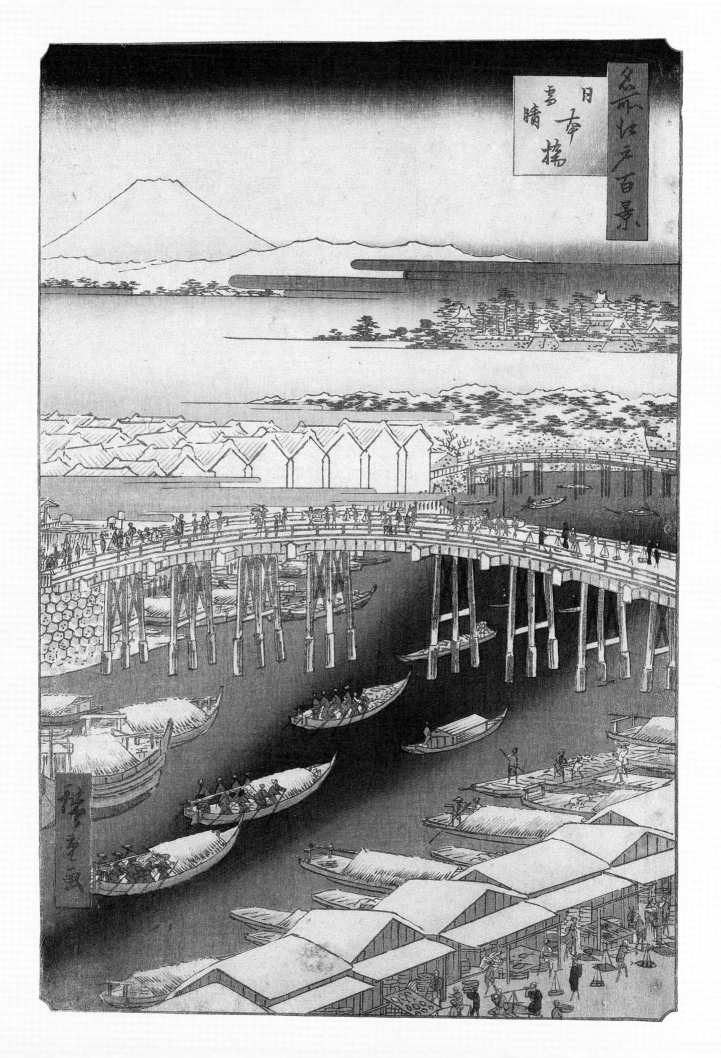

a midsummer's day, or the torrential downpour of an autumn shower.

Just as the individual human memory records images by association, Hiroshige's pictures embody not only the look of the scenes he portrays—the shapes and colors of a snapshot view—but also the events, the atmosphere, and all the other associations that enhance the pleasure of recollection.

In order to understand and savor the richness of these associations, it is useful to know something of the world in which Hiroshige lived and worked, of the geographical, historical, and social background of the Edo era, and of the people of Japan, to whom his imagery has since become synonymous with the beauties of their landscape—and the flavor of the Edo era.

"Teahouses and Market Stalls on the Waterfront at Takanawa." *A popular spot overlooking the moored cargo vessels in Edo Bay, where pleasure seekers, geisha, stall holders, and street actors enjoy the evening air, some in boats, some in the teahouses on the shore, and others on foot in the foreground. Triptych of brocade prints, oban size. Courtesy of the Trustees of the British Museum, London.*

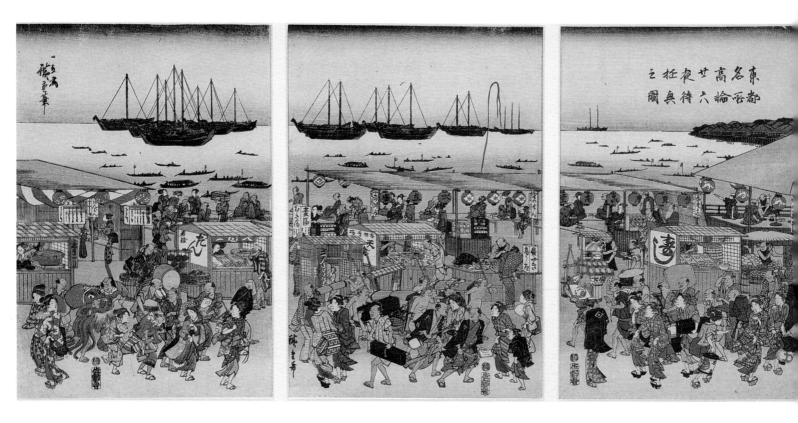

# THE EASTERN CAPITAL

## The Mountains and the Gods

To travelers from Europe, Japan has always been the land at the edge of the world. Medieval merchants following in the steps of Marco Polo, telling of their immense journeys over the mountains and plains of central Asia to the great commercial centers of China, brought back tales of a land even farther away across the ocean, a land of mountains swathed in mist, a land of strange people and stranger gods. Later, when the great explorers of the sixteenth and seventeenth centuries reached Japan by ship—whether by toiling around the tip of Africa, across the Indian Ocean, through the labyrinth of the East Indies, and up the coasts of China and Korea, or by sailing for weeks across the immensity of the Pacific—their final landfall had the same ring of myth and mystery.

Even today, arriving in the ease and safety of the pressurized cabin of a Boeing 747, the mountains of Japan emerge from the ocean like the scenery of legend, their tree-clad slopes climbing steeply from the encircling sea, rank upon rank to rocky, snow-covered peaks.

Japan is indeed a land at the edge of the world—or, more accurately, at the edge of the great tectonic plate that makes up the continent of Asia. It is the movement of these plates against one another, and the associated volcanic activity of millions of years, that has created those mythic mountains. More than three-quarters of the country is covered with them—very steep, and blanketed, at least to the snow line, in luxuriant forests. The people of Japan have

*"And the landscapes in the snow, with the summits white against a sky as luminous as the snow, were just like the winter landscapes that the Japanese have painted."*

VINCENT VAN GOGH

*"Surely there must be Someone crossing The pass of Hakone On this snowy morning."*

BASHO

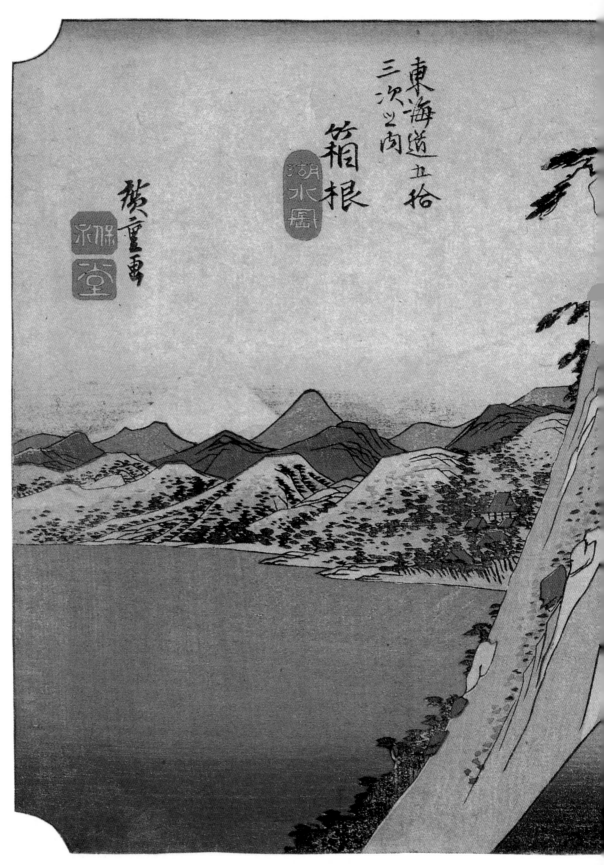

"Hakone: The Lake." *This is the tenth station from the* **Fifty-Three Stations of the Tokaido, 1833–1834.** *The volcanic mountains around Lake Hakone are famous for their hot springs. In the foreground, a lengthy* daimyo *procession struggles up the pass, one of the stiffest climbs on the Tokaido Road between Edo and Kyoto. The roofs of a village nestling in the forest that borders the lake can be seen, and beyond, the peaks march on to the horizon where the sacred white cone of Mount Fuji glows in the distance. Brocade print,* oban *size. Courtesy of the Trustees of the British Museum, London.*

traditionally lived either on the floors of the narrow valleys between these high masses, cultivating rice in the paddy fields that can be formed with dikes and dams in the streambeds, or on the shores of the encircling sea—which is rarely more than seventy-five miles from any point in Japan—winning their livelihood from the ocean. Mountains form the backdrop to virtually every town or village, and their looming profiles, frequently shrouded in mist or cloud, are unmistakably the realm of the gods.

Indeed, the mountains themselves and many other natural features—gorges, waterfalls, pools, and forests—are regarded as sacred. The great, snow-smoothed cone of Mount Fuji, for instance, the tallest mountain in the country—12,388 feet (3,776 meters) high and visible at a distance of fifty miles—is Japan's most sacred landmark.

## Shintoism

The indigenous religion of Japan is known to the outside world as *Shinto,* a name derived from the Chinese *Shin-tao,* or "new way." It derives, as do virtually all indigenous or primordial religions, from the rituals of primitive society: the marking of daily and yearly cycles; the celebration of birth, marriage, and death; the worship of the mysteries of the natural world and of the unique events of time and place; the mythification of natural phenomena and of the world in general—an amalgam of animism, polytheism, fertility cult, myth, and ritual—unique to the place and culture.

*Shinto* gods are particular to their localities. Each is quite literally the *genius loci,* the spirit of the place. There are as many of them as there are places in Japan, reputedly some eight million! The sacredness of such places is celebrated in many aspects of Japanese culture—not least in the tradition of *meisho,* or "famous views," the name by which Hiroshige identifies many of his topographic images. These views are not just a record of the place, its buildings, and its vegetation; they also invoke the spirit of the location, referring to the interests and attributes of the tutelary deity and the related stories from myth and history. Hiroshige's images are greatly enriched with such secondary meanings and associations.

In addition to these guardians of sacred places, there are the gods of creation, such as Amaterasu the Sun Goddess, the most important of *Shinto* deities and the ultimate

*The interior of a large* Shinto *shrine, with offerings and decorative features in front of the god's sealed home* (taisho*).*

*A typical* Shinto *shrine with the characteristic hanging curtain (*noren*), looped at the center with a tasseled rope.*

ancestor of the imperial line. Her shrine at Ise is the most sacred in Japan. A whole pantheon of related gods and goddesses exists with a special shrine and location.

The shrines that provide homes for these *Shinto* gods are frequently sited on the mountain slopes behind the village, near some magical waterfall or spring, often buried in the forest. The shrine itself (*taisho*) is the god's home, an idealized version of the traditional wooden house, a sacred void with a single door and no windows, surmounted by a richly profiled roof. Some are very small, enclosing a space only a foot or two across. A few are immense—enormous sealed caskets perhaps thirty or even forty feet square. The contents of the shrine are a mystery, and no one is permitted to enter. The house of the god, like the house of the most lowly Japanese peasant, is private.

The area around the shrine is also sacred and is frequently enclosed by a wall or fence to mark the sacred area, which may include other buildings—a hall for worship, a bell tower, a house for the shrine attendants, and so on. The smallest shrines may have an enclosure of only a few square yards marked by ceremonial knots of rice straw. The largest occupy many acres with secondary courts and subsidiary shrines, surrounded by elaborate walls pierced by magnificent gateways (*torii*).

At the great shrine complex at Izumo, one of the most important in Japan, there is an immense shrine for the resident deity, Okuninushi, and another for his consort. Around their enclave are hundreds of minor shrines, which all the gods of Japan are said to visit for a great festival in October—a veritable holiday resort for the gods.

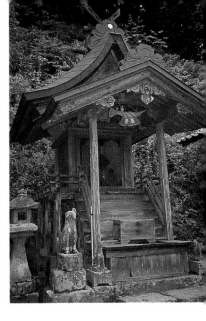

*A country shrine (*taisho*) near Matsue in western Japan. Although of very modest scale, it has all the important features—the closed home of the god, the porch, and a box for offerings. To the side are two guardians and a ceremonial lantern.*

*A modest* Shinto *shrine, with a house for the attendant on the left and a bell stand on the right.*

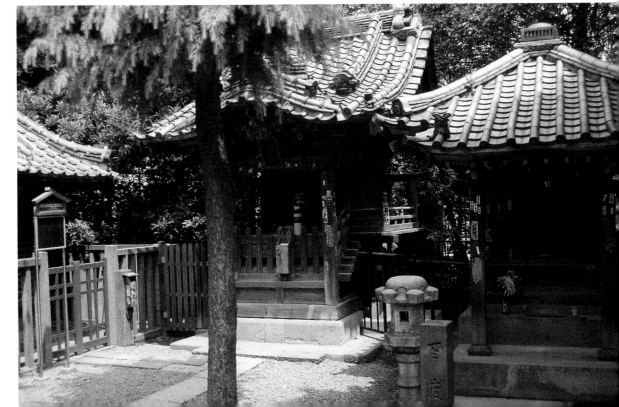

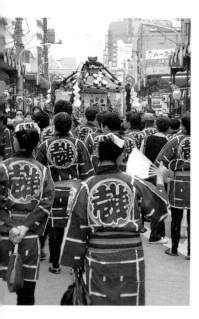

*Guild members carry one of the portable shrines (*taisho*) at the spring festival in Asakusa, wearing the matching jackets (*hapi*) of the guild.*

On their festival days, the gods are transferred with suitable rituals to portable shrines—again, closed boxes sealed with ceremonial knots—which are carried around the village or town to visit all the houses and fields of the district. These portable shrines are richly decorated with the emblems of the god, sacred bindings, gold metalwork, bells, and copious carving. They can be extremely heavy, requiring teams of twenty or thirty bearers, who nevertheless shake the shrines vigorously at various points along the processional route to ensure that the influence of the god is felt in every part of the parish.

In the cities like Edo, the shrines frequently occupy prominent places in the landscape: a small hillock, an escarpment by the river, a promontory on the seashore. The shrine precincts, with their carefully tended gardens, provide green enclaves among the throng of houses. On their way to work each day, townspeople may take a route through one of these parks, wake the god with three ritual hand-claps, and stop for a moment's prayer at the shrine before going on their way.

The powers and attributes of the gods relate them to the affairs of men. They are the patrons of weather and agriculture, of fertility and childbirth, and of various trades and occupations: merchants and fishermen, soldiers and seamstresses, mothers and even the ladies of the Pleasure Quarters. The gods are a part of the community, perhaps friendly, perhaps antagonistic, but always to be treated with the respect and honor due to powerful neighbors.

These qualities of respect and honor are indeed central to the system of beliefs implicit in *Shinto* ritual and are in turn central to Japanese culture. The respect and honor due to the gods is expressed most tangibly in the rituals of purity and cleanliness (*kirie*) which are at the heart of Japanese life.

## Buddhism

In the seventh century, Buddhism, with its sophisticated philosophy of tolerance, self-discipline, obedience, and resignation, was introduced into Japan by Chinese monks and was adopted by the imperial court and ruling classes. The Japanese are remarkable for the way in which they have absorbed new ideas over the centuries, whether of religion, philosophy, technology, or the arts, making them part of their own culture without sacrificing their own national

character. Buddhism seems to have struck a particular chord, and the Japanese have since developed their own Buddhist philosophies (the best known being Zen Buddhism), which are very closely attuned to their specific circumstances and lifestyle.

In the course of time, Buddhist temples and monasteries took their place beside the *Shinto* shrines, adding further places of pilgrimage, further opportunities for festivals, and yet more beautifully tended parks and gardens—becoming in their turn notable features of the landscape that Hiroshige was to record in his famous views.

The development of Buddhism, with its emphasis on perfection and simplicity, complemented the indigenous culture's concern with purity and cleanliness. Many aspects of daily life were subjected to philosophical scrutiny and refined in the form of rituals, the best known of which is the tea ceremony—a ritual celebration of a notional meeting between a Buddhist sage and a group of his guests in a rural enclave. Both the setting and the sequence of activities—the arrival at the enclave, the assembly and greeting of the guests, the hand-washing and the entering of the tea-house itself, and finally the ritual of making and sipping the native green tea from simple rustic earthenware bowls—have been refined into a carefully ordered ritual that seeks to enhance the existential qualities of simplicity and of the uniqueness of place and time.

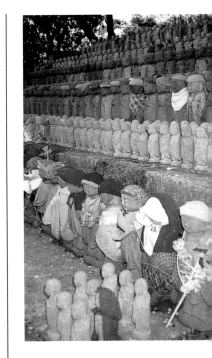

*Rows of miniature Boddhisattvas commemorating the dead, decorated with garlands, caps, and bibs—and occasionally full costumes—for festive occasions.*

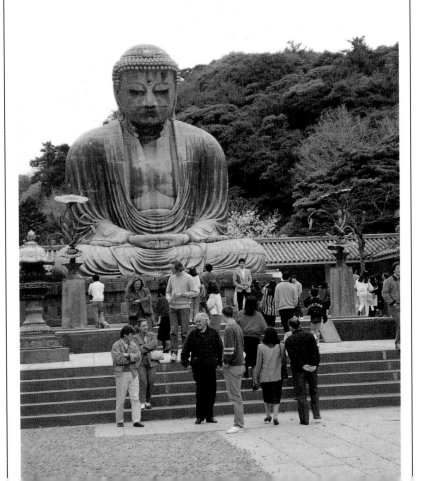

*The giant Buddha (Daibutsu) at Kamakura, near Tokyo, one of the largest cast bronze figures in Japan, dating from 1252.*

# The Shogun and the Emperor

The origins of the city of Edo are very recent by any historical standards. Until 1600 it was little more than a fishing village at the mouth of the Sumida River, clustered around the moated castle of the ruling family of the surrounding Kanto Plain, the Tokugawa. Kyoto, the ancient capital of Japan, was already centuries old, as were the cities of Europe—Rome, Paris, London, and Madrid. But by 1700, a mere century later, Edo was a city of a million inhabitants—one of the largest cities in the world at that time. This remarkable growth was due to the extraordinary developments in Japan in the late 1500s.

Japan was then ruled, at least in name, by the emperor, from his capital at Kyoto. But Japan is a big country. The 1,200 miles (1,900 kilometres) from the northern island of Hokaido to the tip of the southern Island of Kyushu, is equivalent in distance and latitude to the eastern seaboard of the United States between Maine and Florida. In such a large country, and in an age when messages frequently traveled no faster than a horseman or a palanquin *(norimono)* carried on the shoulders of a pair of footslogging retainers, the control of each of the provinces into which the country was divided was in the hands of the local lords or *daimyo*[1]. Although the *daimyo* were answerable to the emperor in theory, much as the feudal lords of medieval Europe were answerable to their various kings, they and their private armies were more or less autonomous, and for many generations Japan was riven by civil wars in which various *daimyo* factions, each with private armies of *samurai* warriors, fought for territory and political power.

At the end of the sixteenth century these civil wars were finally resolved as groups of *daimyo* formed grand alliances behind a succession of powerful leaders—Oda Nobunaga, Toyotomi Hideyoshi, and Tokugawa Ieyasu. The last of these, Ieyasu, established his authority over the whole country at the battle of Sekigahara in 1600 and took the title *shogun,* an ancient name for the commander of the emperor's armies. He was, in effect, the ultimate political

[1] The Japanese language has no special plural form. The word *daimyo,* for instance, can mean lord or lords according to context.

24

ruler of Japan. The emperor remained head of state and retained his court at Kyoto, but the country was ruled from the Tokugawa family's great fortress at Edo—today the imperial enclosure in the center of Tokyo.

In order to establish their control over the distant provinces, the Tokugawa *shoguns* set up a unique arrangement whereby the *daimyo* lords were required to spend every second year at Edo; in the alternate years they had to leave their wives and children as hostages at court. There were some two hundred of these *daimyo* with estates of various sizes in their home provinces.

As a result, all the *daimyo* were required to maintain a residence in Edo for their own use during their alternate years of attendance at court and for their families in the years that they were away. These residences had to house not only the family but also the servants and retainers who would serve the *daimyo* in his Edo home and accompany him on occasions of state and on his yearly journeys to and from his provincial estate. These establishments were large and became a prominent feature of the city of Edo. They also required the services of tradesmen of every sort to supply them with food, clothing, and all the other necessities and luxuries of life in the city.

"Yoritomo on his way to visit the Emperor in Kyoto." *A triptych of prints from a series illustrating a formal visit of this famous character to the emperor's court. Hiroshige will have witnessed scenes very like these when he was part of such a cavalcade in 1832. Brocade prints,* oban *size. By Courtesy of the Board of Trustees of the Victoria & Albert Museum, London.*

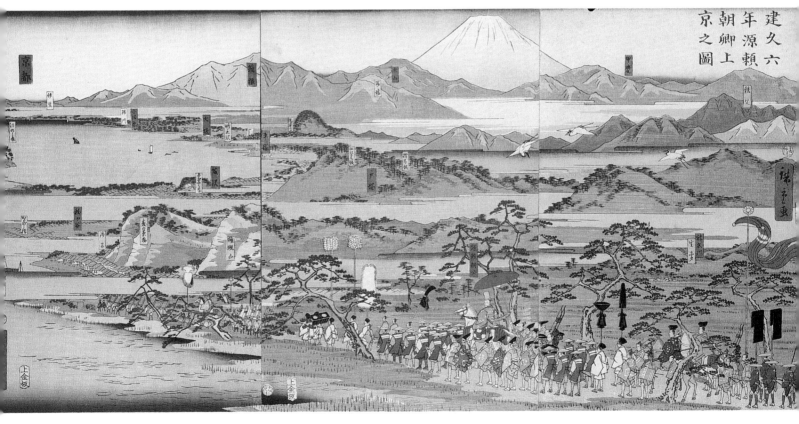

In consequence, the city grew rapidly, and by 1700 the population numbered more than a million people. Edo was quite probably the largest city in the world at that time—and, ironically, virtually unknown outside Japan.

This was because the Tokugawa pursued their policy of centralization to the extreme by cutting off many of the lines of communication between Japan and the outside world. Foreign traders were allowed to enter only certain ports. The Portuguese, the most persistent and energetic of the foreign merchants, were allowed the special privilege of a permanent station on an island in the harbor at Nagasaki—but no more. Native Japanese were not allowed to travel abroad without formal permission from the *bakufu* (the *shogun's* civil service); if they did so illegally, they were not allowed to return to Japan—on pain of death.

Despite these government restrictions, the Japanese themselves have always been curious about the outside world, particularly about foreigners and their cultures and philosophies. In the early part of the Tokugawa period a number of influential ideas which had been absorbed from the foreign trading communities were actively discouraged, such as the use of firearms (which had been decisive in the civil wars of the sixteenth century) and Christianity, to take two examples. The *bakufu* restricted the manufacture of firearms because they gave undue power to the provincial *daimyo* and were, in any case, hardly necessary during the 250 years of peace that Japan was to enjoy under the Tokugawa. Christianity was proscribed as a subversive religion, encouraging allegiance to a distant pope, foreign gods, and foreign philosophies. Where Christianity was suspected, supposed adherents were required to stamp on a Christian image cast in bronze (known as *fumie* or "treading picture"). Despite this form of trial Christianity was not totally eliminated. A remarkable number of Christians in Japan today belong to a tradition that goes back to the sixteenth century—before the split between the Catholic and Protestant churches in Europe.

## Social Strata

The society of Japan in the Tokugawa, or Edo, period was very clearly stratified and rigidly divided. At the top of the social pyramid was the emperor and his family (known collectively as *temno*)—direct descendants of the Sun Goddess Amaterasu.

Immediately below the imperial family were the nobles, or *daimyo,* the most important of whom was the *shogun* himself. Next below him were the *samurai,* the *daimyo's* retainers, traditionally of the warrior class, although by the end of the Edo period few *samurai* had any fighting experience beyond formal education in the use of the pair of swords, one long and the other short, that they were entitled to wear as symbols of their rank. *Samurai* rank (and often a formal appointment to the retinue of a certain *daimyo* family) was passed from father to son—as was the case with Hiroshige.

Next below the *samurai* were the farmers, mostly peasants who produced the rice which was both the staple food of the country and the basis of the economy—measures of rice being used to quantify the value of a *daimyo's* estate or a *samurai's* wage long after the introduction of official coinage.

Immediately below the peasants were others involved in labor or manufacture: craftsmen, artisans, builders, and the thousand-and-one others who made things for Edo society.

At the bottom of the social pyramid of Japanese society were manual laborers and, surprisingly, merchants who

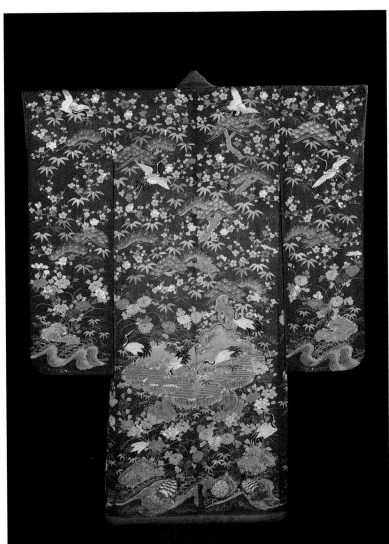

*An extremely lavish* kimono, *probably for use on special occasions or on the* kabuki *stage, of blue silk embroidered in gold and colored silk with a design of cranes, tortoises, and flowers, all signifying long life. By Courtesy of the Board of Trustees of the Victoria & Albert Museum, London.*

made a living purely through the exchange of goods—an activity without the apparent economic value of manufacture or food production or the distinction of the warrior ruling class.

Although this social hierarchy was carefully observed and maintained right up to the end of the Edo period, the actual relationships between the various classes were often very different. Many merchants, for instance, accumulated great wealth and were in a position to set up banking businesses to which even the *daimyo* lords became indebted. *Samurai* retainers, many of whose duties were purely nominal, earned a salary-equivalent in rice that was barely enough to maintain a family, and were bound to look elsewhere to make a decent living—as did Hiroshige. This double standard in matters of social position was (and still is) so much a part of the political and social life of Japan that the language distinguishes between things as they exist in theory—*tatemae*—and in actuality—*honne*.

A similar double standard had existed even before the Edo period in that the affairs of state—nominally controlled by the emperor—were in fact run by a self-sustaining oligarchy of advisors at the imperial court—frequently members of the same clan, the Fujiwara. The power behind the throne became hereditary too. In due course this power was taken over by the *shogun*—but without displacing the coterie of imperial advisors. Later still, there evolved a group of advisors to the *shogun*—who held the reins of government on his behalf—four times removed from the nominal head of state, the emperor.

A similar complexity survives in the power structures of contemporary Japan. The emperor is the constitutional head of state, but holds virtually no powers. His life is entirely controlled by the Imperial Household Agency which determines whom he meets, what he can do—and in certain instances what he can say and even whom he can marry. The government is run—at least in name—by the elected members of the Diet (or parliament) who debate policy and pass legislation. But it is no secret that the party bosses, rather than the members of the Diet, frequently determine the political strategy, and that, in fact, many of the most important policy decisions are made within the senior ranks of the civil service. It is they, for instance, who have set out and pursued the policies of the past thirty years that have

made Japan's one of the most successful economies of the modern world.

In Edo-period Japan the government of the *shogun* was also enacted by a large civil service, the *bakufu*. It was they who issued edicts on his behalf and who were responsible for their enforcement. There were senior representatives in every city and town assisted by a staff of *samurai,* who administered every aspect of community life, including, as is evident in the life of Hiroshige, everything from the organizing of fire-fighting teams to the approval of designs for woodblock prints.

The everyday lives of the ordinary people were as diverse and complex as the social and political background. Most of the rural population were peasants employed in the production of food and raw materials. Their lives were hard, monotonous, and short, dominated by unremitting manual labor and enlivened only briefly by annual festivals and the occasional glimpse of some passing dignitary, *daimyo, samurai,* priest, or merchant. The doggedness, tenacity, and resignation of the peasant is a recurrent ingredient of the Japanese character. The great proportion of townsfolk (*cho-nin*) also led more or less menial lives, but without the certainties of the agricultural world. They, too, were hardworking and tenacious but, being less certain of permanent employment or of the support of the community in times of trouble, faced the world with a bustling, opportunistic, and fun-loving energy, a devil-may-care attitude that responds to adversity with humor.

This, then, is the historical, social, and political backdrop of the world in which Hiroshige lived and worked.

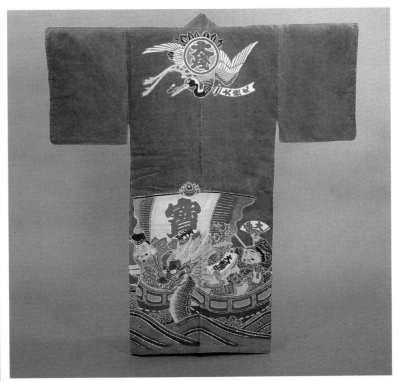

*A fisherman's festival coat of blue cotton with resist-dyed design of a crane and boats. By Courtesy of the Board of Trustees of the Victoria & Albert Museum, London.*

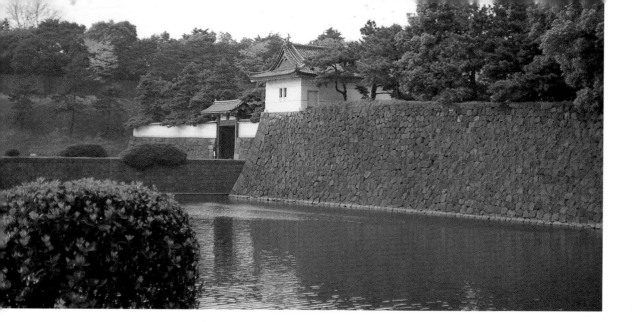

*One of the gates of Edo Castle and its causeway across the moat* (benkei).

# The City of Edo

The city of Edo is sited at the mouth of the Sumida River on the edge of the great Kanto Plain—one of the few parts of Japan where the cultivated coastal strip widens to some twenty-five miles. The Sumida River is one of several that flow across this great plain into a coastal inlet some twenty miles across, now known as Tokyo Bay, which is protected from the Pacific Ocean by the Chiba Peninsula.

These rivers and their deltas form a network of waterways that were improved and modified over the years into a system of canals and moats providing a complete transport and drainage system connecting all sectors of the city and the surrounding agricultural areas. Hundreds of bridges carried the roads and streets of the city across these waterways and canals.

At the city's heart was the original fortress of the Tokugawa—now the Imperial Palace and its gardens—a group of islands fortified by a masonry wall sometimes rising to a height of fifty feet (fifteen meters), and accessible only by means of a series of gated causeways across the wide moat that surrounds it. These and many other public works were undertaken in the early 1600s as gestures of goodwill on the part of the *daimyo* lords, contributing immeasurably to the quality of the city and serving at the same time to consolidate the power of the Tokugawa regime beyond any opposition—by establishing an impregnable stronghold and draining the *daimyo*'s resources.

Around the *shogun*'s own residence were those of the 200-odd *daimyo* clans—each an enclosure of one to five acres—that included not only the residence of the *daimyo*

and his family but also quarters for his retainers and their families, as well as kitchens, gatehouses, stables, and storehouses. The less important members of the household, the servants and junior *samurai*, were housed in blocks often described as barracks—although they were probably less regimented than this term would imply and certainly included family quarters (if only a single room). Such barracks were also provided for junior government officials who were nominally retainers of the *shogun* but could not be accommodated within the *shogun's* island enclave. It was in such a barracks just southwest of the great moat that Hiroshige was born and grew up.

The most important commercial area of the city lay between the residences of the *daimyo* and the Sumida River. Here could be found all the shops and businesses that supplied the needs of the ruling classes, from groceries through clothing and furniture to banking services, construction supplies, and boat building. The center of the commercial district was (and still is) Nihon-bashi—the Japan Bridge—where the central street of Edo crossed the largest of the waterways that connect the Sumida River to the moats around the *shogun's* fortress. On one side of the canal was a row of immense fireproof storehouses, easily

"Shower over the Nihon-bashi," *shows the Japan Bridge in central Edo with the towers of Edo Castle and Mount Fuji in the distance. From the series* **Famous Places of the Eastern Capital (Toto Meisho), 1831.** *Brocade print,* oban *size. The Whitworth Art Gallery, University of Manchester.*

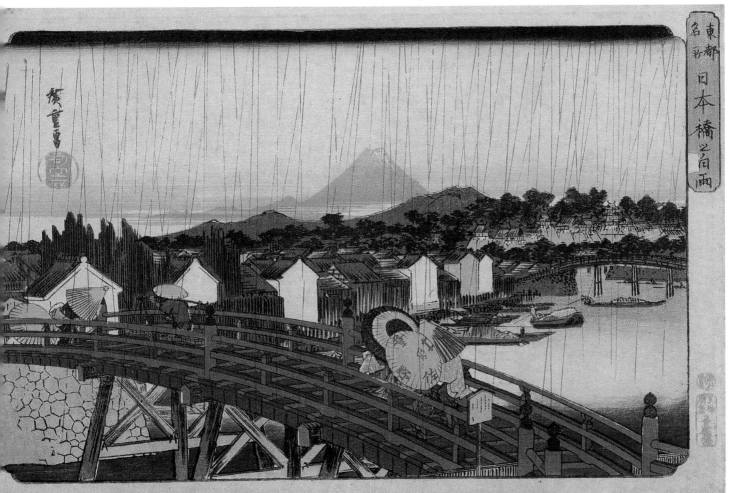

distinguished from the usual delicate timber buildings by their heavy windowless construction and white-painted plaster walls. These contained, among other things, the huge quantities of rice that were both the dues paid by the *daimyo* to the *shogun* and the city's emergency supplies throughout the winter. On the other side was the central seafood market where the great variety of seafood that contributes so much to the gastronomic and visual delight of Japanese cuisine was available—fresh every morning.

From the commercial center, the city's many subsidiary districts were spread out on all sides—each with its own special character. Kanyo-cho, for instance, the dyers' quarter just to the north, was the center of the textile industry that provided the clothing, household linen, hangings, and the numerous other fabric items, both decorative and practical, that are so important a part of Edo culture. To the south were the bamboo merchants, from whom one of the most important raw materials, for everything from baskets to buildings, could be obtained. A district of restaurants and teahouses lined the bank of the Sumida River to the east, where patrons could enjoy the cooling breezes off the water and the lively views of boats and barges.

Just across the river was an area devoted to more lively entertainment—archery and fortune-tellers' booths, theaters and so forth. In the city's early days (1600–1700) these amusements were temporary in nature and formed a sort of fairground city on the east bank. In the course of time the city itself spread farther to the east and these amusements became more regularized, with permanent buildings and all the secondary services, shops, and workshops, of an independent city district. The permanent theaters found their home elsewhere, in Surawaka-cho to the north.

Dotted around the city were shrines and temples with their calm and shady gardens, providing a welcome respite from the bustle of the rest of the metropolis and always open for a moment's rest and contemplation—such as Asakusa Kannon, to the north, or Ekoin-ji, across the river to the east.

On the northern edge of the city, upstream on the western bank of the Sumida, was the Yoshiwara—the licensed Pleasure Quarter, with its teahouses, restaurants, and brothels. There were other parts of the city where such entertainment could be obtained but only the Yoshiwara enjoyed the formal approval of the *bakufu*.

*The interior of an original samurai house at Matsue in western Japan, showing an array of serving dishes.*

Beyond the city itself was the Kanto Plain, a landscape of mixed agriculture, marshes, rivers, and low hills, peppered with small villages and minor towns where the principal activities were directed toward supplying the great city with food and other raw materials.

## The Japanese Home

Japanese culture, as any other, celebrates the rituals of daily life, in particular the rituals of the home. These rituals and the form and nature of the house are fundamental to Japanese culture.

The traditional house, whether in town or country, is a simple shelter, often a single room made of natural materials, usually wood. The floor is raised a foot or two above the ground and is covered with rice straw mats (called *tatami*), each the shape and size of a sleeping mattress. The rooms are enclosed by screens of wood, plaster, or paper, some of which may be slid aside to open the room to the outside world. A steep pitched roof with wide projecting eaves throws off the copious rainfall of the country.

Life conducted in this exquisitely simple environment requires continual attention to order and cleanliness. Possessions are kept to a minimum, and there are no tables or chairs as we know them. At mealtimes the family sits cross-legged on cushions on the floor, sometimes with (but frequently without) a low table some ten inches off the floor. At night, quilted mattresses (or *futon*) are laid out for each sleeper. Every object, from the bedding roll and clothing to the smallest kitchen utensil, has its place in a cupboard or chest.

To ensure the cleanliness of the interior, the entrance is divided from the main part of the house by a step where every family member or visitor leaves shoes and outer garments on entering. This step, or threshold, is a recurring theme in Japanese architecture, ranging in scale from the domestic threshold to the gates (*torii*) of the great temple complexes. The threshold is frequently enhanced with a

*Another view of the samurai house, with all the rooms open on every side to the garden.*

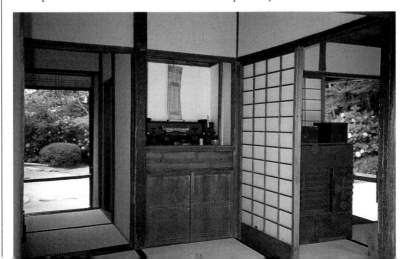

curtain (*noren*) hanging to just below head height, which forces the arriving guest to duck his head as he enters. Thus the very buildings insist on deference in the action of arrival, a form of reverence echoed in every aspect of Japanese life.

The rituals of personal cleanliness and hygiene are provided for with similar care. Larger houses are provided with a bathroom, where the entire body is soaped, cleaned, and rinsed before immersion in the traditional hot tub. Earth closets, once provided outside the confines of the house, have been replaced by water closets. Special slippers are used there to prevent contamination. Because the house is small and fragile, physical activity is severely limited and social gestures closely conventionalized.

Traditional clothing, too, is very simple. Varieties of untailored coats (*kimono*) that can be folded flat and stored compactly in chests and cupboards, with skirts and sleeves of various lengths and bound at the waist with more or less decorative belts, are worn by both men and women. The cut of such costumes hardly varies, but the design of fabrics is the most elaborate and sophisticated in the world. An immense range of techniques is involved: dyeing, printing, tie-dyeing; brocade, tartan, and ikat weaving; embroidery, quilting, patchwork, and appliqué. The visual richness and variety are unparalleled, the sense of color and form unique and of never-ending invention.

*Two* kimono *for everyday use: on the left is a cotton workman's jacket; on the right a ladies' silk jacket; both using designs based on the ikat technique where the strands of weft and warp are dyed before weaving. Private Collections.*

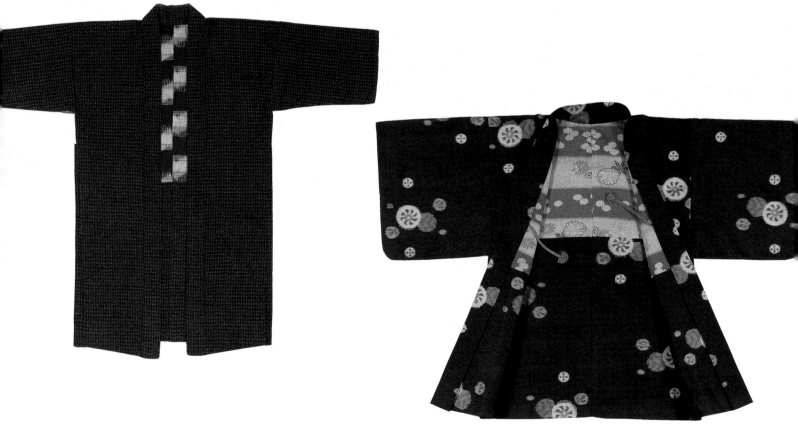

## Commerce

The vast majority of the citizens of Edo were employed in commerce of one sort or another, providing food and clothing to their fellow citizens, manufacturing articles of daily use, or importing raw materials and made-up goods for manufacture or distribution by others.

In the early days, before a comprehensive local system of supply and manufacture was established, an enormous proportion of the durable goods sold in Edo were imported from Osaka, the great port on the Inland Sea to the west, that already served as the port to the imperial capital at Kyoto. The merchants of Osaka became very rich and even today Osaka retains a sense of mercantile self-confidence not unlike that of medieval Venice, nineteenth-century New Orleans, or modern New York.

Because merchants, as a class, were at the bottom of the social scale despite their wealth and commercial power, they formed great alliances among themselves, often based on the wealth of individual families. The house of Mitsui, for example, ran the largest emporium for imported goods in Edo, the original department store, dating back to the mid-seventeenth century. With the passing of the years, the Mitsui Corporation has graduated into banking and its role as the primary department store has been taken over by their cousins, Mitsukoshi. Nevertheless the two families still occupy the same prime site in central Tokyo as they did 250 years ago (see page 113).

Around the great commercial houses were thousands of smaller businesses engaged in commerce of every kind: grocers, flower sellers, fishmongers, pastry cooks, paper makers, cloth dyers, tailors and seamstresses, ceramicists and lacquer workers, makers of *tatami* mats and the quilted *futon,* jewelry-makers, ivory workers, and makers of seals and fans, sandals, socks, and paper umbrellas—all with their small workshops and stalls.

The perfection of craftsmanship is central to Japanese culture, growing as it does from the *Shinto* ideals of purity and cleanliness and the Buddhist ideals of simplicity and refinement. This perfection can be seen in every product of Edo culture, from the simplest clothing and tableware to the most sophisticated painted screens and formal architecture. One of the most rewarding examples of this search for perfection is the woodblock print, which, after a century or so of development, became the most technically sophisticated method for the mass production of colored images of its day.

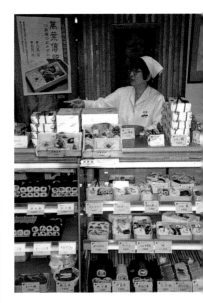

Sushi *stall in central Tokyo, presenting a variety of raw fish delicacies, many served rolled in rice and edible seaweed—a delicious and popular snack or* hors d'oeuvre.

*A selection of highly decorated fans for sale in central Tokyo.*

*A variety of noodles and other dried goods on sale in a typical shop in Tokyo.*

Commerce is dependent on transport. Many of the roads of Japan traverse rocky and mountainous terrain and were quite unsuitable for wheeled transport until modern engineering techniques became available. In fact, the *bakufu* restricted the use of wheeled vehicles even in town. Goods were transported by porters or, in Edo itself, by boat. A large segment of the population was employed as porters, ferrymen, oarsmen, and sailors, or in the vast ancillary industry of boat-building and maintenance. There were very few parts of the city more than a few hundred yards from a waterway, large or small. The rivers and canals that quartered the city made it a veritable Venice of the East.

# Ukiyo: The Floating World

As a result of the system of alternate attendance, the *daimyo* and their *samurai* retainers were bound to spend a minimum of four months in Edo every other year, although their homes, and sometimes their families, were in distant provinces. Their duties in Edo were few, and they made up a large leisured class in need of recreation and entertainment.

The business of recreation and entertainment occupied a large proportion of the energies and resources of the city. It was known to Edoites as *uki-yo*—the Floating World.

## Restaurants and Teahouses

Japanese houses are small, and it was (and is) unusual for people outside the immediate family to be entertained at home. Gatherings of friends, acquaintances, and business associates were held in teahouses or restaurants, which might be found in all quarters of the city. They varied

greatly, some providing cheap and simple sustenance, others elaborate and expensive gastronomic delights. Some were intended for ladies to lunch together, some for sober businessmen, some for riotous young blades. Some were single-roomed dives in a side street, while others had elaborate internal gardens or were sited to enjoy some special view.

Certain establishments were used, like the cafés of Paris, as informal meeting places of intellectual and artistic groups. Over the years, the *samurai,* and the upper middle class in general, had turned from military to literary pursuits, and they prided themselves on their learning, their literary accomplishments, and their calligraphy. Poetry societies, at which these literary efforts were aired, flourished. The favored forms were short—the seventeen-syllable, three-line *haiku,* and the thirty-one-syllable five-line *waka*—well suited to the sense of simplicity endemic to the culture and the subtle interplay of metaphor so particular to the Japanese language. Many of these societies would collaborate in the printing and distribution of their poems, which were frequently decorated with elaborate illustrations by the woodblock artists of the day.

The smarter restaurants offered entertainment as well as food. Carefully trained *geisha* not only served at table but also recited poetry, sang, danced, presented episodes from well-known theatrical pieces, and engaged the guests in conversation. *Geisha* with special individual skills in these accomplishments became familiar characters of the official and unofficial Pleasure Quarters and were much sought after as dining companions. Certain of them graduated to the more exalted rank of courtesans, who alone were available for private assignations.

These beauties (*bijin*) were the pinups of the Floating World and provided the subject matter for a vast proportion of the woodblock prints at every period throughout the hundred-and-fifty year history of the art.

## Theater

The theatrical episodes presented by the *geisha* in private restaurants were not available to the general populace. Women were forbidden to act in public from the mid-sixteenth century. However, public theatrical performances with men in all the roles were very popular, particularly in *kabuki*—a form of theater which combines the visual

*A miniature bridge in the garden of a traditional house in Kyoto—now a fine restaurant.*

*An exquisitely presented Japanese delicacy—the grilled head of a dory.*

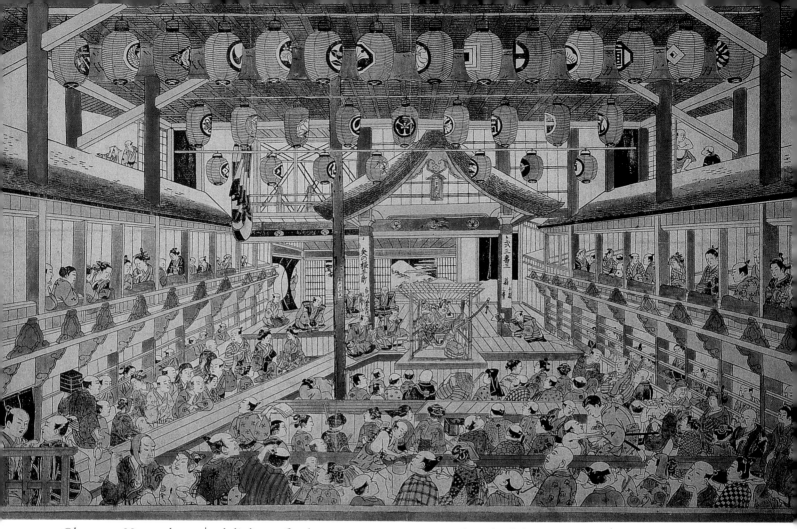

*Okumura Masanobu, "The interior of the Nakamura-za during the Kaomise performance of 1740." A large perspective view (uki-e). On stage an actor in warrior's costume adopts an aggressive "mie" pose; behind him are musicians and singers. A stage-hand lurks behind a curtain while others move the screens of the clerestory to let in more or less light. The audience includes old and young, samurai with their twin swords, courtesans in the boxes, and peddlars with trays of sweetmeats, "bento" meal boxes, and sake flasks. A rose print, large oban size. Courtesy of the Trustees of the British Museum, London.*

delights of glamorous costumes and colorful sets with music, poetry, dance, and melodramatic plots, both comic and tragic. Compared with the more ancient *Noh* theater patronized by court circles, the *kabuki* was (and is) garish, coarse, exaggerated, and very lively—though some of these features are not immediately obvious to a foreign audience. The costumes are wildly extravagant in color and design. The form of diction is highly exaggerated. The characters are frequently stylized to the point of caricature and the plots are far-fetched, but there are moments of great wit, pathos, and beauty.

*Kabuki* fans then, as now, were very appreciative and enthusiastic. Successful actors were the male stars of the Floating World and prints of popular actors in their most admired roles were distributed widely—as posters, on fans, and even on wrapping papers. In fact, the production of prints of *kabuki* actors was one of the most successful sections of the print market and attracted some of the most talented artists—particularly those who relished the extravagance of gesture and costume. Hiroshige contributed a number of prints to this genre, although it was not the area to which his talents were best suited.

38

## The Pleasure Quarters

There is no exact parallel to this important institution in the modern world—even in Japan. The modern red-light district, with its guilt-ridden and sleazy obsession with sex, is a very misleading equivalent. The social background, of course, was very different.

The conventions of everyday life in Tokugawa Japan, particularly of family life conducted in single rooms in small houses with virtually no privacy, required a strong sense of discipline and self-restraint. The Japanese are no less fun-loving than anyone else on earth, but it is difficult to have fun in the delicate surroundings of a Japanese home or a rigorously ordered business establishment. So there were special places for fun—places for forms of social release like the Mardi Gras festivals of South America and elsewhere, but not limited to special occasions. As at Mardi Gras, fun includes music and dancing, poetry, food and drink, dressing up, processions, street theater, and many other types of self-abandonment and enjoyment.

The Yoshiwara, licensed by the *bakufu* under a series of rigorous regulations, provided for all these forms of relaxation at every level in the market. In the Yoshiwara were teahouses, restaurants, and brothels, where the entertainment was vigorous and varied, including eating and drinking, music and dancing, lively conversation, concert parties, and poetry gatherings, as well as opportunities for private assignations. The entertainment was provided almost entirely by young women, known as "beauties," or *bijin*, who were ranked according to their skill, beauty, and accomplishment. The least privileged were the servants, who welcomed guests, prepared food behind the scenes, served at table, and assisted the more exalted ladies in their preparations. The middle rank were the fully qualified *geisha*, who would entertain groups of guests with lively conversation, music, dancing, mime and theatrical performances. Their arts can still be enjoyed in select restaurants in Japan and combine the delights of a very high quality fashion show, a private chamber concert and ballet, a five-star restaurant, and the most engaging conversation—carefully balanced between delicate flirtation and the most refined intellectual discussion.

The courtesans were at the top of the pecking order. Only they were expected to entertain guests in private, and their favors had to be won with much more than the mere

Geisha *in traditional costume.*

39

redistribution of cash. The Japanese, like most self-confident cultures, have always had a very strong sense of family loyalty. But although committed to the principles of family life, they are less constricted—or at least they were in the Edo period—by notions of fidelity. At the same time, sex was not the sole objective, nor was it regarded solely as a matter of self-gratification for the client. It is quite clear from the "pillow books" and editions of *shunga* (literally "spring pictures") that the ladies of the Yoshiwara expected to be courted, entertained, and pleasured in every sense—if their clients were to be allowed a second visit.

Japanese attitudes to what we think of as venal pleasures were very different from those of the West and remain so in many ways. Drinking and inebriation, for instance, carry no social stigma whatsoever. It is not unusual, or in any way offensive to the Japanese, to see an elegantly dressed but drunk businessman being helped by his friends onto the last train home. Likewise, to enjoy the entertainment provided by the often very beautiful and accomplished *geisha* and to indulge in flirtatious conversation with them was (and is) in no sense improper; nor, in Hiroshige's time and society, was an evening spent with a professional courtesan—although, of course, Japanese literature is full of tales of the unfortunate consequences that might follow from a passionate but unsuitable love affair in such circumstances.

## *Travel*

The tradition of pilgrimage to temples and shrines goes back to the earliest times. A pilgrimage might involve a voyage of days, if not weeks, to some remote but famous location such as the great shrines at Ise, or it might be an afternoon's stroll to the local sanctuary. In either case the religious and recreational values of the journey are not differentiated, and it is clear that in the later Edo period the leisured classes regarded a trip to a shrine or temple as a delightful and rewarding way to spend the time, whether measured in hours or days.

In consequence, the shrines and temples that might be visited and the views that might be seen in the course of the journey became the objects of purely aesthetic pleasure. It is from this appreciation of the visual qualities of scenery and landscape that the tradition of famous views, exemplified by the work of Hiroshige, ultimately grows.

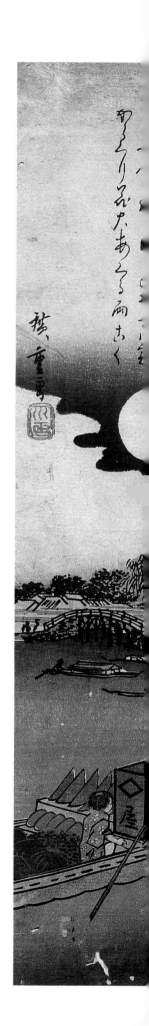

### The Images of the Floating World—Ukiyo-e

The world of recreation, entertainment, and pleasure in any culture requires fashion to sustain it. Fashion thrives on the fashion plate—the mass-produced image of today's beauty, today's star, today's look. It was the woodblock print that provided these fashion plates and in doing so developed an art form that was to thrive throughout the Edo era. Wood-block prints were produced in the thousands and were available at a price that made them accessible to all but the most poverty-stricken inhabitants of Edo. They were the post-cards and fashion magazines of their day.

Woodblock prints started in the early seventeenth century as simple black-and-white line drawings of pretty girls and famous actors, but in the course of time the technology improved to include fully colored images and the genre expanded to include illustrations of legends and stories, images to accompany poems, pictures of plants and ani-mals, vegetables and food, and by the mid-nineteenth century, views of the cities and landscapes of Japan. These are *ukiyo-e*, literally "images of the Floating World"—the ending "-e" indicating "image," or picture.

The culture of Edo-period Japan has now passed into history and these *ukiyo-e* provide us with one of the most useful records of the everyday life of Edo and its whole cul-ture. The opening of Japan to the West and the subsequent displacement of an exclusively Japanese culture began with the arrival of Commodore Perry's Black Ships in 1854. Hiroshige, who died a few short years after that pivotal event, is one of the last artists to work entirely within the conventions of the genre. His art stands as one of the most complete records of Edo and its culture.

*"Walking in the middle of the river*
*With straw sandals—*
*The boatman."*

ANONYMOUS

"Moonlight at Ryogoku." *The Summer print from the series* Famous Places of Edo in the Four Seasons, 1834, *showing a boatman with melons and other delicacies, probably for sale to those partying on the river in the cool of the evening. Brocade print,* chu-tanzaku *size. By Courtesy of the Board of Trustees of the Victoria & Albert Museum, London.*

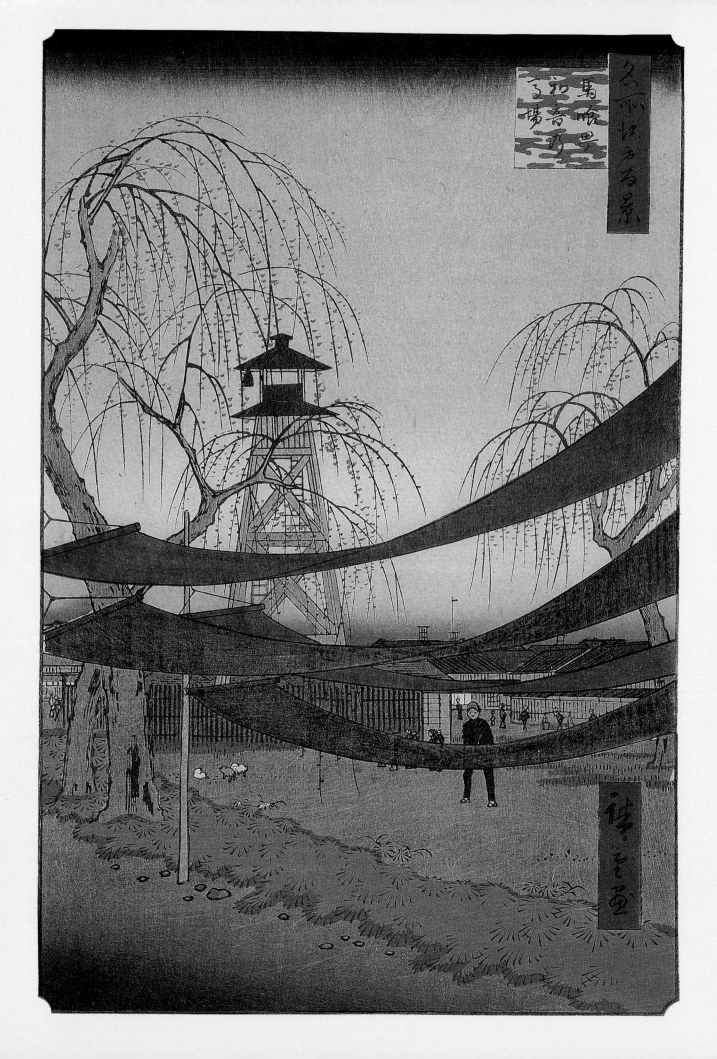

# CHAPTER 2

# UTAGAWA HIROSHIGE:
## Life and Times

The historical record of Hiroshige's life is small. He is said to have written an autobiography during his later years but, apparently, it was lost in a fire. From what we do know, his life was relatively uneventful, but it is clear from the quantity and character of his work that he was a diligent craftsman, and a man of charm and humor, alive to the beauties of nature and the boundless diversity of his fellow men.

His father, Ando Genemon (by Japanese convention the family name, Ando, precedes the given name), was a fire-warden. The city of Edo, built almost entirely of timber, was very vulnerable to fire, particularly since the whole of Japan is in an earthquake zone. Even today the inhabitants of Tokyo are quite familiar with earth tremors and minor quakes, which disturb their lives from time to time. In Hiroshige's day, a small tremor or domestic mishap could upset a lamp or cooking stove and ignite the rice straw mats that covered the floors of every house—with catastrophic results.

Ando Genemon was a hereditary employee of the *shogun*—a *samurai*—attached to the *bakufu* government based in Edo Castle. He was not a fire-fighter himself but was in charge of a team of fire-watchers and fire-fighters based in the Yayosu Barracks, just to the south of Edo Castle. It was they who manned the fire-watch towers that punctuated the city and can be seen in many of Hiroshige's prints. These teams were also responsible for fighting fires, although their primary obligation was to prevent fires from spreading by pulling down houses already alight or in the path of the fire rather than extinguishing the blaze at its source. It is said that the water provided for fighting was used as much to cool the fire-fighters as to douse the blaze.

**"Bakuro-cho: Hatsune Riding Grounds,"** 1857. *Newly dyed fabric is hung out to dry in early spring. In the middle distance is one of the many fire-watch towers of Edo with their roofed cabins and a warning bell hung from the eaves. Number 6 of* **One Hundred Famous Views of Edo.** *Brocade print,* oban *size. Courtesy of the Trustees of the British Museum, London.*

*"The artist will tend to see what he paints, rather than paint what he sees."*

ERNST GOMBRICH

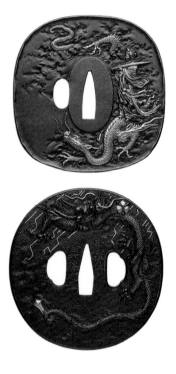

*A pair of sword guards (tsubo) in cast iron with gold inlay dragons and a Shinto deity. By Courtesy of the Board of Trustees of the Victoria & Albert Museum, London.*

Ando Genemon's only son was born in his home in the married quarters of the Yayosu Barracks. The baby was given the name Tokutaro. The name "Hiroshige" by which we know him was a *nom d'artiste* given him on graduating as a print artist some years later. Virtually nothing is known of Tokutaro's childhood, but we can imagine that he was brought up in the traditional manner for a child of his class and station. Although not wealthy, his father would have been proud of his *samurai* status. Even in limited circumstances, *samurai* were a class above the general population of artisans, merchants, traders, and working people of Edo. Their first duty was to their *daimyo*, in Ando's case the *shogun,* and their lives, behavior, and attitudes were ordered by a strict code of honor handed down from generation to generation, that governed much of their everyday life.

A sense of family pride and duty (still a strong feature of Japanese society) was paramount, and the young Tokutaro will have been taught the conventions of everyday life: of dress, of speech, of manners, of attitude toward elders and betters, and much else. He will have been trained in the martial arts traditional to the *samurai*, including the use of the two swords that he would be entitled to wear when he inherited his father's post and station—although it is extremely unlikely that he ever had to use them in earnest.

He will have learned to read and write, not in the fairly straightforward stages that we know from using our phonetic alphabet of twenty-six letters but as a gradual process based on an ever-widening knowledge of the Japanese system of *kanji*, or ideograms, some of which are phonetic, representing syllables, and some of which stand for whole words or concepts. Children in Japan start to recognize simple *kanji* at a very early age and soon acquire a working knowledge of a basic two hundred or so that make reading simple and enjoyable. On this basis, Japan had, and continues to have, the highest literacy rate in the world. However, a Japanese of moderate education will need to learn to read and write some four thousand *kanji,* and a well-educated scholar something in excess of ten thousand!

The use and development of these ideograms has a long and complex history that goes back in part to the Chinese writing system. In the course of that history, the meaning, significance, and pronunciation of many *kanji* has changed and developed, producing a realm of multiple and alternative meanings, internal puns, and other figurative associa-

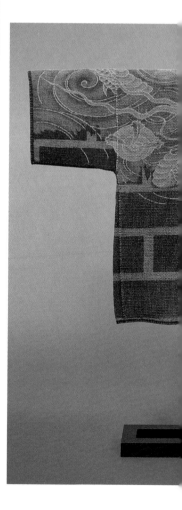

tions which are the basis of much poetic and literary language. Even in the highly pressured world of modern Japan, businessmen will interrupt their negotiations to discuss the precise significance of a word or phrase in terms of the *kanji* used to represent them.

Besides his basic education and his introduction to the duties of the *samurai*, Ando Tokutaro will also have learned about the life of the city and its activities and recreations. He will have joined in parties at restaurants and teahouses with family and friends. He will have been introduced to literary discussion and poetry. He was to become something of a poet himself, and a fair number of the prints that he was to produce in later years were commissioned by poetry societies. He was clearly gifted in drawing and will have seen, as well as heard appreciated, the painted scrolls that hung in the ceremonial niche (*tokonoma*) of every Japanese house, as well as the innumerable woodblock prints that circulated in the city, illustrating every aspect of the Floating World.

He will have visited the theater to see the *kabuki* productions of ancient stories, with their extravagant, stylized acting and colorful sets and costumes. He will have attended archery contests and *sumo* wrestling bouts (page 111). He will have heard about and, in due course, have visited the Pleasure Quarters, with their professional entertainers.

Young Ando Tokutaro's mother died in 1809; his father, only a year later. Although only thirteen years old, he inherited his father's post as fire-warden—which he was to pass on in turn to his own adopted son a few years later, in 1832. Like many *samurai*, he would have been underemployed and underpaid, so it is no surprise that he sought additional employment. It was generally rather demeaning to a *samurai* to take paid employment, but in Hiroshige's time it was not unusual, and employment in literature or the arts was more or less acceptable.

He clearly had ambitions as an artist at an early age. It is said that he wanted to be apprenticed to one of the most prominent woodblock artists of the day, Toyokuni, but was unable to get a place in his studio. In fact, he was apprenticed in the year after his father's death to the less prestigious Toyohiro, a competent but unexceptional master of the Utagawa school of printmaking artists. The boy clearly showed promise, since he was given his own *nom d'artiste*, Hiroshige, in 1812—even though prints were not to appear under that name until 1818. His artistic surname,

*A fireman's coat in quilted cotton printed with a design in red, gold, and black, of a fire-dragon consuming a building. These coats, with matching quilted hood, were worn by firefighters as protection from heat and flying sparks. By Courtesy of the Board of Trustees of the Victoria & Albert Museum, London.*

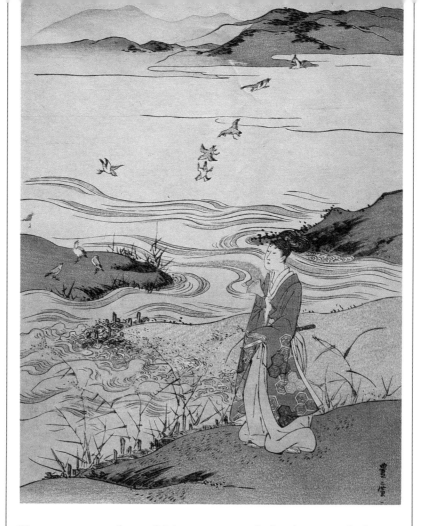

*Utagawa Toyohiro,*
"The Chidori-tama River,"
*from the series* **Six Famous
Rivers with the Name
Tama,** *features a young*
samurai *forlornly
watching diving birds in
the swift current. This
print by Hiroshige's
master shows the delicate
coloring and sense of
landscape that Hiroshige
was to develop so
successfully in his own
career. Brocade print,*
oban *size. By Courtesy of
the Board of Trustees of
the Victoria & Albert
Museum, London.*

Utagawa, was that of his master and the long and distinguished line of some ninety other *ukiyo-e* masters of the Utagawa school.

In the early years of his apprenticeship, Hiroshige will have developed his drawing and painting skills and learned about the technical facets of painting, drawing and calligraphy; the use of the traditional Japanese brush (which is held at right angles to the paper rather than inclined, as are watercolor brushes in the West); and the preparation and mixing of colors for painting on different surfaces. He will also have studied various aspects of the printing process itself: the preparation of blocks; the use of inks and dyes; the special techniques of *bokashi* grading, so-called blind printing, and metal dusting; and the way in which these techniques could be used to achieve pictorial effects.

In due course he produced his own original designs for prints, most of them in the established genres of the Utagawa studio—prints of beauties (*bijin*), scenes from the *kabuki*, studies of birds and flowers. Many of these early prints are indistinguishable from the run-of-the-mill product of the studio. Only gradually did Hiroshige discover his own particular strengths and sensibilities. It wasn't until

46

after Toyohiro's death in 1828 that the special skill and interest in landscape and topographic views that was to make him famous emerged in a fully developed form.

The landscape print had been popularized a generation previously by Hokusai, the most prolific and inventive of all the *ukiyo-e* masters. Hokusai's series *Thirty-Six Views of Mount Fuji,* including the famous "Waves of Kanagawa," the "Red Fuji," and a number of other masterpieces, appeared in 1831, establishing the genre. Hiroshige was quick to follow.

He had already been working on landscape views, as backgrounds to his earlier work, but his first notable contribution to the landscape genre itself was the ten-print series *Famous Places of The Eastern Capital* (*Toto Meisho*) in 1831. The next year, 1832, he traveled with one of the formal processions that regularly made the journey from the *shogun's* court at Edo to that of the emperor in Kyoto. He was part of the escort for a traditional gift of horses for the emperor, accompanied no doubt by certain high officers of state, members of the *bakufu* who ran the day-to-day business of government.

Whether he was seconded to the cavalcade as part of his duty to the *shogun* or as an official recorder, he took the opportunity to sketch the scenes he witnessed along the way. Indeed, he may have engineered the secondment specifically to make the drawings that were to become the basis of his next great project. In the year or so following, his first and most famous series of prints, the *Fifty-Three Stations of the Tokaido,* was published.

The Tokaido was the most important of the two roads from Edo to Kyoto, the "low road" along the coast. The "high road" (or *Kiso-kaido*) took a longer and more adventurous route through the mountains. These were the most important arteries of Japan, connecting as they did its two most important cities—the emperor's capital at Kyoto and that of the *shogun* at Edo. Both roads were well used by travelers of all sorts: wandering beggars; farmers taking their goods to local markets; groups of pilgrims; merchants transporting goods to their great emporia; officials of the *bakufu* on state business; *daimyo* lords, with their families and retainers, traveling to and from their second homes in Edo; and the great ceremonial processions carrying the exchanges between the two capitals—like the one to which Hiroshige was attached.

Over the centuries, a series of towns and villages had

*"An artist who is self-taught is taught by a very ignorant person indeed."*

JOHN CONSTABLE

grown up along the route to serve these many travelers. Those at which the weary voyager might stop for refreshment, to change horses and porters, or to end a day's hard journeying became known as way stations. Here travelers might enjoy the local scenery, the local culinary specialities, the local stories, and the local entertainment.

Many tales had grown up in the various places along the route, some based on historical fact, some on remote mythology or folklore. These were doubtless retold during the evening's entertainment in verse or song, and many travelers would associate the places with these stories and possibly with those whose company they shared. One of Hiroshige's contemporaries, Eisen, who specialized in female portraits, also produced a series on the stations of the Tokaido, illustrating not the scenery but the girls who might be met along the way. Hiroshige's prints are notable for the way in which they evoke these stories and associations and at the same time give a most eloquent picture of

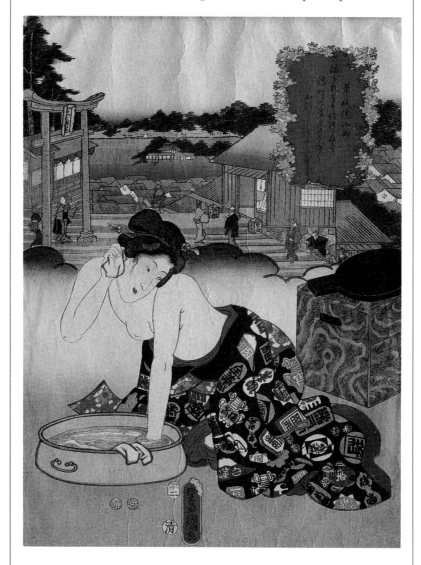

*Keisai Eisen,*
**Beauties** of the Tokaido.
*An image from a series that combined landscape views of the various stations with voluptuous* bijin *portraits (late 1830s). Brocade print,* oban *size. By Courtesy of the Board of Trustees of the Victoria & Albert Museum, London.*

the landscapes through which the traveler would pass, the picturesque activities of the people along the way, the changes in the weather, and the special atmosphere of solitude, elation and exhaustion that can overtake a traveler on such a journey.

This first series was a great success and immediately established Hiroshige's reputation as a designer of landscape prints. There was immediate demand for more, and over the next twenty-five years Hiroshige provided the print-sellers with literally thousands of designs: a total of eight series of scenes along the Tokaido, nine series of scenes along the Kisokaido, twelve series of views of Edo itself, eleven series of provincial scenes, and many others.

Of all these series, the masterpieces which include the most memorable and evocative of his prints are considered to be his first, the *Fifty-Three Stations of the Tokaido* of 1833–1834 and his last, *One Hundred Famous Views of Edo,* which appeared between 1856 and 1859—the last few prints of the series appearing after Hiroshige's death in 1858.

Few if any events in this, the most productive part of his life, are recorded—except of course in the prints themselves. It is to these that we must turn for a deeper insight into the man and his art. In his art Hiroshige explored every aspect of the world in which he lived: the beauties of nature and of landscape and their changes through the diurnal and annual cycles; the stories of history and myth associated with individual locations; the activities and idiosyncrasies of his fellow men, their artifacts, their occupations; commerce, entertainment, and, most important, the city of Edo itself.

At the age of sixty, in fact just before he began his final great series, *One Hundred Famous Views of Edo,* Hiroshige became a Buddhist priest, shaving his head and renouncing the world. This was not an unusual thing for a man of his years, but it clearly marked a final stage in his life, which was reflected by a change in his art. The images of *One Hundred Famous Views of Edo* have a particular detached quality. Although observed with the same perspicacity and sympathy as before, the activities illustrated seem less personal, as if seen from afar. Even though we can be sure that in his earlier life Hiroshige took part in, and enjoyed, many of the scenes and activities that he depicts, he is now an observer, no longer a participant.

In the fall of 1858 Hiroshige fell victim to a cholera epi-

demic which swept through Edo. On his deathbed, he quoted an old verse, typical of the sardonic humor of the Floating World of Edo, intended to discourage his family from planning an extravagant funeral:

> *When I die,*
> *Cremate me not nor bury me:*
> *Just lay me in the fields*
> *to fill the belly of*
> *some starving dog.*

Shortly after his death, Kunisada, a close colleague and successor in the Utagawa lineage, published a memorial portrait print of Hiroshige with a more fitting farewell verse:

> *Though my brush remains*
> *In the Eastern Capital,*
> *I shall travel afresh*
> *to see the famous views*
> *of the Western Paradise.*

*Utagawa Kunisada,* **"Memorial Portrait of Hiroshige,"** 1858. *Brocade print,* oban *size. Courtesy of the Trustees of the British Museum, London.*

# UKIYO-E:
## Images of the Floating World

The decorative arts of Japan have always been an important part of its culture. Among them, painting and drawing have always had a very central place. In every traditional Japanese home (and many modern ones) there is a formal niche (*tokonoma*) in the principal room framed by the king post of the roof. In it are displayed a seasonal flower arrangement and a picture—usually a scroll painting of a landscape or other natural subject. These images serve to remind the inhabitants of their traditions and of their relationship with nature.

Painting and drawing were also used to decorate many other features of daily life: plates and bowls, fabrics, boxes and pieces of furniture, movable screens, and even whole walls. No artifact, from the smallest button to immense temples and shrines, was beyond the range of the pictorial artist.

The subjects of these images would be taken from every imaginable source: frequently from the natural world—mountains, waterfalls, seascapes, forests, gardens and fields, individual plants and flowers, fishes, mammals, birds, and insects. Some of them would be taken from episodes in history, legend or famous works of poetry or fiction—great occasions of state, battles, travelers' tales, or dramatic encounters between lovers. Some would be views of well-known landscapes and cities or everyday scenes of rural and metropolitan life. Others would illustrate contemporary style and the famous beauties of the day.

### The Traditions of the Woodblock Print

The development of woodblock printing in the seventeenth and eighteenth centuries made all these subjects available to a much wider audience. But the subject area which was most successful and which has given its name to the art of the woodblock print was the Floating World (*uki-yo*) of fashion, entertainment, beauty, and pleasure. *Ukiyo-e*, the

> *"Nature can afford to be prodigal in everything, the artist must be frugal down to the smallest detail."*
>
> PAUL KLEE

*Boxwood netsuke showing a puppeteer and two children. By Courtesy of the Board of Trustees of the Victoria & Albert Museum, London.*

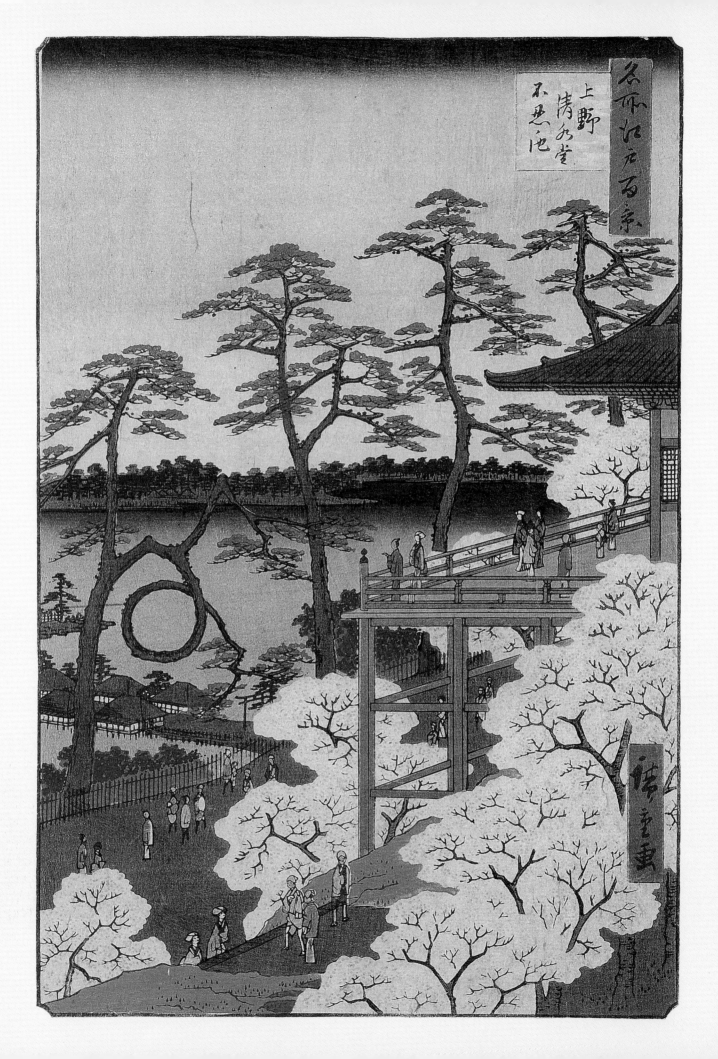

generic term for the Japanese woodblock print, means quite literally "image (or picture) of the Floating World." The very nature of the woodblock print—small, portable, relatively cheap, disposable, and repeatable—lent itself to the ephemeral, to images for amusement and immediate delight rather than for extended contemplation or public display.

The technique of woodblock printing had been used for books long before the appearance of single woodblock prints. The earliest images were illustrations for books of poetry, novels, traveler's tales and histories, and, indeed, the "pillow books" that circulated widely in the Pleasure Quarters. These last served as both guides to the uninitiated and stimulus or amusement to the more experienced. The independent woodblock print continued this genre, and as much as a quarter of the product of the *ukiyo-e* workshops is estimated to have been *shunga*—overtly erotic subjects. Although ephemeral, this form was not regarded as inferior or demeaning to the artist. Many of the best-known and most distinguished *ukiyo-e* masters, including Utamaro and Hokusai, worked in this field, producing some of their most striking and artistically inventive images.

There was also an enormous output illustrating the famous beauties of the day in less revealing poses. The *geisha* and courtesans, both in the officially sanctioned Yoshiwara and elsewhere, were, in the nature of their occupations, well known. Their beauty, the elegance of their costumes, and their accomplishments as musicians, dancers, and conversationalists were celebrated again and again by *ukiyo-e* artists. These *bijin* pictures made up an even larger proportion of the output of the *ukiyo-e* printing shops than the *shunga* images. Sometimes the beauties would be portrayed in "large head" format, sometimes in full-length portraits that exploited the elegant lines and exquisite fabrics of their costumes. Sometimes they would be portrayed in more or less discreet deshabille, adjusting their makeup in a mirror, reading a letter, admiring a view. Frequently they would appear in groups with other beauties, with their girlfriends or servants, engaged in everyday activities such as hanging out clothes to dry, bathing, shopping, visiting a shrine or pleasure garden, dining at a picturesque restaurant. Sometimes the *bijin* would appear engaged in activities normally undertaken by men, as in Kunisada's depiction of the activities of an *ukiyo-e* workshop—not because this ever happened but as an entertaining extension of the genre (page 62).

*The Shinobazu Pond at Ueno today with a causeway across the lotus-choked water.*

*A typical* kabuki *print by the artist Kunichica (1835-1900), showing the actor Ichikawa in the role of Sadan-ji.*

No doubt it was in the interest of these ladies of the Pleasure Quarters to appear in print as a means of enhancing their reputations. They clearly encouraged the attentions of the best artists of the day. The artists in their turn became well-known figures of the Floating World.

To judge from the frequency of the portrayal of *bijin* in Hiroshige's prints, he too was quite familiar with the Pleasure Quarters and their inhabitants, although he is not known for the overtly erotic subjects that might be thought to follow from this familiarity. In fact, his view of the Pleasure Quarters becomes increasingly distant as he develops his own artistic personality. The figures in his pictures represent types rather than individuals, offered less for their particular charms or idiosyncracies than as examples of the infinite variety and oddity of human beings and their multifarious activities.

Beauties would also be portrayed as characters in famous stories. Women were not allowed to appear on the

public stages of the *kabuki* theaters, but they would frequently enact a *kabuki* scene or dance for a private party—a display that can still be seen in certain traditional restaurants even today.

The public theater, too, provided endless opportunities for image making. The *kabuki* theaters were very popular, and in the early part of the nineteenth century, four or five theater companies presented performances in the city of Edo almost continuously throughout the year. A number of *ukiyo-e* artists specialized in *kabuki* prints, some on familiar scenes or moments of high drama—confrontations between the hero and the villain, dramatic fight sequences, poignant farewells, and moments of discovery—others on portraits of famous actors in their best-known roles.

The style of both acting and presentation on the *kabuki* stage is highly formalized, extravagant, and exaggerated. The costumes are fabulously colorful, the style of diction highly contrived, and the gestures stylized. Facial expressions are extravagantly developed beyond everyday mannerisms and enhanced by dramatic makeup so as to be read clearly at a distance. The settings are gorgeous in the extreme. This extravagance is a gift to the graphic artist and the prints of the Katsukawa school in particular. The prints of Sharaku, for instance, exploit the design and form of the costumes, those of Shunsho the facial expressions of the actors.

**"The Dream of Hitsune."** *A triptych showing a critical moment in a well-known* kabuki *drama. The wicked Hitsune is deterred from a further act of vengeance and humiliation against the defenseless princess by a vision, in the garden behind him, of the skulls and skeletons of his previous victims. Three brocade prints,* oban *size. By Courtesy of the Board of Trustees of the Victoria & Albert Museum, London.*

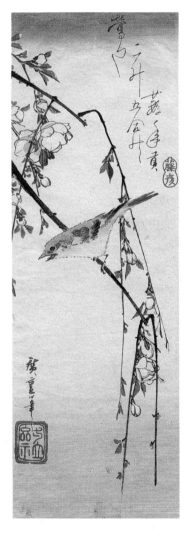

"Greenfinch on Plum Blossom." *The Spring image from a set of* kacho *prints with* kyoka *poems. Brocade print,* tanzaku *size, 1830s. By Courtesy of the Board of Trustees of the Victoria & Albert Museum, London.*

Those who sought more contemplative literary pleasures than the theater might be members of the poetry clubs. In the eighteenth century these were a feature of the *samurai* class, but by the nineteenth century they were found in every section of Edo society—though some of them may have been little more than loose associations of friends who liked some pretext for an evening's sociable dining and drinking.

The more serious of these poetry clubs often commissioned prints including both the text of the latest *haiku* or *waka* composed by their members together with appropriate illustrations. These *surimono,* as these special privately produced prints were known, would be commissioned from a popular artist and were produced with extravagant care and technical expertise—with particularly delicate colors, special papers, embossing, and metal dusting. They would be distributed among the members of the club and to friends and admirers, often as a seasonal gesture at New Year or some other festival.

The New Year productions were of particular importance since they often included a calendar for the coming year. The traditional Japanese calendar dealt with the problem of the year's awkward length of 365¼ days by having short and long months in a sequence that varied from year to year. A new calendar each year was an essential aid to keeping track of the months, providing the *ukiyo-e* artists with a fruitful field for the development of their graphic and calligraphic skills—not unlike the calendars distributed by commercial agencies today. As with contemporary calendars, those of the Tokugawa period might vary greatly between the entertaining and the banal, the elegant and the lubricious.

Hiroshige had something of a reputation himself as a poet, although his interest in the subject doubtless arose from his concern for the matching of word and image rather than for the cunning assembly of words alone. The association between pictures and poetry was very important to the *ukiyo-e* artist, and many images include references to well-known poems or familiar literary allusions.

Many of these references would be to plants and animals and other features of the natural world. Prints devoted solely to the elegant portrayal of these subjects, in particular those illustrating combinations of birds and flowers, were known as *kacho,* a field which Hiroshige clearly relished, particularly in his early years. From individual creatures, it

was a short step to the beauties of landscape and the recording of topography, in which Hiroshige excelled.

## The Technique of Woodblock Printing

Hiroshige, like all the *ukiyo-e* masters, was in fact a painter, working in the traditional materials and techniques of the Japanese artist—ink and wash colors on paper, applied almost exclusively with a brush. A number of his original paintings survive (page 58), but these are of much less artistic interest than his designs for reproduction as woodblock prints. It is on his work in this medium that his fame rests.

The work of making the blocks and printing was done by others, often equally skilled, although their contribution was never as highly regarded as that of the artists.

The basic principle of woodblock printing is said to have been invented by the Chinese about the fourth century A.D. It involves carving a design on the flat surface of a block of wood and reproducing the design by pressing paper onto the inked block—a technique familiar in its simplest form to every school child through the potato-cut or lino-cut. In the case of Japanese woodblock printing the design was drawn in ink on a light sheet of paper, which was then pasted, face down, on the surface of the uncut block. The paper was wetted slightly to make it translucent, and then it, and the wood below, were cut away, leaving the areas to be printed standing proud.

From the earliest times, the technique was used for the reproduction of both writing and pictures. In the Far East there is little distinction between the two, since the Chinese and Japanese alphabets are essentially pictorial and the enormous number of characters involved makes the use of movable type (the basis of Western book printing) impractical.

In the early seventeenth century, the balance between text and illustration began to change. Works of literature with a few illustrations gradually gave way to picture books with extended captions. It was from these books that the independent print evolved, from three genres in particular: tales of adventure (*kinpira-bon*), love stories and erotica (*ko-shoku-bon*), and commentaries on leading figures of the Floating World—the *geisha*, the courtesans, and the *kabuki* actors (*hyo-ban-ki*). These subjects remained of abiding interest to *ukiyo-e* artists for over two hundred years.

*"Ivy arabesque*
*Colorful as a*
*kerchief*
*Tinted with the*
*dyes*
*Of Autumn's*
*maple leaves*
*Mixed in a*
*summer shower*
*of rain."*

HACHIJINTEI

In the course of time, other genres evolved with less obvious literary connections, such as the *kacho* bird-and-flower prints, the calendars, the printed fans, and the theater bills—and, ultimately, the landscape prints, developed first by Hokusai and brought to special preeminence by Hiroshige.

## The Brocade Print (Nishiki-e)

In the seventeenth century, images were mostly printed in a single color—usually black—although hand coloring of individual prints was widespread and became increasingly sophisticated, with the use of a variety of dyes and pigments.

The earliest prints with block-printed colors appear in Japan in the 1740s. Their success depended on each color printing being precisely located (or "registered") in relation to the others. This requires each printing to fall in exactly the same position on the sheet. To achieve this, the block for the first printing (known as the *sumi* block, after the Japanese black ink usually used for the original

outline drawing) included raised marks (*kento*) which identified a corner (usually the bottom right) and the edge of the sheet (usually top right). Impressions were then taken from the *sumi* master block and pasted onto the blocks to be used for the other colors. The *kento* marks at the bottom corner and top edge were reproduced on each block, ensuring that the paper was laid on each one in precisely the same position.

The early colored prints imitated their hand-colored predecessors with a limited number of colors, mostly simple vegetable dyes used to fill in the black-on-white design. In the course of time, a larger range of pigments and dyes became available and an increasing number of blocks were used. By Hiroshige's day, as many as twenty blocks might be used. These richly colored prints were known as "brocade images" (*nishiki-e*) after the richly decorated fabrics (*nishiki*) which were very popular with the ladies of the Floating World and are a prominent feature of early colored prints.

The most sophisticated prints included a range of secondary techniques which gave them additional character and interest. Some blocks were used without ink to produce parts of the design embossed in the paper (*kara-zuri*). Fabric might be pasted onto the block to give the printing a woven texture (*nunome-zuri*, page 42). In certain instances the ink was wiped off parts of the block to produce a graded transition in color (*bokashi*) or to reproduce on the print the pattern of the grain of the woodblock itself. Sometimes a glue would be printed on the sheet and mica or metallic powder sprinkled on the print to give a sparkling or colored texture. Certain parts of the print could be burnished with a piece of metal or ivory (*tsuya-zuri*) or varnished (*nisu-biki*) to produce a reflective glint.

With the developments in technical sophistication came new developments in artistic composition. The *sumi* block itself might be printed in a color other than black. Certain outlines might be omitted altogether, leaving the colors alone to establish outlines and edges (page 81). The graduated *bokashi* technique could be used to represent the sky at sunset or the current in a flowing river.

It is important to note that the production of *ukiyo-e* involved a large group of interrelated crafts and business interests. A project would usually be initiated by a publisher, who controlled and paid for the entire process. He was the entrepreneur and commissioned the design or

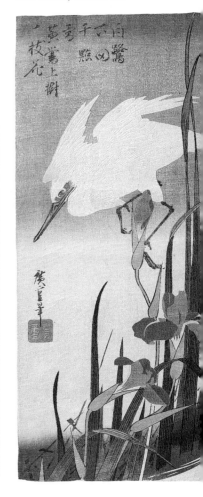

**"White Egret and Irises,"** *illustrating the use of the "blind" printing process (*kara-zuri*), sometimes known as* gaufrage, *to render the plumage of the bird.* Kacho *print,* tanzaku *size. By Courtesy of the Board of Trustees of the Victoria & Albert Museum, London.*

59

designs from the artist. He then had the design transferred to the master (*sumi*) block and engraved by specialist engravers. These were craftsmen of immense skill who could cut away the wood from either side of lines as little as $^1/_{250}$ inch (0.1 mm) across to represent the finely combed hair of an elegant *geisha* or the delicate outline of a bird or flower. They used a variety of cutting tools—knives to cut the outlines and gouges of various shapes and sizes to remove the wood from the unprinted areas. It is intriguing to note that although many Japanese tools and techniques differ significantly from those in other parts of the world (most particularly the wood saw, which is designed to cut on the "pull" stroke rather than the "push" stroke), these knives and gouges are similar in shape and function to equivalent tools used by woodcarvers all over the world. The astonishing skill and accuracy of the engraver are sometimes credited in a separate cartouche in the margin of the print and very occasionally by an encoded symbol incorporated in the design itself (pages 128 and 144). But the engravers are never given the prominence of the originating artist. The genius of the original creator, rather than the supposedly inferior manual skill of the engraver, remain the source of the greatest wonder and admiration.

The size of a printing block was limited, first by the size of timber that might be available. The engravers favored fruit woods such as cherry, for the density and evenness of its grain. Fruit trees rarely grow to great size, and blocks could not be obtained much wider than ten inches, even from the thickest trees. The length might be greater but not enormously so. It is of interest to note that the direction of the grain was fixed, and hence the possibilities for exploiting the image of the grain in the print were limited. In a print of horizontal format the grain would generally be from left to right; in a vertical format, from top to bottom (page 131).

The size of the print was also limited by the risk of stretching or shrinking in the paper between successive printings. Paper grows on wetting and shrinks on drying by as much as 5%, and does so even under slight differences in the weather. The effect of these unpredictable changes in size can be reduced by limiting the overall size of the sheet. Over the years a number of standard formats developed, the most popular being *oban* size 15½ x 10 inches (39 x 26 centimeters)—although a number of variants were also

*"The day the fresh green leaves burst from the bamboo shoots; The time when gold fills the trees for gathering in my basket."*

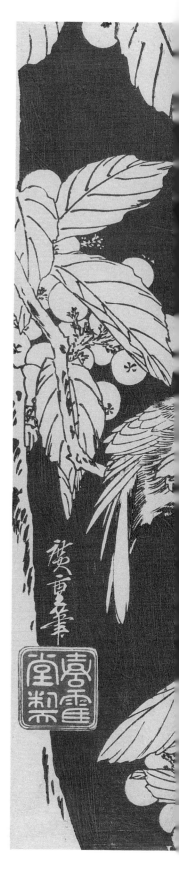

60

used. Both paper and blocks were produced in these standard sizes, determining the layout and design of prints over many generations.

Larger images were produced by assembling blocks in groups, often as triptychs (pages 55, 62, and 63) and sometimes in larger groups of six or even eight. They would be sold as individual prints and could be mounted together or kept separately—giving the artist an intriguing problem in composition.

Prints could not be sold to the public without the approval of the *bakufu*. Before the color blocks were prepared, proofs of the design, usually from the initial *sumi* block, would be submitted to the government censor. The censor's seal was then incorporated in one or another of the blocks. Political commentary of any sort was always prohibited. Hiroshige's portrayal of an audience with the emperor carefully excludes a representation of the emperor's face in deference to this ruling. From time to time the *bakufu* also issued edicts prohibiting supposedly licentious pictures, in an effort to curb the extravagant diversions of the Pleasure Quarters. In 1842, for instance, the so-called Tempo reforms made it illegal to publish the traditional representations of the current beauties of the Yoshiwara. The printmakers had to fall back on rather transparent ruses, such as Hiroshige's fan prints of views of Edo (pages 8, 70/71, and 104/105) or Kunisada's triptych the "Production and Harvesting of Edo's Famous Produce— *Nishiki-e*" (page 62). Only when the design had been licensed would the colored blocks be cut and the edition put in the hands of the printer.

The printer, too, was a highly skilled craftsman. His touch in the application of color to the block or its careful removal to expose the subtle pattern of the wood grain, or to produce the graduated *bokashi* effects, was vital to many designs, particularly those of Hiroshige, with their delicate skies and illusions of distance. The printer's tools were very simple—a number of brushes of different shapes and sizes to transfer the inks and dyes to the block and a circular pad of twisted bamboo fibers (called a *baren*) to rub and press the paper evenly onto the block. The printers were known as a brash and brassy lot, improvident and unpredictable, given to drink and womanizing—clearly something of a contrast to the painstakingly careful engravers. Their immense skill was of an instantaneous and intuitive sort—one false move and the print would

**"Brown-Eared Bulbus** (hiyodori) **on a Loquat Tree"** *with a poem in antique script. This* o-tanzakuban *print uses only two blocks, blue and red, showing how Hiroshige made striking prints using his composition and drawing skills alone. By Courtesy of the Board of Trustees of the Victoria & Albert Museum, London.*

*Utagawa Kunisada, triptych of* oban *prints showing* bijin *engaged in printing* ukiyo-e. *Top right, the artist drawing the original design onto a preliminary* sumi *print; bottom right, sharpening the engraver's tools; middle upper right, the block cutter removing the background from the block; lower middle, wetting the paper before printing; lower left, the printer, whose work table and rubbing pad (*baren*) appear in the bottom left-hand corner, stops for a smoke between impressions; behind her are shelves of brushes and colors; above, the prints are hung up to dry. The Whitworth Art Gallery, University of Manchester.*

have to be rejected, perhaps at the end of an elaborate process involving twenty meticulous printings.

The paper was wetted before each application of color and each printing would have to be absorbed into the paper before the next could be undertaken, so the printing process might easily occupy two or three weeks. However, an accomplished printer could handle a thousand impressions a day. At the end of a couple of weeks of such intense work, it is perhaps not surprising that the printers would go out on the town to let off a bit of steam.

Unlike fine art prints in the West, Japanese print runs were rarely limited in number. Private editions for poetry clubs (*surimono*), might run to only one hundred copies, but popular commercial editions like Hiroshige's *One Hundred Famous Views of Edo* could run into thousands. The blocks might deteriorate after so many printings, becoming worn, broken, or irretrievably dirty with use. If necessary they would be recut; a number of cases are known in which the design of a very popular print changes from edition to edition. The most popular might be pirated and reproduced from a completely new set of blocks—usually

without the care or artistic judgement of the original. This, then, was the tradition of technique and craftsmanship through which Hiroshige's art reached the public.

*Kitagawa Utamaro,* "**Cultivation and Harvest of Edo's Famous Produce — Brocade Prints.**" *A triptych showing* bijin *engaged in the latter stages of printmaking and selling. Top right, the carved woodblocks and paper are delivered to the printer; bottom right, the printer presses the print onto the inked block with the bamboo leaf pad (*baren*); in the bottom corner are her colors and brushes and the flexible straight-edge used to achieve the* bokashi *shading effects; center, the finished prints are displayed; left, the prints are sold. Brocade prints,* oban *size. Courtesy of the Trustees of the British Museum, London.*

*In addition to his signature, many of Hiroshige's prints have one or other of these seals, which include his alternative artistic names "Juemon," "Ichiryusai," and "Rysuai." He often uses the lozenge motif as a decorative element of the design.*

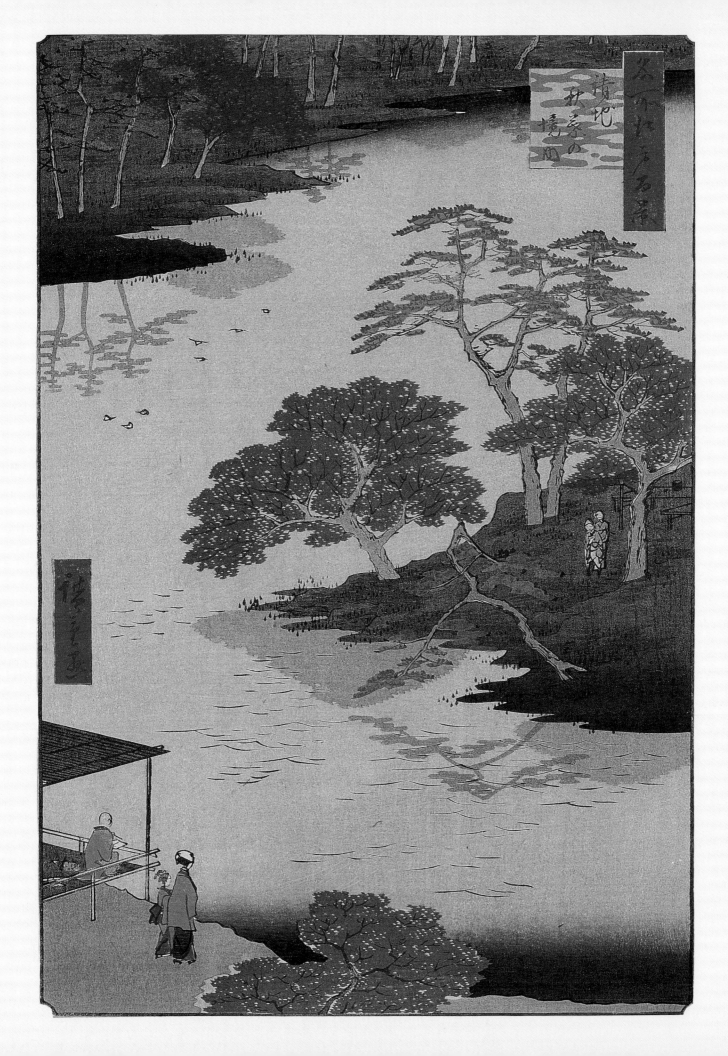

# CHAPTER 4

# HIROSHIGE -GA:

## Hiroshige Made This

During the course of his working life, Hiroshige is esti-mated to have designed, and supervised the production of, between five and ten thousand prints from his own designs and drawings. His prints appeared at the rate of about two a week for forty-five years. Even so, he was by no means the most prolific or most productive of *ukiyo-e* artists. Hokusai, in a working life of sixty-five years, produced many more prints, and Shunsho, in his short-lived but meteoric career, created his entire *oeuvre* in a few short months in 1794, at a rate of about five prints a week!

The work involved in each print would undoubtedly fill a good two or three days: making sketches on the spot; developing the design as a preliminary drawing for discus-sion with the publisher; preparing the *sumi* masterblock; and finally making the color masters for transfer to the blocks. That leaves little, if any, time for the associated business of travel, discussions with the printers, or for rest and recreation, such as an evening with friends or a boat trip up the Sumida River. The picture that emerges is of Hiroshige working unremittingly at his chosen craft in his little studio in downtown Edo.

Perhaps it is not surprising that not all his prints are of the highest artistic quality. Many of his designs, particularly in the early part of his career, are derivative or repetitive. Many of the blocks were crudely cut and badly printed, with a limited number of colors, often varying significantly from edition to edition. Tens of thousands of cheap and cheerful prints were made and sold on the streets of Edo, many of them bought on a whim, like a postcard, to recall an afternoon at the the-ater, a pleasant outing, or some other event. Thousands of these were thrown away or used as wrapping for some more valuable item when their immediate appeal had dimmed.

"Ukeji: Inside the Akiba Shrine," 1857. *Number 91 of* One Hundred Famous Views of Edo *in which an artist, perhaps Hiroshige himself, is seen sketching the autumn foliage reflected in the water. Brocade print,* oban *size. Courtesy of the Trustees of the British Museum, London.*

"*A work of art— a corner of nature seen through a temperament.*"

EMILE ZOLA

"*In art, everything is best said once and in the simplest way.*"

PAUL KLEE

Nevertheless, since Hiroshige is now recognized as one of the masters of *ukiyo-e*, copies of even his less successful prints are preserved in museums and can be found in specialist print shops and general antique stalls, in Japan and elsewhere, for quite modest prices. Many of the best designs have been reproduced both in the literature on Hiroshige and that on *ukiyo-e* in general and as designs for postcards, wrapping paper, ceramics, fabrics, and scores of other uses.

It is therefore relatively simple to track the course of Hiroshige's artistic career and to watch the development of his style, his technical prowess, and his artistic sensibility over the course of his working life.

Among the earliest of his dated prints are a series of very finely drawn studies of animals and plants illustrating an exhibition of shell work at Okuyama in Asakusa in 1820, when Hiroshige was twenty-three years old. These are tours de force in draftsmanship and block cutting, the quality arising from the network of lines that articulate both the forms and the surface texture of the animals and plants portrayed. The coloring of the prints is limited, and their appeal lies in the study of detail and the sense of uniformity of the drawing texture over the entire block—derived no doubt from the detail and texture of the original exhibi-

"Cherry Blossom, Morning Glory, Cranes, and Rabbits." Oban *print from the series* Shellwork Shown in the Senso-ji Temple at Okuyama, 1820. *A very demanding exercise in drawing and block cutting with very restrained coloring. By Courtesy of the Board of Trustees of the Victoria & Albert Museum, London.*

*(Left)* "Two Terrapins," *an original painting by the little-known late-nineteenth-century artist Kakuo, showing how the formulae for drawing such images were copied by succeeding artists. Private Collection. Compare with Hiroshige's fan print of the same subject (right) and his print of the* "**Mannen Bridge**" *from* **One Hundred Famous Views of Edo**. *By Courtesy of the Board of Trustees of the Victoria & Albert Museum, London.*

tion. The impression is of a young man proving his ability in a highly technical skill and the completion of a very complex and carefully executed composition. The calm confidence of the later years and the mastery of form with minimum use of line has yet to emerge.

Ten years later, we can see that Hiroshige has developed fluency and ease in his drawing of a pair of terrapins on a fan print of 1830. This was a familiar subject explored again by other artists and used, perhaps tongue in cheek, by Hiroshige himself in one of his last prints of the Mannen Bridge from *One Hundred Famous Views of Edo* (page 117). However, the simple balance of the design and the economy of brushwork and printing colors speak of a growing confidence.

During these early years, he produced a large number of studies of the natural world. In a series of decorative studies of fish in 1835, for instance, he is sharpening his sense of composition, arranging contrasting pairs of sea creatures in elegant shapes on the page, and exploring the ways in which a limited but carefully selected range of colors can be used to best effect.

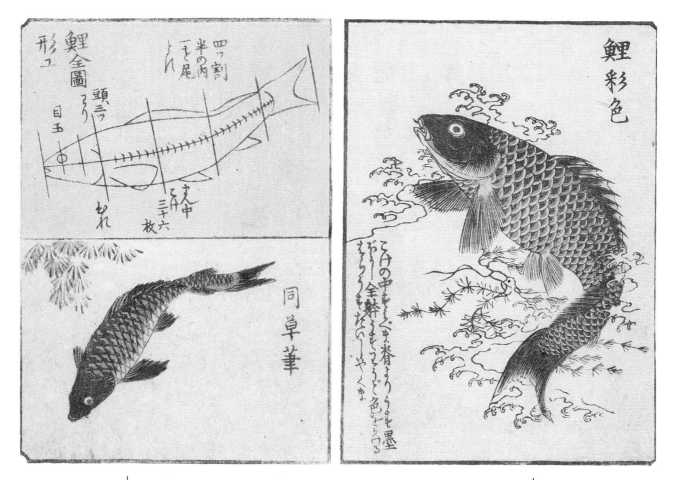

The Victoria & Albert Museum in London preserves a small book of such studies from the natural world, together with Hiroshige's preparatory drawings. It is intriguing to see from his analytical sketch that a knowledge of the geometry of the fish's skeleton is the basis of the successful drawing. How many times have teachers of drawing elsewhere in the world made the same point? In fact Japanese tradition does not lay great emphasis on observation from life. If Hiroshige examined his subject matter in detail, it was probably on the fishmonger's slab. However, he will have studied many similar images by other artists with a view to capturing the sense of movement and energy he will have wished to convey. It is this knowledge that he uses to deduce the shape of a live fish or of a fish-shaped wind sock (page 115)—either of which would be very difficult to capture from direct observation.

A study titled "White Egret and Irises" from 1833 (page 59) shows Hiroshige exploring not only the artistic possibil-

*A page from* **A Picture-Book Miscellany, 1849.** *Hiroshige's original drawing, compared with the finished printed book. This page shows how the skeletal structure of the fish is used in two different compositions.* Chubon-*size book. By Courtesy of the Board of Trustees of the Victoria & Albert Museum, London.*

68

ities of his subject but also the technical possibilities of the block-cutter's craft. The feathers of the bird are exquisitely rendered by the "blind" printing process (*kara-zuri*) that embosses the design onto the paper.

Hiroshige worked on many of the popular subjects of the day in his early years. For instance, he produced a series illustrating the life of the sixteenth-century hero Yoshitsune—mostly scenes of his fabled military achievements. Although vigorous, these prints have the feeling of theatrical set pieces. Indeed, the happy citizens of Edo had none of the firsthand experience of war (except as portrayed in the *kabuki* theaters where the acrobatic skill and picturesque costumes of the players completely overshadowed the bloody realities of war) that Goya had depicted a few years earlier in Europe.

He did a number of "ghost pictures," of the type popularized by Hokusai and Kuniyoshi, in which terrible dreams and fantasies, many derived from scenes and stories of the *kabuki*, are drawn in a deliberately spooky manner, such as the triptych "Dream of Hitsune" (page 55).

He made prints illustrating the beauties of the day, mostly mimicking the manner of his master, Toyohiro, and others of the Utagawa school. But it is interesting to note

*Original drawings for these illustrations of a fish. By Courtesy of the Board of Trustees of the Victoria & Albert Museum, London.*

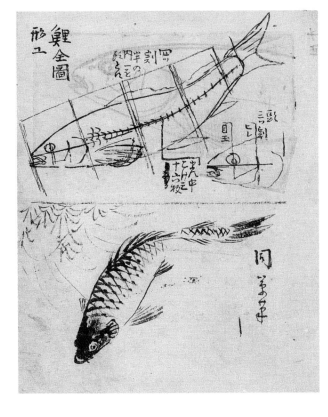

*"Fireworks at Ryogoku Bridge." Fan print (aiban) from the series* Eight Famous Views of Edo (Toto Hakkei), 1839. *Two girls are perched on the lightweight timber framework over the tiled roof which many householders used to erect festival decorations, as a drying rack, or as an escape from the constrictions of daily life at street level. On the river are boats of all sizes, including the "palace boats" that catered for large parties—all enjoying an early fireworks display. (A similar view appears in* One Hundred Famous Views of Edo *some fifteen years later, see page 121) By Courtesy of the Board of Trustees of the Victoria & Albert Museum, London.*

that he favored their portrayal as participants in some scene rather than as individuals. His contemporary and collaborator on *Sixty-Nine Stations of the Kisokaido,* Eisen, was better known for his *bijin* pictures—seemingly a bit more of a "ladies' man" than Hiroshige. Hiroshige arranges his beauties taking tea by a riverside, promenading along the busy waterfront at Takanawa (page 16), or perched on a roof to watch the Ryogoku fireworks of an evening in late summer. In doing so, he is able to develop and display his interest in the scenery as well as the figures themselves.

In fact, he was clearly much more interested in the real idiosyncracies and oddities of his fellow human beings— their expressions, their gestures, their habits—than in the idealized charms of the *bijin* stereotypes. Over the years, he developed a talent for gentle caricature (page 94), drawing out the vigor and energy of his subjects as much as their oddity or awkwardness. In Hiroshige we see a special sympathy with the tough, but apparently merry, lives of the ordinary folk of Edo, displaying them as he did with frankness, sympathy, and humor.

Through each of these different types of design, we can see emerging his real talent and natural sympathy for the depiction of views and landscapes—concentrating in particular on the way such views and landscapes were appreciated by his fellow human beings.

His earliest landscape prints are a series of ten images called *Toto Meisho* or *Famous Places of the Eastern Capital* (Toto, the Eastern Capital, was an alternative name for Edo). In these, he begins to explore the artistic possibilities opened up by Hokusai's famous series of views of Mount Fuji from 1829–1833. Hiroshige concentrates on locations that he knows intimately, the prominent places of his home city of Edo. But these are not just informal snapshots of familiar views, nor are they the iconic idealizations of Hokusai's Fuji prints. Each view is given a specific time of day and season of the year, and the viewpoints are chosen not just to show the view but also to evoke the flavor of the place and the time. Thus in "Takanawa by Moonlight," the mellowness of the night sky and the flock of geese silhouetted against the moon on their homeward flight suggest the end of a day's jollity in the popular teahouses or restaurants along the strand at Takanawa.

These early views are, indeed, slightly mawkish in their blatant nostalgia, but over the years this saccharin

70

quality is countered by a number of artistic developments: first, the use of unexpected color combinations to evoke the particular qualities of early morning, of spring sunshine, of winter snow, or summer rainstorm; second, the concentration on human detail, on figures in boats, on mountain paths, and in teahouses; and third, a dry clarity in the drawing which is both extremely economical and richly evocative.

It was in 1832, only a few years after the death of his master, Toyohiro, that Hiroshige undertook the journey along the Tokaido that was to be the turning point in his artistic life. With the publication of his first series, *Fifty-Three Stations of the Tokaido,* his real talents and sympathies are displayed in full. (This series is the subject of the following chapter.)

To complete this overview of Hiroshige's art it is interesting to look forward to the work of the late 1830s and 1840s. Although he continued to work successfully in other genres, his topographical work dominated the output of these later years. He produced series after series of views—of Edo itself, of the Tokaido and Kisokaido roads, of the cities and sights of the Kanto region and other provinces of Japan, of waterfalls, seascapes, and

*"Separated we shall be Forever, my friends Like the wild geese Lost in the clouds."*

BASHO

"Takanawa by Moonlight," *from the series* **Famous Places of the Eastern Capital (Toto Meisho),** 1831. *Brocade print,* oban size. *Courtesy of the Trustees of the British Museum, London.*

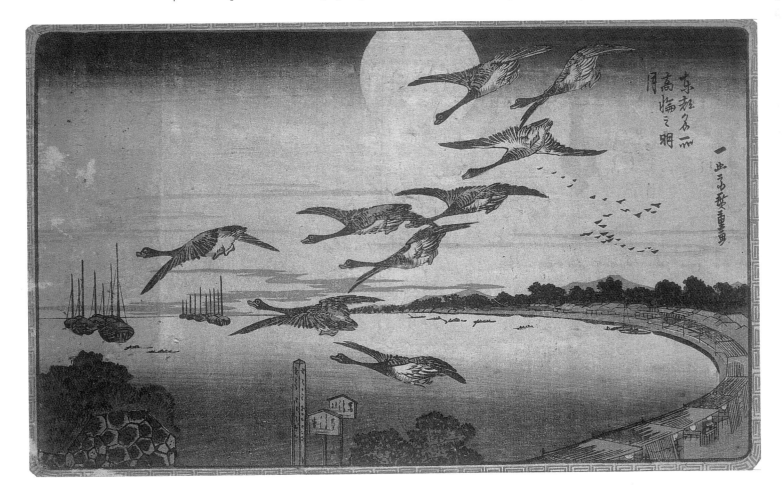

mountains—and much else. In some of these series, he shared the work with other artists—with Eisen on the famous Kisokaido series of the late 1830s, with his friend and pupil Kunisada on a later Tokaido series in 1854–1857. But Hiroshige himself remained the master of the form and continued to experiment with technique and composition and with the development of the genre until his final years.

From the enormous production of these years, a number of particular prints stand out, both as artistic masterpieces in their own right and as landmarks in Hiroshige's development.

One of his wonderful triptychs, of one of the great draper's stores in central Edo, shows Hiroshige turning to a city view rather than a rural landscape, combining the use of an extravagant perspective projection (quite possibly developed from an examination of Western prints and drawings) with his own particular delight in human detail, color, and composition. Another triptych, the famous "Whirlpools at Naruto in Awa Province," demonstrates his continued interest in the technical tour de force, not wholly dissimilar from his early line studies (page 66) but now concentrated on the myriad swirls and eddies of the water—here rendered in a few carefully chosen shades of blue.

**"Whirlpools at Naruto in Awa Province."** *A triptych of prints from 1857, showing the notorious tidal maelstrom between the islands at Naruto. Brocade prints,* oban *size. By Courtesy of the Board of Trustees of the Victoria & Albert Museum, London.*

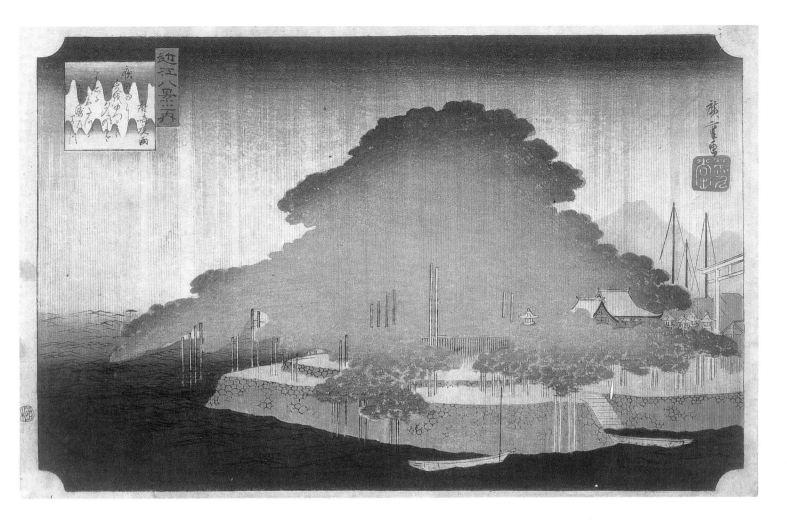

"Night Rain at Karasaki,"
*print from* Eight Famous
Views of Omi Hakkei No
Uchi *published by
Eikyudo in 1834. This
print is known in a
number of color versions.
Brocade print,* oban *size.
Courtesy of the Trustees
of the British Museum,
London.*

Rainfall in Japan is about five times greater than in Europe or the temperate zones of the Americas and is, therefore, an important, if less picturesque, characteristic of the scenery. Hiroshige does not shy away from the depiction of bad weather but relishes it. Nor is he put off by the prospect of night scenery. In "Night Rain at Karasaki," one of the series *Eight Famous Views of Omi Hakkei No Uchi,* we can almost smell the drizzle-damp foliage of the great tree, represented here by a bare silhouette—which in some printings is a deep green and in others a gray black. In either version, the dark, brooding mass of the ancient tree dominates the image.

In "Seba" (page 103), one of the prints from the famous series *Sixty-Nine Stations of the Kisokaido* (which Hiroshige took over after Eisen is said to have quarreled with the publisher) he depicts the wind—here streaming across the marshy flats of the river. The scudding clouds leave smudges across the moon; every reed and branch bends with the repeated gusts; the very angle of the boats against the windswept horizon echoes that of the boatmen straining against the wind.

*"Far and distant
Lighter than
  cherry blossom,
Floating like a
  mirage
The pine tree of
Karasaki."*

BASHO

In "Oi: Travelers in the Snow," another print from the same Kisokaido series, Hiroshige displays the deepest winter weather—not the elegant and clean beauty of new-fallen snow in a familiar place in the city, but in a lonely village, virtually cut off at this season of the year, where a group of frozen travelers, heads tucked into the precious warmth of their coats, struggles the final few steps to shelter.

It is Hiroshige's ability to portray the very feelings of the characters in his images that makes him unique in the world of *ukiyo-e*. In fact, the people he presents to us are not of the Floating World at all—those creatures of ephemeral style and short-lived pleasure. They, like us and Hiroshige himself, are flesh and blood, rich with individual experience and private memories, feeling the piercing cold at Oi, relishing the sweet smell of night rain at Karasaki, transported by the melancholy beauty of the geese and full moon at Tanaka, or enlivened by the merry scenes of the shopping or theater districts of Edo.

The pictorial world created by Hiroshige may be highly stylized by comparison with the standards of representational art in the West or of modern photography. But it offers far deeper insights into the lives and feelings of the people of Tokugawa Japan than we might glean from such supposedly realistic representation or, indeed, from countless tomes of social history.

"Oi: Travelers in the Snow," *from* Sixty-Nine Stations of the Kisokaido; *published by Kinjudo in the late 1830s. Brocade print,* oban *size. By Courtesy of the Board of Trustees of the Victoria & Albert Museum, London.*

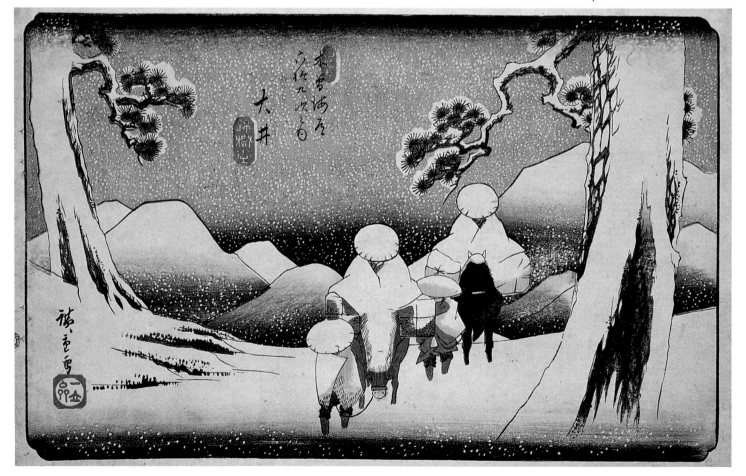

# CHAPTER 5

# THE JOURNEY:
## "Fifty-Three Stations of the Tokaido"

The idea of prints published as a series was already well established in Hiroshige's day, and prints of well-known scenes or views of distant places were already becoming popular. Hokusai's famous series *Thirty-Six Views of Mount Fuji,* had appeared in 1831, and Hiroshige himself had already done a series of views of Edo. But it seems that Hiroshige's *Fifty-Three Stations of the Tokaido* was the first to link these sets of views with the sequence of stations or rest stops along the famous roadways that connected the great cities of Japan. Indeed, it was a very ambitious project, since the fifty-five prints (including one each for the start and finish of the journey as well as the fifty-three way-stations) would make a much larger set than had ever been produced and would occupy the artist, and the team of engravers and printers, for some time. No little credit should go to the publisher, Hoeido Takenouchi, for taking on such an endeavor and following it through so successfully to the end.

The Tokaido road between Edo and Kyoto was familiar to much of Hiroshige's public. Thousands traveled the road each year as part of the countless official journeys between Edo and Kyoto, as members of one of the *daimyo* cavalcades traveling between Edo and their provincial homes, as traders and pilgrims, or as itinerant entertainers.

A huge number traveled the road as porters. Many of the river crossings were without bridges, in part because the *bakufu* discouraged their building to prevent armed insurrection against the Tokugawa regime. In addition, the mountain passes were steep and narrow, making them unsuitable for wheeled traffic. Porters—lots of them—were

*"Determined
to fall
A weather-
exposed skeleton
I cannot help
the sore wind
Blowing through
my heart."*

BASHO

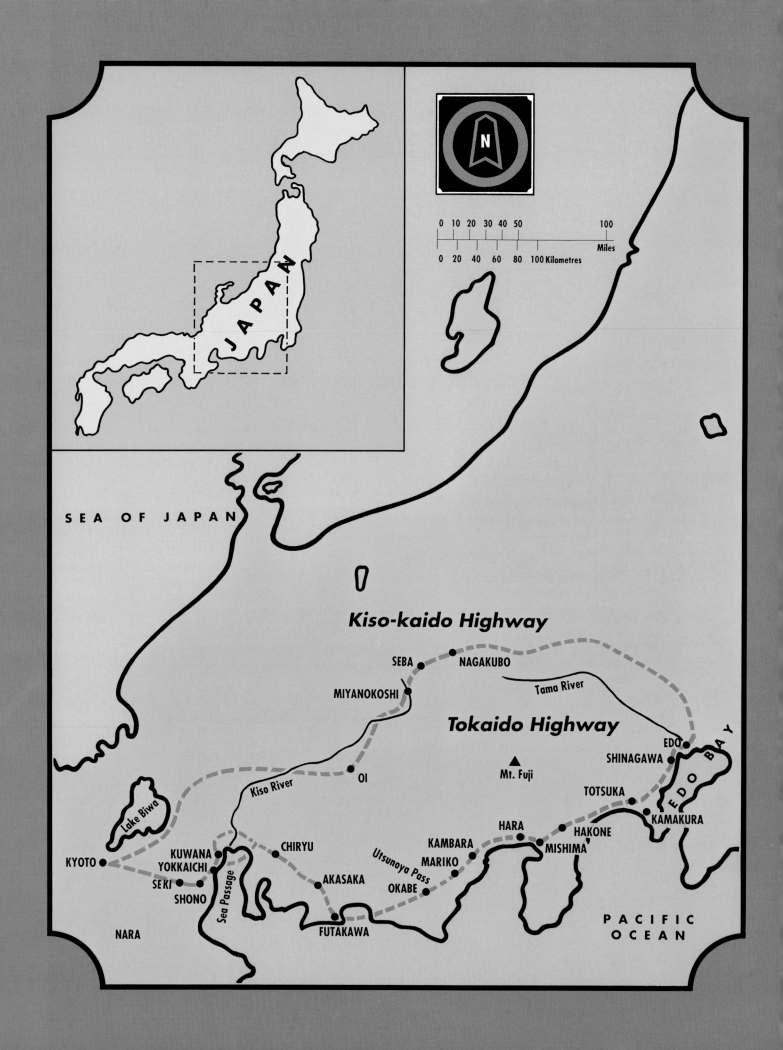

the only available means of transport. Even a modest expedition involving a single palanquin *(norimono)*, such as that shown on the Great Sanjo Bridge at Kyoto (page 93), involved a dozen people. There are at least fifty hats in the procession struggling up the mountain path at Hakone (pages 18-19), and the procession clearly extends some distance out of sight.

As a result of this enormous number of travelers, the scenes along the road would have been familiar to thousands—many of whom would have been happy to have a memento of their journey or a picture by which to show their friends the scenery they had traveled through, the hardships they had endured, and the events which might have taken place along the way. In addition, there was a growing interest in travel as recreation. A comic novel by Jippensha Ikku called *Tokaidochu Hizakurige* (usually translated as *By Shank's Pony Along the Tokaido*) had appeared in the early years of the century, concerning the adventures of a couple of Edoites along the road. By the 1830s the book was very well known, even in the less literary circles of Edo.

The market was clearly ripe, and Hiroshige's unique blend of sensibilities—for the beauties and oddities of landscape, for the idiosyncrasies of human behavior, for the natural world and the myriad changes in light and weather—made him the ideal artist for the task.

There was inevitably an enormous industry along the route to supply the needs of this vast army of travelers. The full distance from Tokyo to Kyoto is some 300 miles (490 kilometers) so the fifty-three stations of the series are roughly six to eight miles apart, perhaps two or three hours on foot—perhaps longer over the mountains. The station might be a hamlet, village, or town—the busiest at the end of a day's stage, providing for an overnight stop. Others would offer the chance of a brief rest during the course of a day's journey, sometimes in some lonely or picturesque spot out on the highway. All of the stations provided refreshment, and tea stalls feature in many prints of the series. Porters and horses could be exchanged at certain stations so that the traveler could proceed without delay.

Under pressure, the journey from Edo to Kyoto could be covered in a week, though it would usually take twice that time. Many of the stations provided overnight accommodation—guest houses for the most exalted (page 87) and more modest lodgings for porters, pilgrims, and all the

*"Would that my wife and I, Unfastening our girdles for each other And with our snow-white sleeves overlapping, Had reckoned the day of my return Before I came away upon my journey!"*

TAJIHI KASAMARO

77

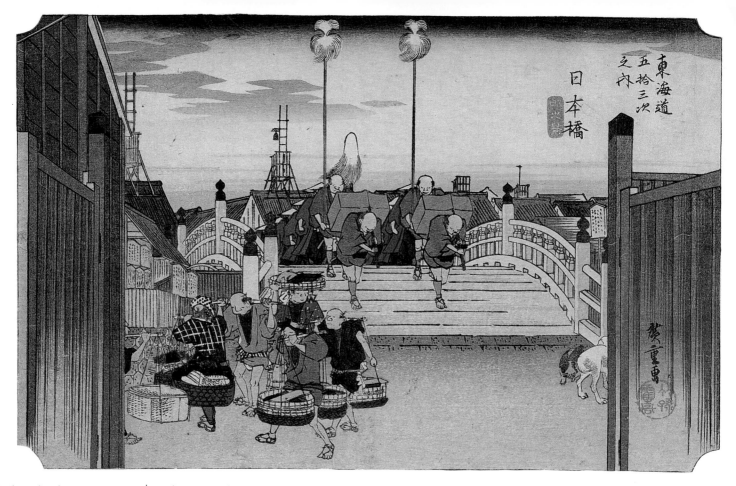

"Nihon-bashi: Morning View." *The first in the series* Fifty-Three Stations of the Tokaido, 1833–1834. *Brocade print,* oban *size. Courtesy of the Trustees of the British Museum, London.*

other travelers on the highway.

This series marks Hiroshige's debut as a master of his craft in his own right. The recent death of his teacher, Toyohiro, may have allowed him a new breadth. Certainly this series shows a newfound confidence in his own particular skills and interests. He chooses subjects that meld his wry observations of human situations with the great set-piece landscapes of Hokusai. He develops his special skill in the portrayal of the seasons, the time of day, the light, and the weather, be it sun or rain, wind or snow. He explores the most startling compositions with strong diagonals, unconventional perspectives, and vivid contrasts between foreground and background, left and right. And throughout the series he observes the scenes portrayed as if he, and we the viewers, are indeed part of the scene.

## Nihon-bashi: Morning View

The series starts at Nihon-bashi, the "Japan Bridge" in central Edo, the point from which all distances in Japan were reckoned. It is morning, and there is a fresh glow in the sky. A group of porters are carrying baskets of fresh fish from the markets just along the bank (see also page 15). A *daimyo* procession, led by pairs of porters and ceremonial

standard bearers, marches over the bridge, evidently setting out on a full day's march along the Tokaido. On the roofs across the canal can be seen a number of framed turrets. These are not the official fire-watching towers that can be seen on page 42, although one does have a warning bell. These were private belvederes, flimsy timber structures that allowed the occupants of each house to take the air of an evening, to look out across the city, to mount displays on ceremonial occasions (see also page 115), or to hang out clothing or bedding to air.

A version of this same view from a later series includes a scurrying mass of people in the foreground, all struggling to get out of the way of the procession on the bridge. A number of alternative versions exist for other prints in this series, highlighting the kind of human predicaments which clearly brought a wry smile to Hiroshige's face.

### Shinagawa: Sunrise

At Shinagawa the road meets the sea for the first time. On the edge of the village is a tea stall with three serving girls trying to persuade the passing travelers to stop for a rest. But it is still early in the day, and this particular procession, with its sword-bearing *samurai* in matching blue livery, is

"Shinagawa: Sunrise."
*The first of the actual stations after leaving Edo, from* **Fifty-Three Stations of the Tokaido, 1833–1834.** *Brocade print,* oban *size. The Whitworth Art Gallery, University of Manchester.*

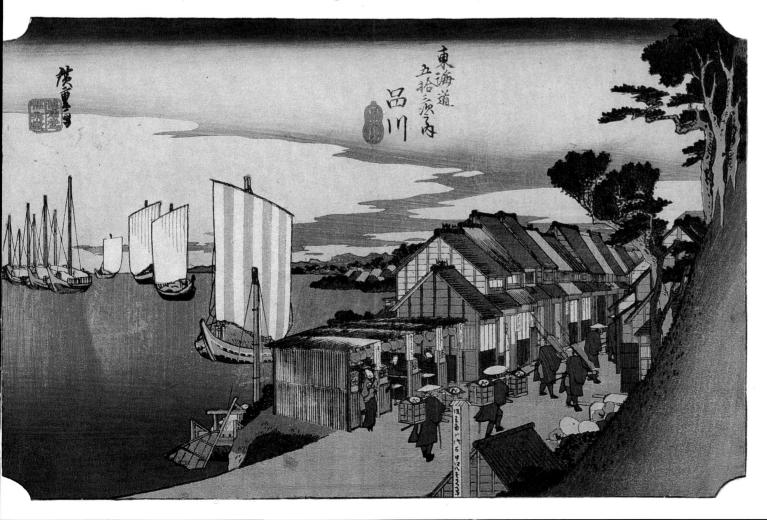

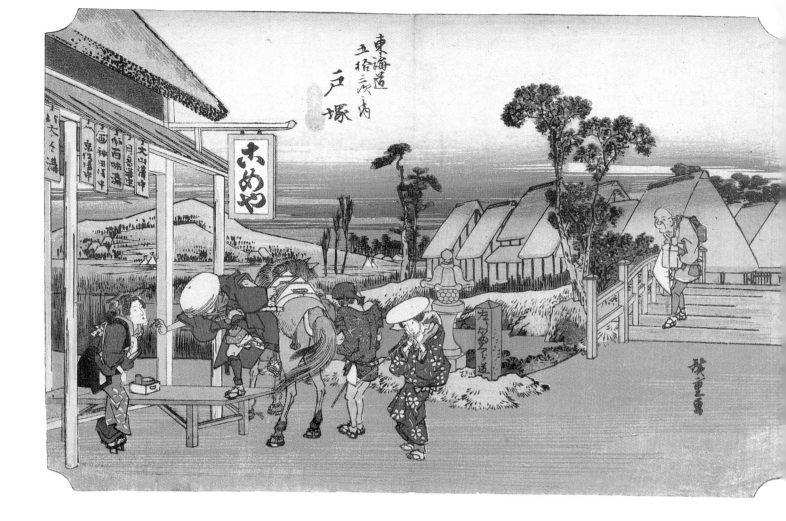

東海道五拾三次之内　戸塚

not going to stop so early on the journey. A couple of palanquins are parked on the right, their bearers teasing the girls in the tea shop opposite. Behind the houses of the village, a number of cargo ships ride at anchor, while others, their sails slack in the light morning breeze, try to make headway up toward the city.

## Totsuka: the Motomachi Detour

This print also exists in two versions. In the first, the rider is dismounting at the restaurant on the left while an attendant holds his horse. His lady companion prepares to loosen her hat while an elegantly dressed serving girl on her raised clogs welcomes them. Another single traveler observes the scene as he crosses the bridge.

In the second version, the rider has caught his foot in the stirrup and is about to fall into the arms of the serving girl, to the evident alarm of his traveling companion and the amusement of the man on the bridge—Hiroshige's delicate sense of humor pointing out the precarious hold we keep on our dignity.

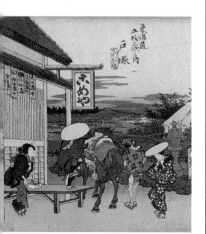

80

## Hakone: The Lake

Some 70 miles (110 kilometers) farther down the road, the route leaves the shore and climbs into the foothills of Mount Fuji past Lake Hakone, famous throughout Japan for its hot springs (pages 18-19). The calm expanse of the lake, with the gentle hills and pristine cone of Mount Fuji on the horizon, contrasts with the volcanic peaks and cliffs on the right. The drawing of the crags and the trees that cling to them suggests that they are being thrust up by volcanic forces before our very eyes, the extravagant choice of colors reinforcing the violence of the scene. An enormous *daimyo* procession, its standards dipping under the strain of the ascent, is reduced by the scale of the mountains to a stream of hats snaking up the pass between the crags.

## Mishima: Morning Mist

A new day breaks as this small group of travelers sets out: the first, a young woman perhaps, on horseback; another carried in a palanquin between two gnarled old porters; an old lady wrapped in a woven straw shawl; and a third porter with a carrying pole. It's going to be a hot day's work, to judge from the open garments of the porters, but the early morning mist is chill and softens the outlines of the surrounding scene.

**"Mishima: Morning Mist."** *The eleventh station from* **Fifty-Three Stations of the Tokaido, 1833–1834.** *The omission of the usual black outline from the background features evokes the misty morning.* Brocade print, *oban size. Courtesy of the Trustees of the British Museum, London.*

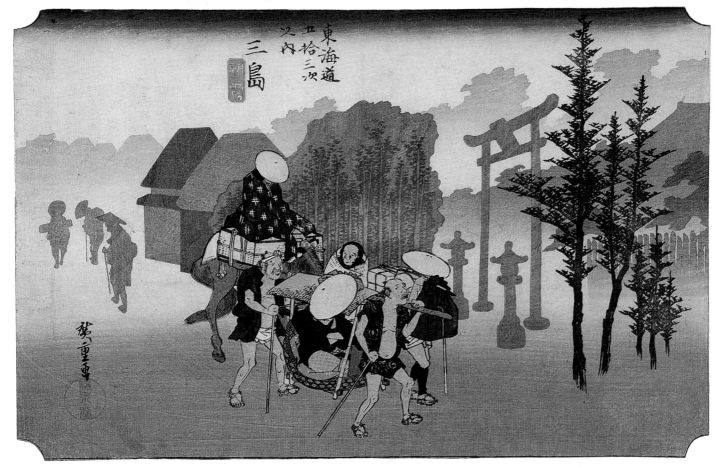

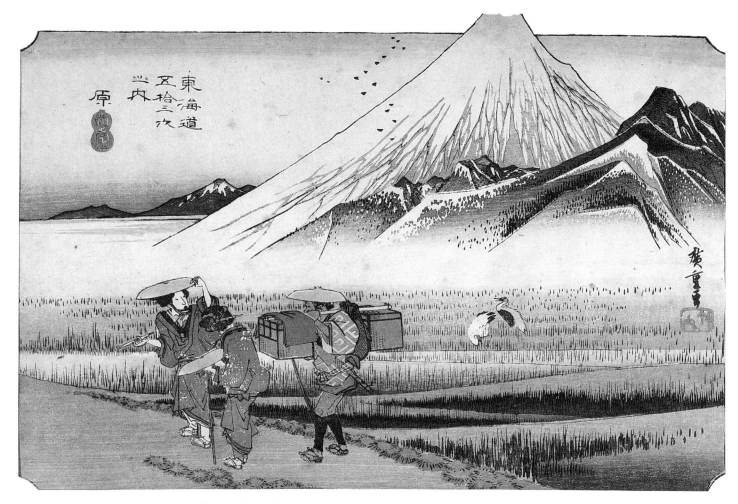

The technical mastery of this print is astonishing. The effect is achieved first of all by omitting the black outlines of the background features—a tricky business, since the engraving process is usually coordinated by the outlines on the *sumi* master block. Hiroshige has made a virtue of this difficulty by using a small number of blocks in grays and blues, each with simple but highly detailed profiles that define the details of the shrine, the village, and the distant figures, each color having a strategic *bokashi* shading to imply mist rising from the ground.

*"Hara*: Mount Fuji in the Morning." *The thirteenth station from* **Fifty-Three Stations of the Tokaido,** 1833–1834. *Compare this view (above) with a similar one done some twenty years later in vertical format (below) which gives a greater sense of distance, emphasizing the size of Mount Fuji. Brocade prints,* oban *size. The Whitworth Art Gallery, University of Manchester.*

## Hara: Mount Fuji in the Morning

After the mountains of Hakone and the mists of Mishima, the road emerges at the foot of Mount Fuji, which we see here soaring above us, piercing the very frame of the picture. The road winds through paddy fields, where a pair of cranes are hunting for frogs and other morsels. The two ladies in the foreground in matching kimonos are impatient with their porter. The design on his coat is made up of the lozenge design that Hiroshige uses as his own emblem. Perhaps Hiroshige is hinting at the impatience of his publisher (see also page 91).

82

A similar view from one of Hiroshige's last series of Tokaido prints (c.1854) shows many of the same features—including the summit of Mount Fuji piercing the frame—but arranged in a vertical rather than horizontal format. This has the effect of dramatizing the height of the mountain and the sense of distance in the picture.

## *Kambara: Night Snow*

This, one of Hiroshige's most famous snow scenes, evokes perfectly the stillness and solitude of the road in winter. The houses, hills, and trees are rendered in black outline with a couple of shades of gray softened by the subtle hand of the printer to a mere wash across the ground. The figures, reduced to simple outlines with only the slightest color, are huddled against the cold, isolated from the world and from each other, their faces hidden by hats or umbrellas.

Intriguingly, this print exists in two states: one with the sky graded to black at the top of the picture and one with it graded to black against the skyline. This difference would have been achieved not by making a fresh block but by wiping away the ink in one area rather than another. One can imagine Hiroshige conferring with the printer and the publisher and being unable to decide which version was the more successful—and leaving it to the market to decide.

"**Kambara: Night Snow.**" *The fifteenth station from* **Fifty-Three Stations of the Tokaido, 1831–1833**. *This print is rightly famed for its sense of loneliness and cold. Brocade print,* oban *size. The Whitworth Art Gallery, University of Manchester.*

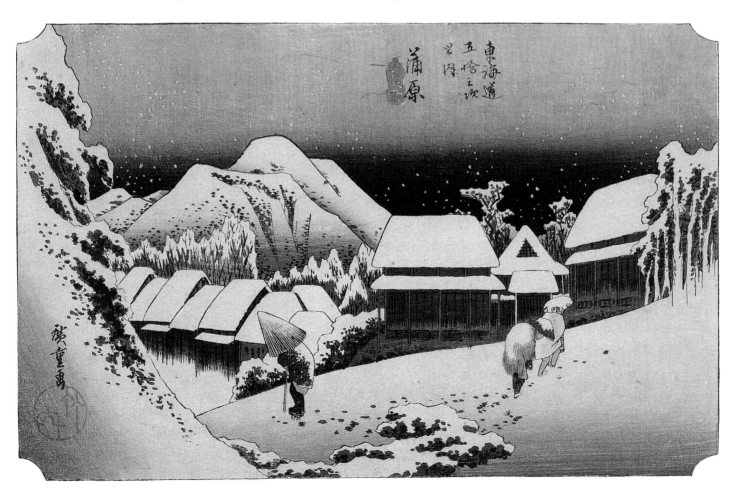

## Mariko: The Famous Tea Shop

The fact that this apparently modest tea shop at Mariko was famous was due to the poet Basho, whose simple *haiku* was evidently well known:

> *Young leaves of plum,*
> *and at the Mariko way station,*
> *a broth of grated yams.*

Hiroshige celebrates the poet's imagery quite literally with a budding plum tree to the left and a sign—advertising the grated yam broth—leaning against the stall. What other delights the poet may have had in mind we can only guess, but Hiroshige includes a number of engaging details which evoke the rustic charms of the place: the pair of sparrows twittering on the roof, the baby strapped to the back of the serving woman, the dried fish decorating the stand at the back of the shop, and the enthusiasm with which the two customers are digging into their broth.

"Mariko: The Famous Tea Shop." *The twentieth station from* Fifty-Three Stations of the Tokaido, 1831–1833, *famous on account of the poet Basho's* haiku. *Brocade print,* oban *size. Courtesy of the Trustees of the British Museum, London.*

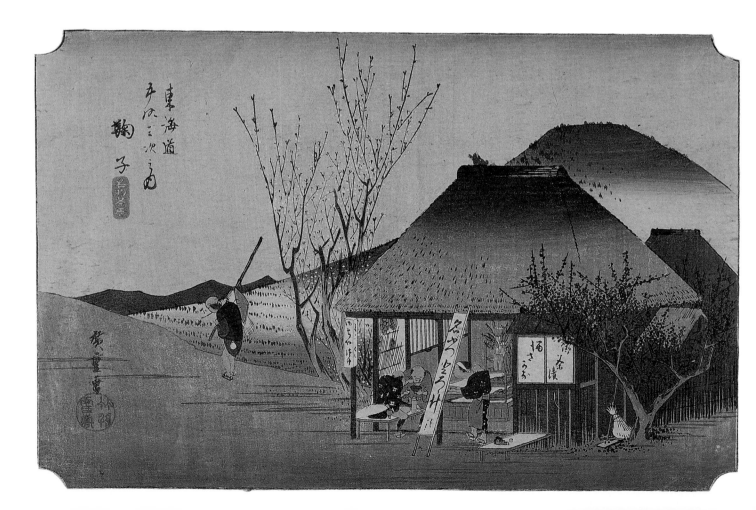

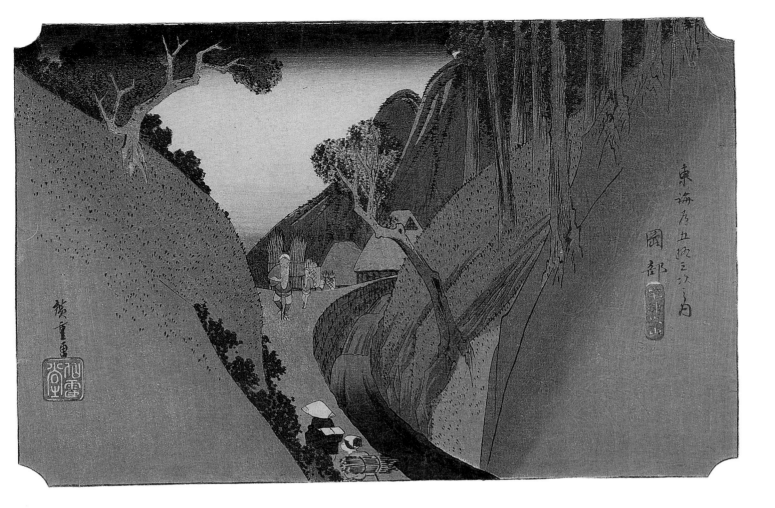

## Okabe: Mount Utsu

Once again the road turns inland, this time through the wooded hills at the foot of Mount Utsu. The startling simplicity of this composition—with the bulging forms of the grassy slopes on either side—catches the special sense of enclosure in which both road and stream flow through this sharp defile.

"Okabe: Mount Utsu." *The twenty-first station from* **Fifty-Three Stations of the Tokaido, 1833–1834.** *This picture shows the steep mountain pass between Mariko and Okabe. Brocade print,* oban *size. Courtesy of the Trustees of the British Museum, London.*

"Futakawa: Monkey Plateau." *The thirty-third station from* **Fifty-Three Stations of the Tokaido,** 1831–1833. *Brocade print,* oban *size. The Whitworth Art Gallery, University of Manchester.*

## *Futakawa: Monkey Plateau*

This strange landscape of open scrub and stunted trees is unusual in the usually verdant landscape of Japan, as the bizarre name Monkey Plateau clearly indicates. Hiroshige has represented this strangeness with an unusual abstracted technique, characterized, as ever, by extreme economy—a couple of grays and washy blue-greens shading into the distance. In the foreground is a group of traveling musicians, evidently women, each carrying a *samisen,* the Japanese three-stringed lute. One can sense their relief, and that of the man who precedes them, as they reach the tea stall on the left.

## Akasaka: Inn with Serving Maids

This is a real five-star establishment, bustling with activity in the early evening. A series of rooms with elegantly decorated sliding screens, each with a veranda, are arranged around a garden with a shapely palm tree, rock, and stone lantern. In the suite on the left a *samurai* (with his characteristic shaved crown and pigtail) is taking his ease after the day's journey. He is enjoying a pipe, clearly in company, for the lady of the house (under the watchful eye of a liveried retainer) is presenting two identical trays with matching chopsticks, covered soup bowls, and other dishes. We can't see his companion, but one or the other of them has draped a garment or cloth over the hanging rail, adorned with Hiroshige's own crest.

In the suite adjacent, three girls with colorful *kimono* and elaborate coiffures are attending to their makeup with a concentration that suggests they do not wish to be compared unfavorably with the sophisticated ladies of the Pleasure Quarters of Edo or Kyoto. Beyond them in the cupboard are bedding rolls—which may or may not be part of the entertainment for which they are preparing.

"Akasaka: Inn with Serving Maids."
*The thirty-sixth station from* **Fifty-Three Stations of the Tokaido, 1831–1833.** *Brocade print,* oban *size. Courtesy of the Trustees of the British Museum, London.*

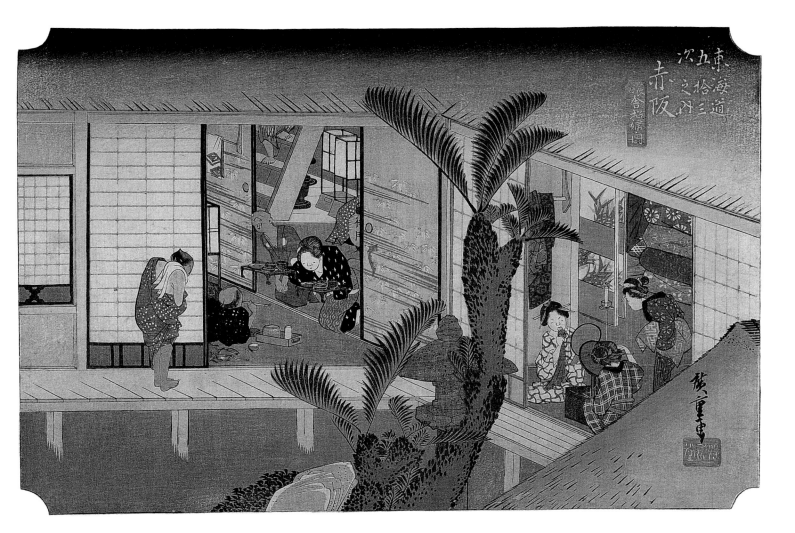

## Chiryu: The Summer Horse Fair

Chiryu was famous for its horse sales. These hilly uplands were evidently a landscape with plenty of rich pasturage, particularly in early summer. The sales were held on the twenty-fourth of the fourth month and on the fifth of the fifth month (April and May). Some four or five hundred horses would change hands on these occasions. The group gathered under the tree is clearly in the thick of the bargaining. The attendants in the foreground are anxiously awaiting their turn before the auctioneer.

As ever, Hiroshige uses a remarkably simple range of colors and achieves a striking sense of distance by a combination of varying textures, diagonal swathes of grass dying into the calm expanse of the distant sky, and a masterly use of *bokashi* shading.

*"Chiryu: The Summer Horse Fair." The thirty-ninth station from Fifty-Three Stations of the Tokaido, 1833–1834. Brocade print, oban size. Courtesy of the Trustees of the British Museum, London.*

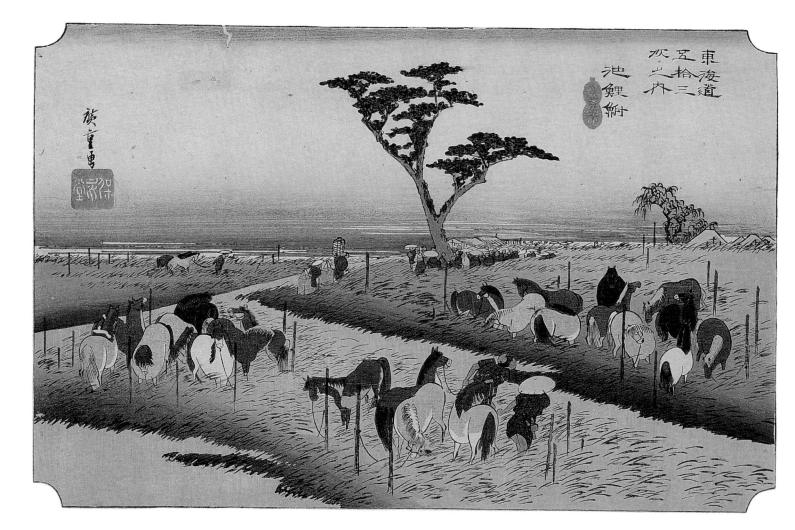

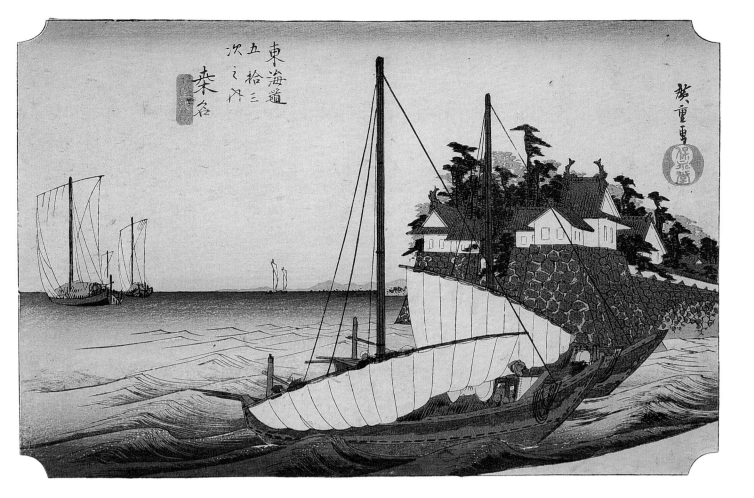

東海道
五拾三
次之内
桑名

広重画

## Kuwana: The Port

Between Miya and Kuwana the road crosses the mouths of a number of great rivers—without bridges. Rather than struggle on and off numerous ferries or attempt to ford the shallower streams carrying baggage at shoulder- or head-height, many travelers would undertake this stage by sea. The two ships in the foreground are just lowering their sails as they come into the harbor, laden with travelers. The anxious faces of their passengers can just be seen under the tarpaulins that would have protected them from rain or sun during the crossing. The harbor was clearly prosperous, to judge from the splendid fortifications with their white-painted guardhouse and fish-tailed finials.

*"Even the boat, which sails Upon the pathless sea, Where white waves toss their heads, Finds a trusty guide in the breeze."*

FUJIWARA NO KATSUOMI

89

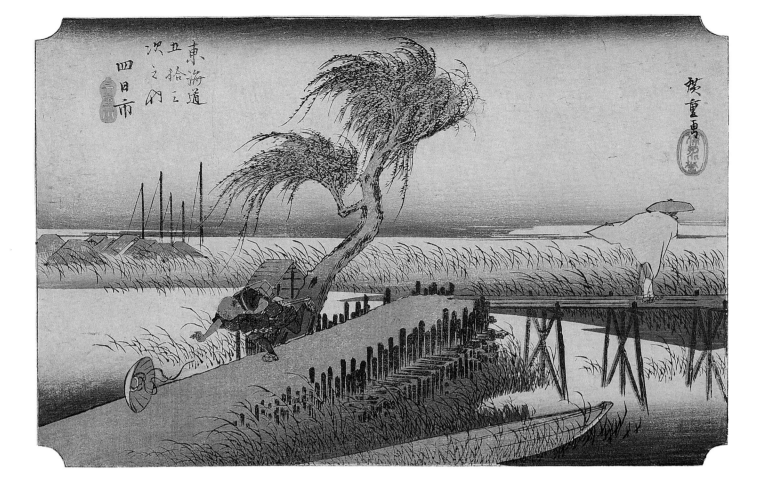

## Yokkaichi: The Mie River

At Yokkaichi the road crosses the mouth of the marshy flatlands at the mouth of the Mie River on a series of causeways and bridges of the type portrayed here. Hiroshige highlights the sense of exposure peculiar to this flat, open landscape, and the special threat presented by the winds. Once one's hat has blown across the marshes, no amount of running will recover it.

The effect of the wind is caught in every line, the billowing of the cloak on the causeway, the thrashing of the willow branches, the lines on the boat masts, and the curve of every reed. It is further reinforced by the diagonals of the boat, and by the path with the flying hat moving toward the bottom left-hand corner. As in many prints of this series, this utterly convincing pictorial effect is achieved with the barest minimum of blocks—probably no more than eight or nine in all: a series of three blues for the water, the marshes, and the sky to the horizon; a buff, a gray, and a yellow for the figures, the tree, the boat, the village, and the hat; a single smudge of brown to complete the sky; and the exquisitely drawn black line block to pull the details together.

## Shono: Driving Rain

This, one of the most vivid and evocative of Hiroshige's many masterpieces, catches that heart-stopping moment when the thunderclouds that have been building overhead suddenly break, letting loose a mind-numbing deluge. The diagonal slope of the hill, cutting across the composition against the driving rain, and the repeated banks of giant bamboo tossing in the wind, stress the urgency of the moment. The travelers are hopelessly confused, two of them rushing downhill into the storm and a third being blown uphill in search of shelter. The two porters in the middle are stuck. Without straw raincoats or umbrellas, and unable to run for fear of tipping their passenger into the mud, they are resigned to a drenching. And their passenger is in trouble, too, as he struggles to hold on to the flimsy cloth that shelters him.

The characters on the umbrella spell out the name of Hiroshige's publisher, Hoeido. He is going to have to run very fast if he's not to catch a cold. In the event, this print—with its amazing economy of form and color—was one of the most successful in the series and was produced in many versions with different shadings and contrasts.

"Shono: Driving Rain."
*The forty-fifth station from* **Fifty-Three Stations of the Tokaido,** **1833–1834,** *shows a sudden storm among the bamboo forests as the road climbs overland toward Kyoto. Brocade print,* oban *size. The Whitworth Art Gallery, University of Manchester.*

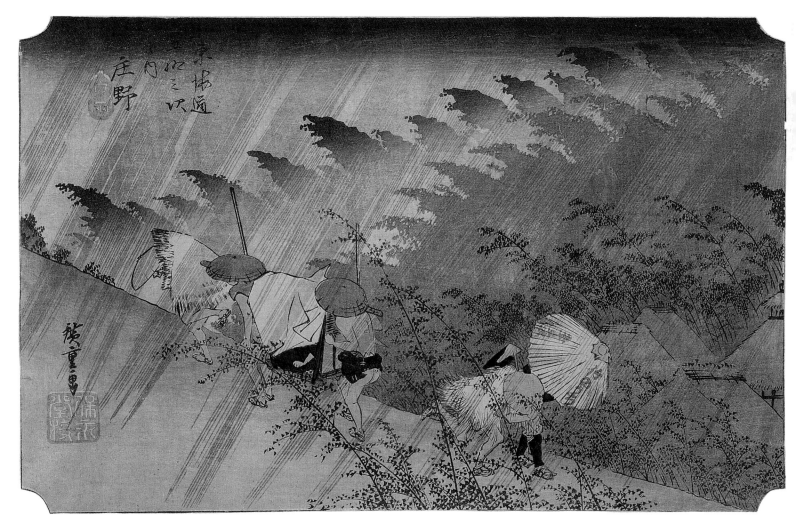

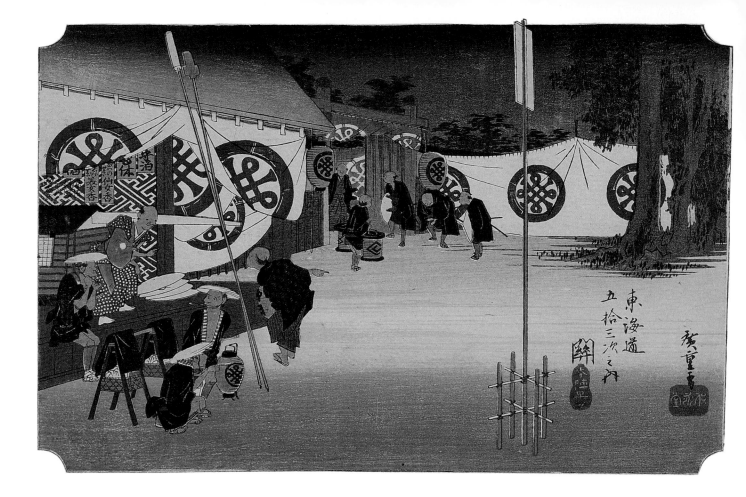

## Seki: Early Departure of Daimyo

The sky is still dark, but preparations are under way for the departure of a large *daimyo* procession. Although the *daimyo* may have stayed only a single night, the house has been fitted out with drapes marked with his clan insignia, matching that on the lanterns. On the left a senior retainer, still in his indoor socks, is handing out hats, straw sandals, and the black overgarments to be worn by the day's porters. Behind him is the magnificent palanquin they will be carrying. In the middle distance a group of *samurai* retainers with their swords and coiffures of office, are preparing to greet their lord, looking to the senior retainer within and pulling up their leggings. A small boy carries a pair of lanterns with Hiroshige's own crest—to shed his own special light on the scene.

## Arrival at Kyoto

The final scene of the series shows the Great Sanjo Bridge into Kyoto, whose importance and grandeur is marked by the bronze finials on every fourth post of the balustrade. The roofs of the city, punctuated with palaces and pagodas, occupy the middle distance. The mountains beyond shelter the famous temples, shrines, and monasteries in their foothills.

On the bridge, a pair of hooded figures with a servant and a group of ladies with parasols, are looking forward to the end of their journey. A local hangs over the bridge contemplating the water below. At the same moment a *daimyo* procession is setting out from the city, led by a standard bearer, a pair of porters, and a heavily laden packhorse. The palanquin and guard of honor follow.

This, the culmination of our journey, is the beginning of that of others.

"Arrival at Kyoto."
*The arrival in Kyoto at journey's end, the final print from* **Fifty-Three Stations of the Tokaido, 1833–1834.** *Brocade print,* oban *size. Private Collection.*

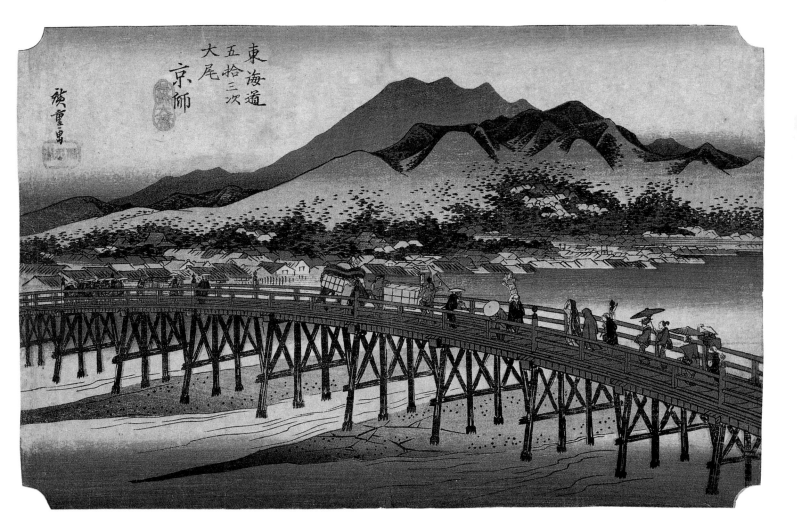

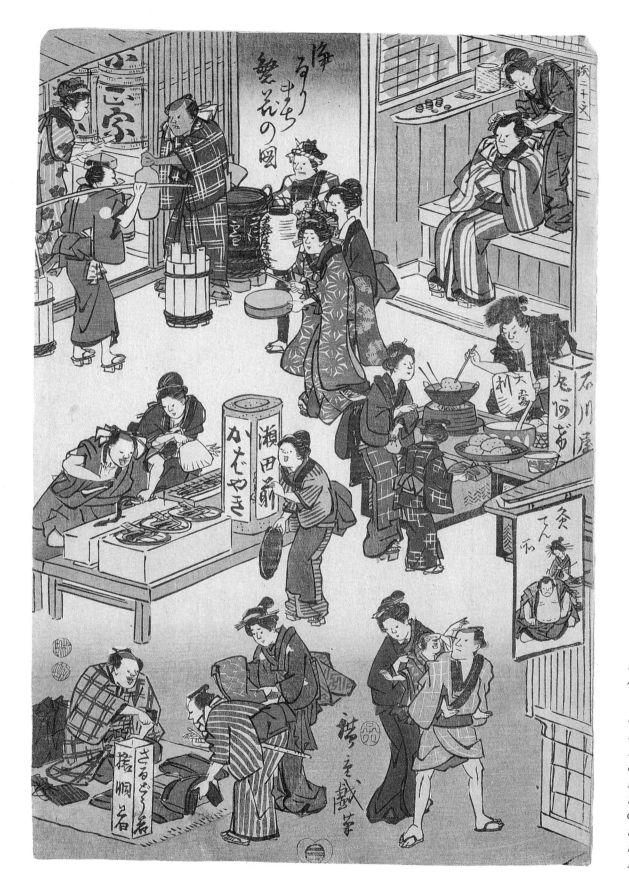

**"Street Stalls and Tradesmen in Joruricho."** *This print of merry caricatures of the street life of Edo shows Hiroshige's sympathy with everyday people and his special gift in drawing them. Brocade print,* oban *size. By Courtesy of the Board of Trustees of the Victoria & Albert Museum, London.*

## CHAPTER 6

# HIROSHIGE -SENSEI:

## Master of a Thousand Wisdoms

Children all over the world play the game of spotting images in clouds: faces, figures, animals, plants, landscapes, legendary heroes, and anything else. This mechanism of recognition is central to the work of the graphic artist—be he painter, photographer, or printmaker.

The wonder of Hiroshige's art is the sheer quantity of information that is relayed by nothing more sophisticated than the arrangement of line and color on a single plane. This is the basis of every form of graphic art, from the crudest graffito to the most refined, and exquisite artistic expression—whether from medieval Flanders, Renaissance Italy, or Tokugawa Japan.

Like Hokusai and the others of the *ukiyo-e* tradition before him, Hiroshige studied the art of representation not through the precise reproduction of the world as it appears to the so-called naked eye, but through the use of shapes in line and color that act directly on the unconscious minds of his viewers, calling up images that, in some way, are already there.

Unlike the artists of Renaissance Europe, he does not seek to create a complete illusion by the perfection of perspective and the exact representation of light and shade. Rather, he seeks out those graphic formulae which will prompt the viewer's imagination to conjure up the images he wishes to evoke. This is not to belittle his skill and insight in any way. Indeed, the European sciences of perspective and skiagraphy (shadow projection) make it possible for an amateur, with little innate graphic skill, to make passable pictures simply by applying a few simple rules. Hiroshige, and his colleagues in the *ukiyo-e* tradition, seek

*"There are painters who transform the sun into a yellow spot, there are others who, thanks to their art and intelligence, transform a yellow spot into the sun."*

PABLO PICASSO

95

instead for those unique combinations of line, form, and color that act directly on the recognition system of the mind. As a result, much of the image-making of the *ukiyo-e* artists is dependent on conventionalized representations.

The enormous technical exercise of making and printing the *ukiyo-e* print also conditions the artist to seek out representational formulae. The *ukiyo-e* artist has to instruct his team of engravers and printers in the detailed layout and coloring of as many as twenty different colored blocks, which, in combination, will achieve the magical synthesis of the finished image. To be successful, the instructions to the engravers and printers need to be simple and clear—which is best achieved by simplicity of form and economy of graphic technique.

The creator of such an image must also be much more than the "natural" or "innocent" artist of the Western tradition—a man of intuitive genius, alive with an innate ability to see and record the world around him, dashing off masterpieces in the heat of creative passion. The *ukiyo-e* artist is trained as a painstaking and meticulous craftsman, learning to construct his image, to assemble it from a number of components, which may range from the two brush-strokes that represent a flying bird to the arrangement of an entire picture in a way that draws the viewer into a completely imaginary world. His supreme craftsmanship is an essential prerequisite to his artistic achievement.

The fascinating part of this craft of image-making within a convention, is to watch each successive generation discover and develop new techniques of representation, new subjects to represent, and new graphic formulae. Hiroshige took some time to establish his own vocabulary of graphic conventions. His early work is generally acknowledged as derivative. But, as he discovers the subject matter for which his skills and aptitudes are best suited, he develops his own encyclopedia of conventions.

The most obvious of these conventions is in the representation of human figures. At an early stage Hiroshige was clearly quite skilled in caricature and produced a number of humorous pictures of Edo townsfolk (page 94) in which their idiosyncracies of facial expression, gesture, posture, and dress are lightly exaggerated using quite short brush-strokes, rather than the long, sinuous line of the conventional *bijin* representations (page 16). In the great Tokaido series of 1832, the conventions of caricature are used extensively, but in a mellow or softened manner better suited to

the character and mood of these essentially landscape images (page 87).

The same conventionalizing can be seen in the representation of other features. Take the drawing of flowers, trees, birds, and other animals, for instance. When they are part of a landscape scene, the exquisite detail of the special fish or flower prints is not called for.

Similarly, in the representation of distant mountains and open skies, Hiroshige relies increasingly on simple monochrome profiles or carefully controlled shadings of unexpected colors—yellows, pinks, grays, and browns.

In his mature work, these formulae identify Hiroshige's authorship as accurately as a signature. The confidence with which these highly simplified forms are used, the delicacy of compositional balance, and the subtle coloring are unmistakably his.

## Line

The first weapon in the artist's armory is line. In its simplest form it represents a line in real life—such as the kite strings in the view at Hibiya (page 110). A line can also be used to represent an edge, the dividing line between zones, as in

"**Miyanokoshi**," *the thirty-sixth station from* **Sixty-Nine Stations of the Kisokaido**. *This image of a poor family struggling onward in misty moonlight, shows Hiroshige's particular skills and sympathies. A pair of delicately colored blocks, without outlines, sketch in the weary stillness of the night, while the ingenious drawing of the family group points up the sleeping child on the father's back, the long-suffering mother and the servant following them, who alone spots the welcome roofs of houses through the gloom. Brocade print,* oban *size.* By Courtesy of the Board of Trustees of the Victoria & Albert Museum, London.

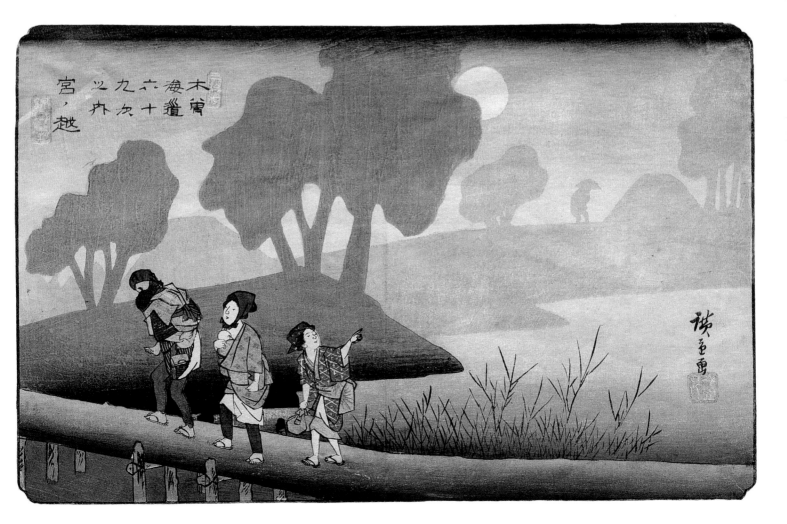

the line of the doorsill of the temple gateway at Asakusa (page 134). Used in groups, lines can define a structure such as the distant temple in the same view. Or a line can be used to enclose a surface—such as the cloud bands in the Nihon-bashi view (page 15). They can curve or wriggle, and in doing so evoke the form of a familiar feature, such as the cone of Mount Fuji or the much greater complexities of a facial profile.

By filling the area enclosed by such a line with color, as the swathes of cloth at Hatsune (page 42), a separate object is created. In certain instances, the zone of color can be left without its bounding line, as the shadow of the courtesan on the *shoji* screen of Tsuki No Misaki (page 129). These curved or moving lines delineate (to use the precise term), and thereby represent, any one of a thousand objects—the claw of a terrapin, a flitting swallow, a leaf, a bowl, a boat, the folds of a kimono, the shore of a river, the outline of a building, or the branches of a tree.

As a further refinement, the thickness of line can be varied to distinguish between near and far—to give substance to an edge, be it of a tree trunk at Kamata (page 114), the curve of the petals of an iris (page 123), or in the representation of facial expression (page 94).

Hiroshige's use of line is full of conventions and formulae. The conventionalized outline of Mount Fuji, for instance, was so familiar to his Japanese audience that it was recognizable from the slightest clues—a single line, the profile of a colored block, or, as in one of Eisen's contributions to the *Sixty-Nine Stations of the Kisokaido* series, from the profile of a bridge. Similarly, the outline of a hat or a temple roof, a bell or a bird was all that was required to evoke a well-established image.

Hiroshige was also a master of the economy of line. With two flicks of the brush he could distinguish the leisurely profile of geese flying homeward across a full moon (page 136) from the pair of twittering sparrows at Mariko.

Animals are frequently represented in a conventionalized way. A pair of dogs, for instance, appears in many prints (pages 98 and 139). Although the pose may vary, the pudgy form and simple outline are repeated each time. All the horses at Chiryu (page 89) come from the same "stable" of graphic convention. The studies of fish (pages 68-69) and of birds (pages 4, 56-57, 59, and 60) show the same search for a perfected and irreducible image, whether of a crane, an eagle, or a sparrow.

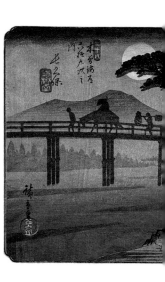

Not surprisingly, faces and facial expressions are subject to the same conventionalizing treatment. There were evidently two quite different conventions. The first was that of the *bijin,* in which grace and beauty were emphasized by the use of smooth, sweeping lines. Hiroshige did his own share of such faces (pages 16 and 58), but he did not explore the subtleties of expression with the same loving care as did the specialists—the tilt of the head, the lowering of eyelashes, or the pursing of lips. But he did work with great expertise in a rather different tradition—his own gentle form of caricature—in which ordinary faces (many of them less than beautiful) are represented in all the variety of expressions that might be seen in daily life: expressions of delight and amusement, of satisfaction and repose, of animation, boredom, and anger. These expressions are frequently achieved with the use of half a dozen strokes of the brush, and in certain instances they are so highly conventionalized that it would be difficult to recognize them out of context—such as the almost piggy nose of the innkeeper at Akasaka (page 87). But in their place they are instantly recognizable and are full of a peculiar sympathy for the oddities of physiognomy and expression.

Many of these conventions can be associated with the characters of Japanese writing (*kanji*). They too are highly conventionalized pictograms, formed with a few intuitively recalled strokes of the brush—but evoking an enormous array of meanings and sub-meanings.

Hiroshige is similarly a master of posture. The hunch of a back at Kambara (page 82) tells us everything about the cold and loneliness of the scene.

Hiroshige clearly came to regard this type of conventionalizing of facial features and posture as much more true to life than the elegant line depictions of the *bijin.* Indeed, in his hands, this type of drawing is not a cruel lampooning of idiosyncracies of physiognomy or expression, but rather is a form of sympathy, a frank, open view which relishes people for what they are—in all their variety.

The same conventionalizing occurs, predictably enough, in the depiction of flowers and trees, and particularly in foliage—most obviously in the *kacho* flower-and-bird prints (pages 56 and 57) and their derivatives, like the wisteria at Kameido (page 124), the misty trees at Mishima (page 81) and the wind-blown reeds at Yokkaichi.

Representation of fabric patterns and textures had long been part of the *ukiyo-e* artists' interests—from the very

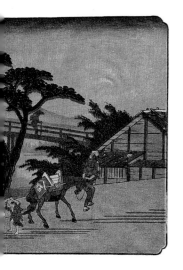

"Nagakubo," *from* Sixty-Nine Stations of the Kisokaido. *A moonlit view of travelers crossing a bridge as children play with two dogs on the shore. Brocade print,* oban *size. By Courtesy of the Board of Trustees of the Victoria & Albert Museum, London.*

99

beginning of the "brocade" print. Such patterns are frequently drawn without regard to the pattern of folds in the garment but are represented flat, so as best to display the character and quality of the pattern and to complement the pose of the figure or underline the graphic qualities of the image.

## Color

In the early years of the woodblock print, color was used just to fill in the outline and was originally applied by hand. With increasing sophistication in the printing technique and greater variety in dyes and pigments, the colors used became increasingly true to life. The colors of fabrics and flowers, the tones of sky or sea would be closer to their originals. However, colors could not be shaded into one another except by the relatively crude *bokashi* technique. The way color changes across the surface of a rounded object, for instance, was difficult to represent, and the use of shadows very limited. For this reason artists avoided using color to these ends and concentrated instead on more abstract effects. Color was used less to mimic nature and more to enhance art, by exploiting the sheer richness of color, by using vivid contrasts, or by using totally unexpected colors—such as the uniformly pink sky over the plum orchards at Kamata (page 114).

Color was increasingly used without an outline. At first the patterns of fabrics were represented by excising the brocade or tie-dye patterns from the block. At a later stage—and particularly in the hands of Hiroshige—the profiles of whole objects were freed from the traditional black outline, and were used, without reinforcment, with very successful effect, in the sky-scapes of Seba (page 103), the mist-shrouded outlines of Mishima (page 81), and the waving bamboo in Shono (page 91).

The *bokashi* shading technique was available for grading color and was used to great and subtle effect (pages 118 and 119), but its use remained highly conventionalized—to represent the depth of a river, for instance (page 122) rather than its true color.

"The Mochi-hana Dance at the Waka-no-ura Festival in Kii Province," *from the series of fan prints* (uchiwa-e*) of* Old and New Festivals in Various Provinces. *These two prints from the same set of blocks show how the choice of colors can change the visual effect. Note in particular the light purplish gray of the skirts (below) as opposed to the light blue (above). By Courtesy of the Board of Trustees of the Victoria & Albert Museum, London.*

100

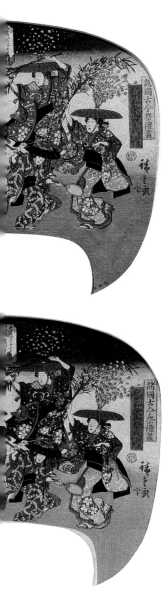

## Light and Dark

It is often said of music that the rests, the moments of quiet, are as important as the sounds of voice or instrument. Likewise in graphic art, the dark areas, reflecting a minimum of light and color, can be very important to design and composition. Hiroshige is a master of darkness. His night scenes, such as the various prints of the late-summer firework displays at Ryogoku Bridge (pages 70 and 121), or "Fox-fires at the Changing Tree" (page 142), brilliantly balance the areas of light and color against the prevailing dark tones. As anybody who has tried to paint a predominantly dark picture will confirm, it requires considerable subtlety of judgement to achieve these effects without making the whole picture too dark to see. It is doubly impressive that Hiroshige achieves such scintillating effects in these and a number of other prints, notwithstanding the severe limitations on the grading of shade and color in the relatively crude medium of the woodblock print.

## Distance and the Third Dimension

The representation of distance in pictorial art has always been a source of interest to both artists and connoisseurs. Japanese art inherited many of the conventions of Chinese painting in this regard. The most obvious of these was the use of cloud-bands to separate remote elements of the composition from the foreground. There was also the axonometric projection of buildings, whereby the facade is represented full face and the sides are shown running off on a diagonal.

Hiroshige uses both these conventions in a variety of contexts, such as in the views of Nihon-bashi (page 15) and Suruga-cho (page 113). He also uses perspective, although not always to the satisfaction of certain Western critics. The artists of the Far East were certainly not oblivious to the fact that objects appear to diminish in size the farther they are from the viewer—although they may well have been unaware of the strict application of projective geometry to this phenomemon, with its apparatus of picture planes, horizon lines, and vanishing points. More or less accurate perspective projection was used in painting and print designs such as Masanobu's view of the interior of a *kabuki* theater (page 38). Such perspective views were known as *uki-e* or "floating images," in acknowledgement

of their illusory effect. Quite a number appear in Hiroshige's *oeuvre*, but perspective was quite clearly of secondary interest to the practising artist—even those working, as was Hiroshige, in the field of topographic representation.

Though Hiroshige uses perspective effects he does not set them out with total fidelity to the geometric principles of planar perspective. The layout of the whole image is of much greater significance than scientific accuracy. In the view of Suruga-cho (page 113), for instance, the horizon line implied by the buildings on either side of the street is far below that implied by the mountain looming over them. In a photograph of this scene the profile of Mount Fuji would be a mere bump, lost on the horizon between the most distant buildings. By raising the viewer's eye line and enlarging the mountain, Hiroshige gives Mount Fuji the graphic force equivalent to its importance in the imagination.

Similar liberties are taken with the rules of perspective in the bizarre empty interior at Tsuko no Misaki (page 129). The planes of the walls and roof recede into the distance but are not represented in a consistent way. On one wall the grid of the *shoji* screens remains parallel; on another the grid shrinks toward a point. These inconsistencies have the effect of accentuating the empty open center of the room.

## Composition

Besides the use of perspective, Hiroshige employs a number of other methods to establish an impression of space and distance. Often he picks an unusual, or even impossible, viewpoint: one that includes both foreground and background in a single image, as at Kamata (page 114); or one that offers a bird's-eye view combined with some feature that is actually on the ground. Sometimes he takes a very low viewpoint to the same end. This technique of the engineered viewpoint occurs particularly in his later work, such as the views of Ekoin-ji (page 111) and Asakusa (page 134).

It is not unusual for a distant object to be partly obscured by one nearer at hand. But Hiroshige deliberately orchestrates certain views to make sure this occurs, as a means of establishing a sense of a third dimension, for instance in the view of Kamata.

In some cases he uses the overall composition and design of the print to represent distance: by the use of a

"Seba: Autumn Moon," *from* Sixty-Nine Stations of the Kisokaido *published by Kinjudo in the late 1830s, illustrating boatmen poling against a stiff breeze in the early evening. Brocade print,* oban *size. Courtesy of the Trustees of the British Museum, London.*

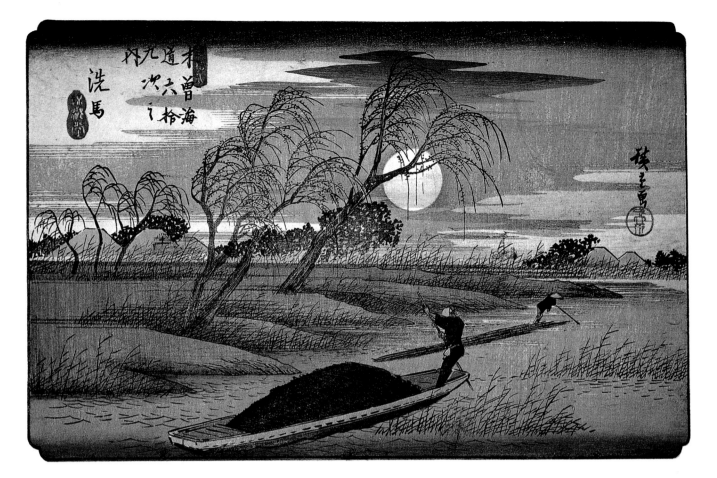

strong diagonal, as in the view of Seba, by a zigzag composition as in the view of Fukagawa (page 139), or by carefully considered curves, as at Okabe (page 85).

One of his favorite techniques, which becomes almost obsessional in his later works, is the use of a foreground feature or features to interrupt or frame a distant image, as in the views of Kanda (page 127) or Hatsune (page 42). The most extravagant example of this stratagem appears in his depiction of the Mannen Bridge (page 117), where the distant view is framed twice—first by the bucket handle, with its dangling terrapin, and second by the rails of the bridge itself.

There is a strong tradition in all Japanese art of conscious and deliberate asymmetry. The great decorative compositions on sliding or folding screens were nearly always composed as complementary pairs. They always offered contrasting compositions: one busy, the other simple; one inclined to movement, the other still; one full of line and detail, the other relatively empty. In the decorative arts, too, motifs, whether on lacquer objects or in the designs for fans, are frequently placed to one side—deliberately at variance with the form and symmetry of the frame or the object being decorated, giving the design a life almost independent of the object.

*A fan from Kyoto, hand painted with a traditionally asymmetrical image of a pine tree.*

This asymmetry is an essential ingredient of the graphic tradition of which Hiroshige is part. It can be found in his *kacho* prints, where foliage on one side may be balanced by a flying bird on the other, and in his landscape prints, such as the view of Hakone (pages 18 and 19), where one side is filled with looming crags and the other a distant horizontal shore.

Japanese writing is traditionally laid out in vertical columns and read from top right to bottom left (although it can also be laid out like Western writing, in rows to be read from top left to bottom right). Pictures, also, were composed to be read from top right to bottom left—suggesting the passage of time or, occasionally, cause and effect. So, the Hakone print implies that the struggle through the mountains will be followed by the ease and calm of the distant landscape, and the teahouse at Futakawa (page 86) is presented as the culmination of the desolate journey across the Monkey Plateau.

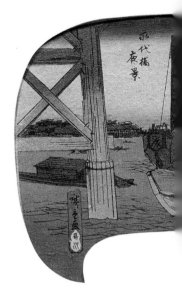

One of the compositional tricks which Hiroshige deploys with great skill is the use of sympathetic forms, or "graphic echoes." In "Timberyards at Fukagawa" (page 139), the diagonal of the leaning planks and poles is repeated on the opposite shore, setting up a rhythm within the picture which leads the eye to the distant waterway. In the rain-swept view of Shono (page 91) the profile of the waving bamboos is repeated again and again like the subject of a fugue, reinforcing the sense of movement and of the unrelenting wind. In "Hatsune Riding Grounds" (page 42), the willow branches all follow the same weeping curve and contrast richly with the taut stripes of the hanging fabric.

The use of shadows and reflections was not among the usual conventions of Japanese art. They are, in any case, difficult to render precisely in the medium of the woodblock print. But when they do occur they have a marked significance. The moonlight shadows of Surawaka-cho (page 131) are a famous instance in which they are used to accentuate the lateness of the hour and the eerie quality of the full moon. The reflections of the maple trees in the lake at the Akiba Shrine (page 64) are also unusual and confirm the special autumnal quality of the image.

Hiroshige's fame arises from many aspects of his art, but one of the most telling is his representation of wind and weather. The streaking rain and lowering cloud at Shono or at the Atake Bridge (page 119) evoke the downpour with startling success. The effects are achieved by a subtle combi-

nation of a very obvious convention (the overprinting of the scene with a mass of fine parallel lines) with an extremely delicate balance in the tone and color of the background. In these great rainscapes the balance is so controlled that the viewer is quite taken in by the convention.

The last, and in many ways the most important, aspect of Hiroshige's art is his choice of subject matter. We have seen how he graduated from the conventional subjects of the Utagawa school—the *bijin*, the *kacho*, the *shunga*, the *kabuki* prints, the illustrations of history and myth—to his own world of the *meisho*, or "famous view," with its emphasis on landscape and topography. In exploring his chosen field, he observes and represents the world about him with a newfound sensibility for the picturesque, for the shapes of mountains and rivers, for the qualities of wind and weather, light and atmosphere, sky and sea.

It is a fascinating coincidence that the same sensibility was emerging in Europe around this time and that it too was propelled in no small degree by poets and writers, such as Wordsworth and Goethe. Although there was virtually no interaction between the cultures of Japan and western Europe at that time, the development of the picturesque sensibility in Japan was also promoted by literary interest. Indeed, other connections between literature and the visual arts in Japan, particularly *ukiyo-e*, were well established—as evidenced by the *surimono* prints for the poetry clubs, the *kabuki* prints illustrating great dramatic and literary moments, and the endless literary allusions, word plays, and visual puns that pervade the *ukiyo-e* tradition.

Hiroshige employs these literary connections too, but in his hands they are not just clevernesses designed to entertain the cognoscenti. They serve more profoundly, to engage the imagination of the viewer at levels other than the purely visual—by reminding him of a scrap of poetry or a piece of myth or history that illuminates the scene portrayed. Examples are plentiful and can be found in the commentaries accompanying virtually every print illustrated here. Some of the most subtle and sonorous occur in the last great series of Hiroshige's career, *One Hundred Famous Views of Edo*. In this, as in every other aspect of his art, we see Hiroshige deploying every possible technique to engage the viewer and draw him into his own world of images and memories.

*"**Night View of the Eitai Bridge**" shows two ladies in a small pleasure boat heading out between the pillars of this last bridge on the Sumida River into Edo Bay. Hiroshige's lozenge emblem decorates the paper lantern. A little ahead is a similar boat with the blinds lowered for privacy. Fan print,* uchiwa-e *size. By Courtesy of the Board of Trustees of the Victoria & Albert Museum, London.*

# THE CITY:
## "One Hundred Famous Views of Edo"

In 1857, at the age of sixty, Hiroshige had renounced the world and become a Buddhist priest. He had just begun what was to be the last print series of his life. It is almost as though he were aware that this would be the summation of his artistic career for, just as his first great series, *Fifty-Three Stations of the Tokaido*, which had marked his debut as an independent artist twenty-five years earlier, this series marks a new departure in his artistic development.

This new project was to be a series of one hundred views of Hiroshige's home city of Edo. In the Chinese-derived tradition of *meisho* (famous views) the prints of this series also reflect the seasons of the year, although they were not produced in any strict order.

It seems likely that the images were selected in collaboration with the publisher, Uoya Eichiki, and passed to the engravers and printers in a fairly haphazard sequence over a period of roughly two years, and arranged in their seasonal groups only after Hiroshige's death.

The format for the series is the standard *oban* size, but, unusually for a series of topographic views, it was to be laid out vertically (portrait format) rather than horizontally (landscape format). Thus the images were restricted in width, encouraging the use of the cut-off marginal features that Hiroshige (and other artists) clearly relished as a form of artistic challenge. The views had to be extended at top or bottom to fill the block, giving rise to many ingenious and evocative compositions. In fact, Hiroshige frequently exploits the extra height of the image to develop an additional sense of distance: by the use of superimposed images for foreground, middle ground, and background; or by developing wonderfully extended sky-scapes in the upper part of the print.

He had inherited the convention of the landscape print

*Baisotei Gengyo, "Title Page for One Hundred Views of Edo," dated the ninth month of 1858—a month or two after Hiroshige's death—listing the full 118 titles of the series in a sequence based on the seasons of the year. The red title block (lower left) reads like a theater advertisement: "Ichiryusai Hiroshige, Grand Farewell Performance; One Hundred Famous Views of Edo," followed by the publisher's name and address: "Uoya Eichiki of Ueno, Hirokoji." Uoya means "fishmonger," giving rise to a number of fish references in the series. Brocade print, oban size. Courtesy of the Trustees of the British Museum, London.*

> *"After ten autumns In Edo, my mind Points back to it As my native place."*
>
> BASHO

from Hokusai and others of the previous generation, but he had since made it his own in the several richly evocative series on the great roads and famous places of Japan. In this new series, he stretched the convention to include even more varied subject matter, including ever more evocative and witty associations. The subject matter of the views always engages some special seasonal event, or ancient story, associated with the place portrayed.

He also uses a broader range of compositional types, some taken from very different print design traditions. In a number of instances, he combines the conventions of the landscape view with those of the *kacho* bird-and-flower print, with a plant or other feature arranged in close-up to frame, or even block, a more distant view. He develops this compositional technique to quite a remarkable degree, using other highly exaggerated foreground features, such as the drum tower of Ekoinji (page 111) or the turtle at the Mannen Bridge (page 117). In other prints, in a similar way, he chooses to cut a feature off with the margin.

As in Hiroshige's previous work, this set of images is full of careful and loving observation of the natural world. Birds, mammals, and the full variety of trees, plants, and flowers that enrich the Japanese landscape are faithfully portrayed.

But, despite the richness of subject matter, imagery, and allusion, we can sense Hiroshige gradually withdrawing from the world, and particularly from his fellow men. Very few of the images contain full-size figures, and the small figures that do populate many of the scenes, often have their faces hidden, or turned away, from the viewer. Hiroshige has put the gentle humor of his caricature faces behind him. Now he looks down, as if with Olympian detachment, on the foibles of everyday life. Hiroshige's fond regard and deep sympathy for his fellow men remains, but he is no longer among them. He knows their habits and desires but no longer shares them.

This melancholic flavor pervades the series, both in the general views of distant mountains or glittering skyscapes, and in the more intimate portrayals of narrow canals or domestic interiors. With hindsight we know that Japan was just about to open its doors to the rest of the world and embark on the irreversible changes of the Meiji Revolution. This gives a special poignancy to this final portrayal of the great city of Edo.

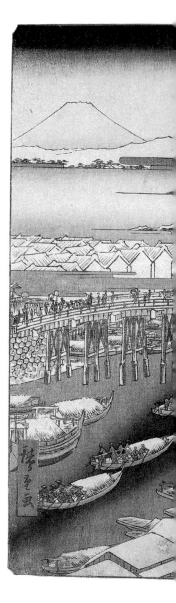

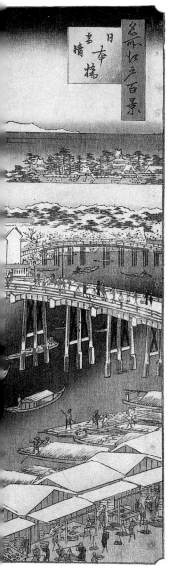

## *Nihon-bashi: Clearing After Snow*

As in Hiroshige's series of views of the great roads, this valedictory collection starts with a majestic view of Nihon-bashi, the "Japan Bridge," the notional starting point for every great journey from Edo (left and page 15). But this view also includes other iconic images. In the distance is Mount Fuji, the sacred mountain of Japan, some sixty miles (one hundred kilometers) from the city, but clearly visible from it on a clear winter morning. Nearer at hand, but separated from the city by stylized cloud-bands, are the towers, gardens, and walls of the *shogun*'s palace, symbol of political power and of the peace and prosperity of the nation. In the middle distance are the white-painted fireproof rice stores that symbolize the wealth and health of the city. Nearer at hand, the river is full of boats of all kinds, sea-going cargo ships from Osaka and other distant ports, barges for carrying goods around the maze of waterways that crisscross the city, the light skiffs of the local boatmen, and, in the center of the river, the fishing boats, being energetically rowed for lack of a breeze on this still winter's morning, racing to bring the freshest of the morning catch to market. Finally, in the immediate foreground is the fish market itself, where the wealth of Japan's richly stocked coastal waters is laid out temptingly on the stalls, and immense tuna (one requiring a pair of porters) are being carried off to the restaurants and homes of the city.

Today Nihon-bashi is familiar to most Tokyoites as one of the central interchange points on the Metro system. Although there is still a bridge over the canal, it has been rebuilt in the European style of the Meiji era. It is now dwarfed by one of the elevated highways that follow the canals of Edo—one of the few areas of modern Tokyo unoccupied by buildings.

*Nihon-bashi today, overshadowed by the expressway snaking through central Tokyo.*

## Hibiya and Soto-Sakurada from Yamashita-cho

At first glance this is a straightforward and characteristic view at the heart of the city. On the right is one of the bastions in the great wall that encloses the *shogun*'s castle, the surrounding moat dotted with gulls sheltering inland from the winter storms. Beyond is the facade of one of the great *daimyo* residences, that of the Nabeshima clan from Saga, rated at 350,000 *koku* of rice per year. Over its roofs can be seen more of the city, dotted with the fire-watch towers familiar from Hiroshige's hereditary employment. On the skyline is the distant reassuring profile of Mount Fuji.

But today is the New Year holiday. The sky is filled with kites, one caught cheekily in the stately pines of the *shogun*'s gardens, a second tangled in its string, a third sporting a pair of red-stockinged legs. And just offstage, to right and left, are children playing the traditional New Year game of Shuttlecock and Battledore.

Today Hibiya Park provides similar recreation for Tokyoites. But the neighboring *daimyo* residences have been replaced by the skyscrapers of the great banks and businesses (left).

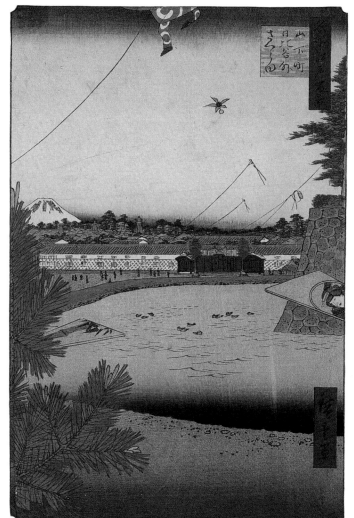

**"Hibiya and Soto-Sakurada from Yamashita-cho,"** 1857. *A view of the moat of Edo Castle on New Year's day. Number 3 of* **One Hundred Famous Views of Edo.** *Brocade print,* oban *size. The Whitworth Art Gallery, University of Manchester.*

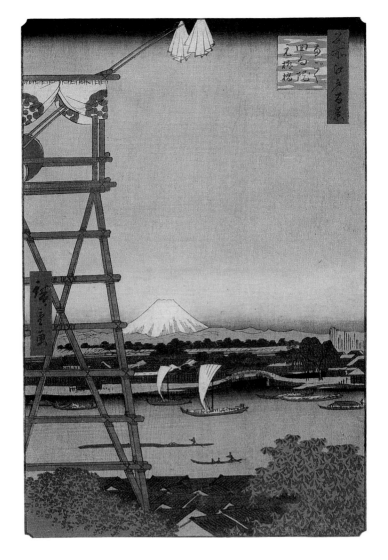

## *The Ekoin-ji at Ryogoku and the Moto-Yaniga Bridge*

Here again is a view toward Mount Fuji, but this time from across the Sumida River. Several vessels head south—a variety of barges, a log raft, a skiff or water taxi, and two heavily laden sailing craft traveling upstream to the morning markets or down for a day's voyage out at sea.

The scaffold tower that fills the image on the left is draped in the characteristic manner of a *Shinto* shrine—in this case the Ekoin Shrine, on the eastern side of the river. The tasseled staff and drum announce that a *sumo* wrestling match, traditionally held in the temple precincts on this less commercial side of the river, is to take place today.

There is still a shrine at Ekoin, but the *sumo* wrestling matches which attract audiences of ten thousand and more, take place in the modern Kokugikan, a few minutes' walk to the north.

## Bakuro-cho: Hatsune Riding Grounds

This open space quite close to the center of the city (page 42), had once been a practice ground for the *shogun*'s mounted retainers. In Hiroshige's time it was used as a drying ground by the fabric-dyers of Kon'ya-cho.

An otherwise ordinary view is given extraordinary strength by the four swathes of cloth that swing across the composition. Behind them the willows are just in bud and various figures go about their business, three dogs play, and a fire-watch tower rises above the roof, with its warning bell hanging from the projecting eaves.

## Suruga-cho

Here we have the commercial heart of the city, a couple of blocks from the Nihon-bashi. This street, carefully aligned on a distant view of Mount Fuji, is flanked on either side by the stores of the great trading house of Mitsui.

In the street are many typical figures of the city: a group of retainers on horseback, groups of ladies out shopping, porters with bales of goods or baskets of fish to be delivered from the store, and a single *samurai* identifiable by his swords and generous green trousers, followed by his servant.

The house of Mitsui still occupies the right-hand side of these sites, now the Mitsui bank building. On the left today is the Mitsukoshi department store, one of the largest and most prestigious in Japan, where the fashionable ladies of the city go shopping in just the same way as they did 150 years ago. The view of Mount Fuji is now sadly obliterated by an undistinguished office block.

## Ueno: Kiyomazu Hall and Shinobazu Pond

Here we are a mile or so north of the center of Edo (page 52), in what remains to this day as Ueno Park, one of the city's favorite recreation places.

This is the first of the views of springtime, and we are perched above the cherry blossom, looking down on the pond as if from Kiyomizu Hall. Built in 1631, the hall was designed to emulate the famous elevated temples of Kyoto, lending imperial grandeur to the *shogun*'s new capital. In the middle distance is a well-known oddity, the aptly named "moon-pine" tree.

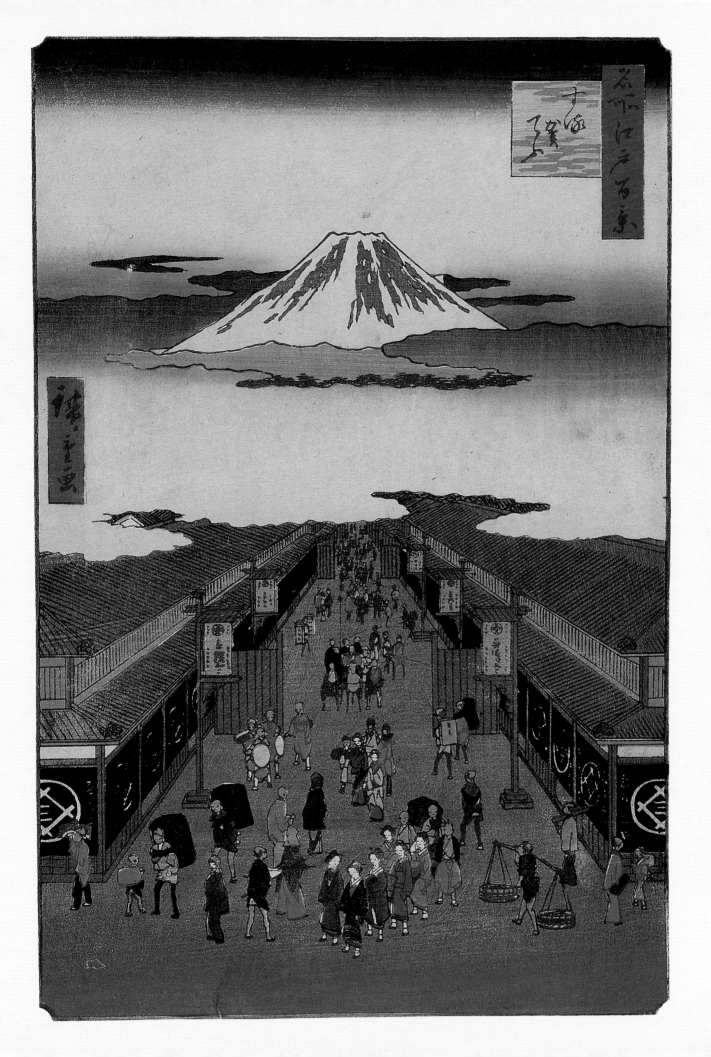

## Kamata: The Plum Gardens

Some distance to the south of the city were the Kamata plum orchards. The plums were cultivated not so much for the elegant blossom we see here as for the plums themselves, which were (and still are) very popular preserved in brine or made into a plum cordial, which was well known as a cold cure.

This is a most mysterious print, starting with the delicate pink of the sky. The composition, too, is very odd. The intruding construction on the right, cut through by the margin in Hiroshige's characteristic manner, is in fact a sedan chair, of a simple open type with a woven straw roof known as a mountain palanquin. It hangs in the air without any apparent support, as though the bearers had been erased from the print. A surreal sense of unease is reinforced by the way in which all the memorial stones (which were an important feature of the garden) are obscured by the trunks of the trees. Both these oddities, however, serve to give the print a remarkable sense of the third dimension; the perspective of the palanquin leads into the distance, and the obscuring of the memorial stones stresses the sense of space and of possible movement between the trees.

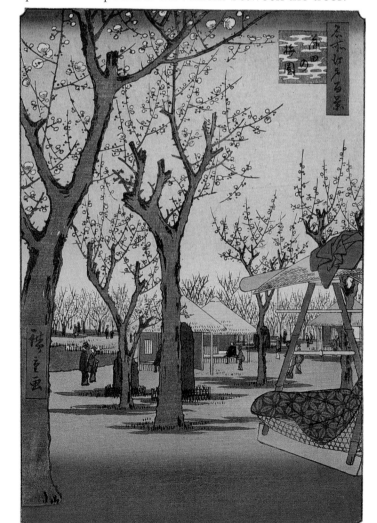

"Kamata: The Plum Gardens," 1857. *Number 27 of* One Hundred Famous Views of Edo. *Brocade print,* oban *size. Courtesy of the Trustees of the British Museum, London.*

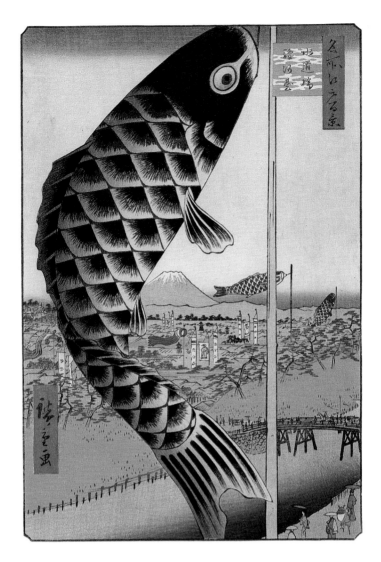

### Suido Bridge and Surugadai

We are back in the city again, on the northern side of Edo
Castle, which can just be seen by the left-hand margin,
looking westward to Mount Fuji over a part of the city
largely inhabited by *samurai.* Sprouting from the roofs are
a variety of banners and two streamers of the type used in
*samurai* and *daimyo* processions. They are celebrating the
Boys' Festival (*Bo'on*), on the fifth day of the fifth month
(early May).

The monstrous fish that dominates the composition cel-
ebrates the same festival but is the emblem adopted by the
*chonin,* or townspeople, as distinct from the *samurai* and
ruling class. The fish leaping upstream was a well-known
symbol for the tireless vigor of young manhood. Note that
the form and detail of the fish are precisely those of page
68. Hiroshige has made no effort to represent the fish as the
kite or wind sock that it actually is but as a live fish—
straight from his collection of established images.

*"Look with what
power the carp
Ascends the
stream; no
wonder
They say he
becomes a
dragon
Among the
clouds."*

115

## Oji: The Fudo Waterfall

Much farther north of the city, in the valley of the Shukiji River, we are in a secret and holy place marked by the sacred tasseled rope slung between two trees. The Shojuin Temple nearby was dedicated to a Buddhist deity called Fudo, always represented wreathed in flame and carrying a naked sword—an image evoked by Hiroshige's startling representation of the falling water.

In the foreground, a man is bathing. Another is being served tea by the lady who attends the shrine. A pair of well-dressed ladies are admiring the scenery.

Despite its apparent simplicity, this is a highly sophisticated image in both composition and printing technique. Note its carefully balanced asymmetry: the *bokashi* shading emphasizing the weight of falling water and the likeness to a naked sword; the colors changing subtly from forest green at the top through a series of lighter greens to the yellows of the adjacent cliffs; the exposure of the wood grain and the rubbing marks of the *baren* in the gray block of the foreground.

"Oji: the Fudo Waterfall," 1857. *Number 49 of* One Hundred Famous Views of Edo. *Brocade print,* oban *size. Courtesy of the Trustees of the British Museum, London.*

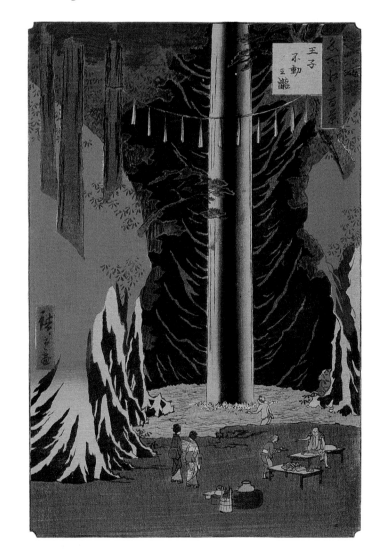

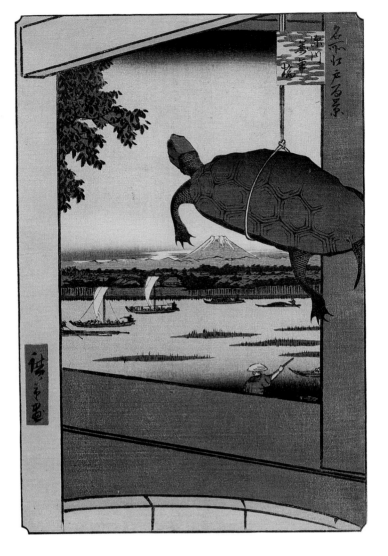

"Fukagawa: The Mannen Bridge," 1857.
*A terrapin offered for sale and a view of Mount Fuji, Number 56 of* One Hundred Famous Views of Edo. *Brocade print,* oban *size. Courtesy of the Trustees of the British Museum, London.*

## *Fukagawa: The Mannen Bridge*

This, one of the most extraordinary compositions in the series, combines a number of puzzling foreground features with an idyllic landscape view. Hiroshige is a master of the simple realization that a place is characterized both by what is there and what you can see from it. Nearest us and framing the scene on three sides are the handle and rim of a wooden bucket. From the handle dangles a turtle. Beyond it, the balustrade of the Mannen Bridge frames a view across the Sumida River to a dazzling sunset behind Mount Fuji.

The turtle is a symbol of longevity in both Japan and China. Both it and the eternal Mount Fuji refer to the ten thousand years (*man-nen*) of the bridge's name. Turtles may well have been offered for sale hanging in this way from bucket handles. To release them was regarded by Buddhist teaching as a way of improving your chances for enlightenment. They may also have been sold to eat.

The drawing of the turtle is repeated from Hiroshige's stock of well-established images (page 67).

## Ohashi: Sudden Shower over Atake

This, one of the most famous of all Hiroshige's images, illustrates an all-too-frequent and characteristic scene in high summer—the moment in mid-afternoon when the muggy heat finally breaks into a sudden torrential downpour. The sky blackens, the distant view dissolves in murk, and the streaking rain fills the frame. A pair of elegant ladies and a number of bare-legged men have been caught unawares in the middle of the New Bridge (*Shin-Ohashi*), one of the long bridges that span the Sumida River. The entire scene tilts as each head is lowered against the squall. The characters on the bridge crouch under umbrellas, huddle under straw capes, or rush, without protection, for the nearest roof. Only the lone poler of a log raft heading for the timber yards of Fukagawa is unmoved. He is resigned to a soaking, for there's nothing he can do to avoid it, or hasten his arrival.

All the printer's technical armory is displayed: the billowing black *bokashi* of the clouds (which differ markedly from print to print); the two blocks that represent the rain with their infinitesimally thin lines in slightly differing grays; and the rubbing marks of the *baren.*

As with so many of Hiroshige's masterpieces, this print represents not just the view, but also the atmosphere, and mood of the viewer.

*"Long rain of May, The whole world is A single sheet of paper Under the clouds."*

SOIN

"Ohashi: Sudden Shower Over Atake," 1857. *Number 58 of* One Hundred Famous Views of Edo. *Brocade print,* oban *size. Courtesy of the Trustees of the British Museum. Another impression of the same print (left) shows a marked coarsening of the coloring and simplification in the application of* bokashi *shading to the lowering clouds, the roadway of the bridge, and the water under it. Brocade print.* oban *size. The Whitworth Art Gallery, University of Manchester.*

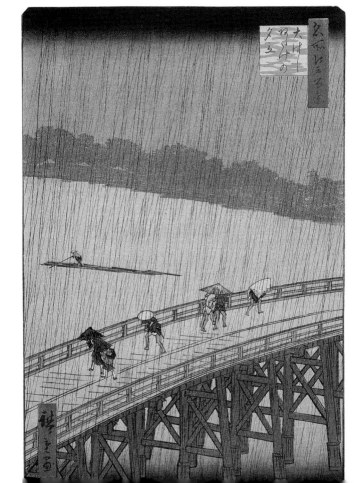

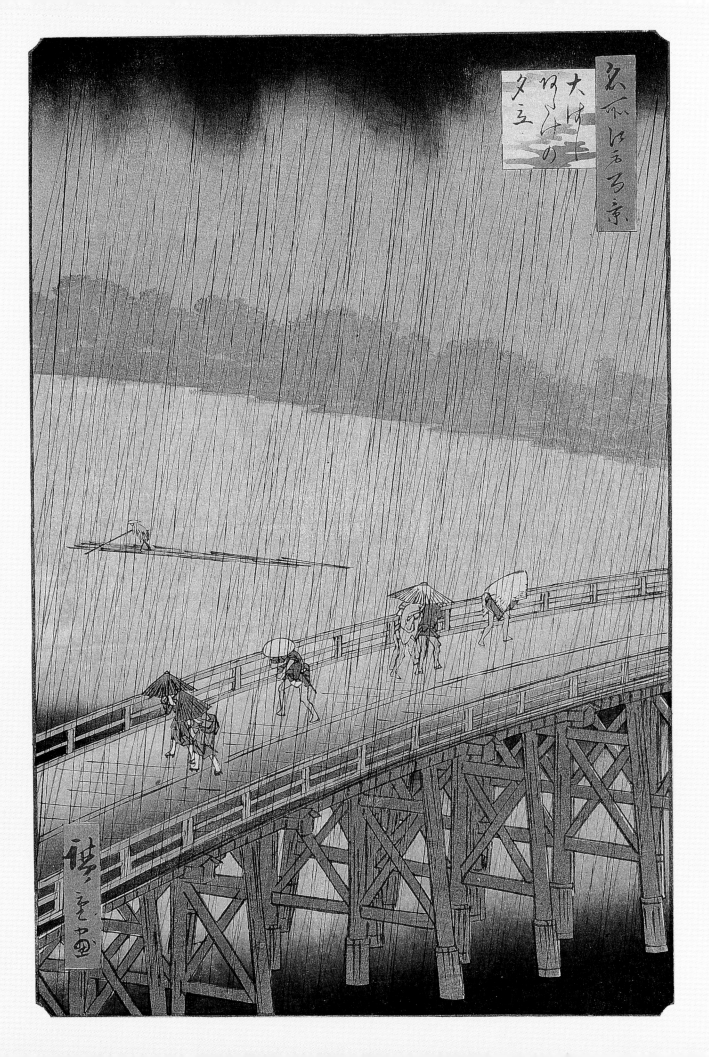

## Ryogoku Bridge and the Great Riverbank

The Ryogoku Bridge was the oldest of the four bridges across the Sumida River, built in the early days of the Tokugawa shogunate to permit the expansion of the city to the east. It was renowned as one of the busiest, being a center of recreation and entertainment, with teahouses, theaters and a great variety of stalls on either bank, which can be clearly seen in the foreground of this print.

Hiroshige uses a Z-shaped composition to establish the width of the river and the length of the bridge—each of its abutments falling outside the frame. At the same time this provides a generous field on which to display an interesting variety of watercraft: seagoing cargo ships on the last stretch upriver, the nearest lowering its sail in preparation for landing; a couple of cargo lighters taking goods farther upriver; two water taxis; a pleasure boat, with its little roofed enclosure.

## Ryogoku Bridge: The Fireworks

The fireworks at Ryogoku Bridge were a traditional entertainment, sponsored by the restaurants along the bank on either side. In earlier years, the displays took place only at

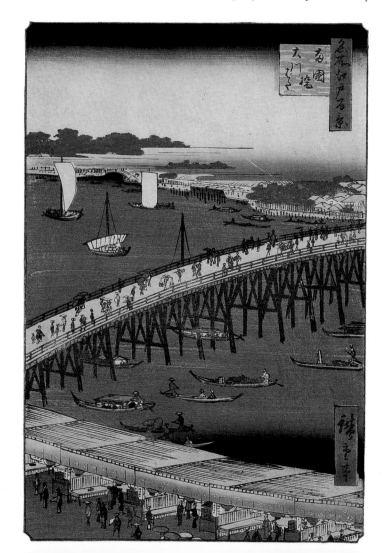

"Ryogoku Bridge and the Great Riverbank," 1856. *Number 59 of the* One Hundred Famous Views of Edo. *Brocade print,* oban *size. Courtesy of the Trustees of the British Museum, London.*

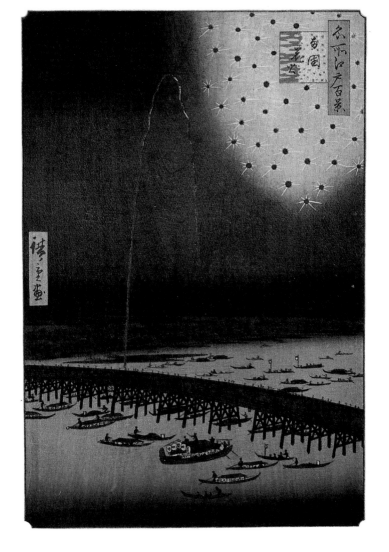

particular festivals, but by Hiroshige's time they were a fairly frequent feature of the warm fall evenings. The fireworks were clearly enjoyed by the populace in general, many of whom took boat parties out on the river in the balmy evenings. In the foreground is a great variety of vessels, from the "palace boats," of a type still available on the Sumida River for large parties, down to the single skiffs, not unlike the gondolas of Venice, for more intimate groups.

Hiroshige uses a subtle range of colors to achieve the necessary contrast between the darkness of the night and the glitter of the fireworks—which is further enhanced in certain editions of this print with a sprinkling of powdered mica.

The fireworks he illustrates are a type of multiple aerial shell which are fired from a barge in the middle distance and explode about 200 feet in the air, filling the sky with a multitude of white starbursts, like a luminous snowstorm.

As a final touch, the cloud-band design, which appears in the title cartouche of most of the other prints in the series, breaks up in a crackling pattern, evocative of the sound of the exploding shells.

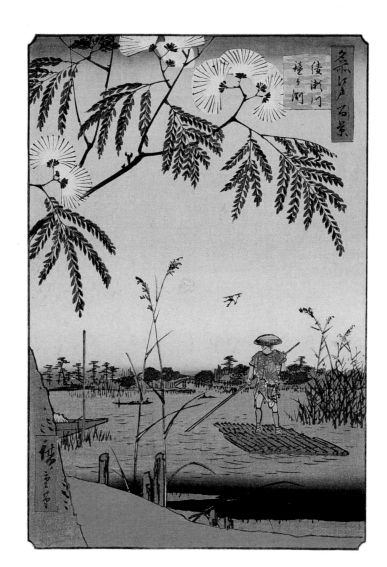

"Ayase River and Kanegafuchi," 1857. *Silk trees and lumber raft, Number 63 of* **One Hundred Famous Views of Edo.** *Brocade print,* oban *size. Courtesy of the Trustees of the British Museum, London.*

## Ayase River and Kanegafuchi

This is one of a number of prints with a plant in the foreground in which Hiroshige deliberately combines the convention of the *kacho* bird-and-flower print with the more recent landscape print tradition. The plant in this case is the silk tree (*nemunoki*), which is shown with its feathery flowers in full bloom. The print carefully reproduces the free brushwork of the branches with two blocks of slightly different grays.

We are looking across the Sumida River some way upstream from the city, at its confluence with the Ayase River, which enters under the bridge opposite. The river is a solid blue with dark *bokashi* margins, reminding us that this is a notoriously deep section, where a temple bell is said to have been lost. In the middle ground, a lightly clad waterman is poling a raft of logs, probably expecting the current to take him downstream to the timber merchants' wharves in the city. An egret, startled by his approach, rises in the still summer air.

## *Horiki: The Iris Gardens*

Another exquisite rendering of plants dominates this print like a seasonal flower study, dependent for its effect on the elegance of the drawing and the exquisite *bokashi* coloring technique on the flowers themselves.

However, this is in fact a specific view of the gardens some distance northeast of the city, where a great variety of irises (*hanashobu*) were cultivated for commercial distribution, both as cut flowers and as plants for cultivation. They were carefully developed and interbred to create new varieties and colorings. Some were even exported to foreign parts and found their way in due course to Europe, where they are now familiar garden plants.

This was a popular spot for sightseeing in the flowering season, offering a pleasant trip up the Sumida River to these open marshes away from the crowds of the city and the opportunity to buy plants or cut flowers for use at home. A few elegantly dressed ladies can be seen making their way along the banks between the paddies where the flowers grow.

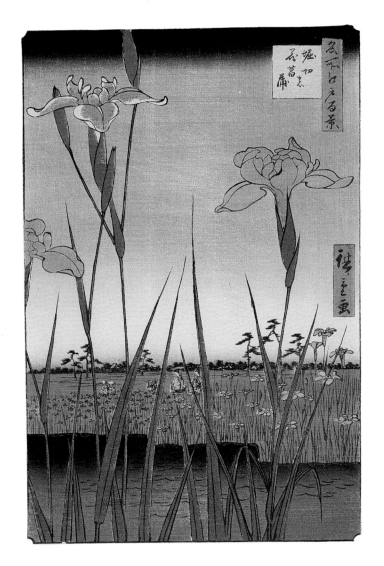

"Horiki: The Iris Gardens," 1857. *Number 64 of* One Hundred Famous Views of Edo. *Brocade print,* oban *size. Courtesy of the Trustees of the British Museum, London.*

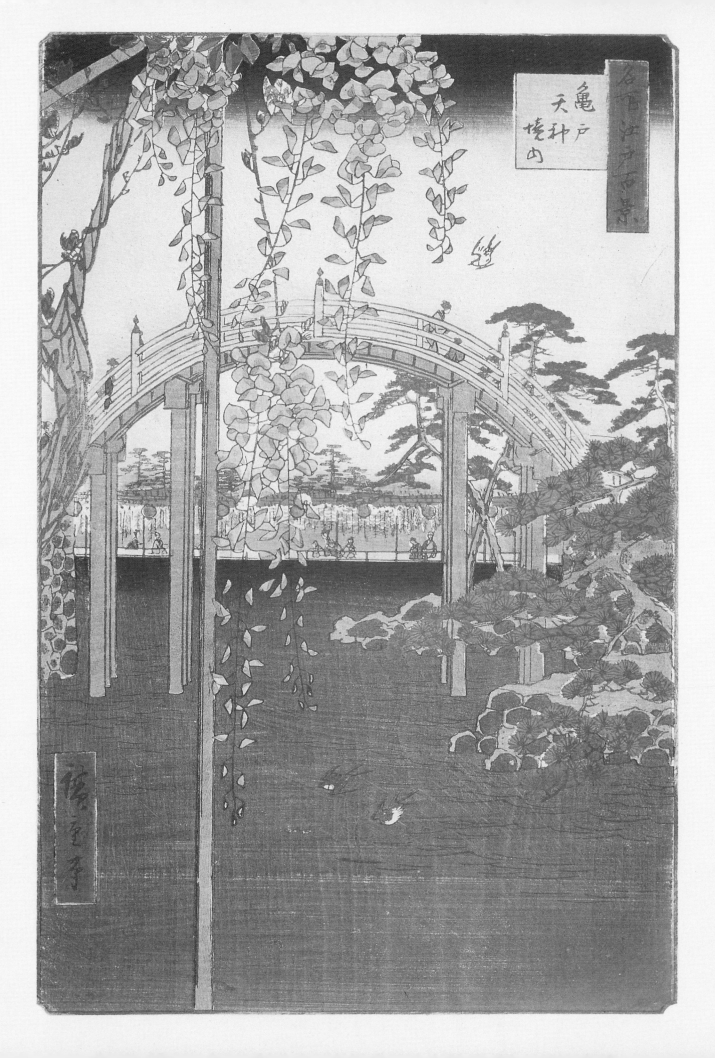

## *Kameido: Inside the Tenjin Shrine*

Here is another *kacho*-style study, this time illustrating wisteria and swallows. Again, this is a specific location: the shrine and gardens established to the east of the Sumida River in the 1660s as part of the early expansion of the city.

This particular wisteria was famed for the length of its drooping cascades of blossom, which extend virtually the whole length of the print. Behind is the lake, The Drum Bridge (*taiko-bashi*), and the viewing platform at the far edge of the lake, where tea is served to visitors, while they enjoy the view. The traditional shape of the Drum Bridge stresses the sense of leap across the water at the expense of practicality and comfort. A number of girls are teetering down its steep sides, probably on their high outdoor clogs (*geta*), amid much giggling and merriment.

The scene remains much the same today, although the tea stall is more garish and the giggling schoolgirls on the bridge are dressed in Western blouses and skirts. But their citified high-heeled shoes doubtless cause as much trepidation as the clogs of their forebears 150 years ago.

This image of the bridge and flowers over water is, of course, universal in its appeal and reappears in the hands of other artists and cultures, as evidenced by Monet's visions of his lily garden at Giverny.

Claude Monet **"The Water-Lily Pond."** *Monet (1840–1926) built this bridge in the garden of his home at Giverny specifically to evoke this* japonnaise *image, reminiscent of Hiroshige's view of the bridge at Kameido and many others. The National Gallery, London.*

## The City Flourishing at the Tanabata Festival

This is the only print in the whole series without a title identifying the location (see cover illustration). However, from the relationship between the darkened cone of Mount Fuji and the turrets of Edo Castle, it is evidently a view looking west, taken from a point a little south of the commercial heart of the city. In the middle distance is the fire-watch tower of the Yayosu Barracks, where Hiroshige was born. In fact, this is, in all probability, the view from Hiroshige's own house and studio at 9-7 Kyobashi 1-chome, where a memorial plaque can still be seen.

It is the first day of fall, the seventh day of the seventh month, the hottest season of year, but a merry breeze is blowing. The festival named in the title celebrates a Chinese myth in which a weaving girl (personifying the star Vega) meets a cowherd (the star Altair) across a river (the Milky Way). This was originally a harvest festival, but in the city of Edo it was celebrated with more urban images, in particular a harvest of poems and calligraphy offered to the heavenly lovers.

Bamboo branches, mounted on the roof of every house, were hung with a variety of objects. We can see the colored slips of paper inscribed with poems and cutout paper fish-nets, representing the harvest of the sea. There are also a *sake* cup and gourd, an abacus, a ledger, a money chest, fruit and nuts, fish, streamers, and a slice of watermelon—items celebrating the tastes and activities of the occupants of each house.

The pole attached to the balcony or framework on which we are perched carries a gourd and *sake* cup, the emblems of a man who enjoys his drink. And in the bottom right-hand corner we can just see part of a blue-and-white *yukata,* the traditional cotton night garment hung out to air—quite probably Hiroshige's own.

## Kanda: The Dyers' District

Here, to an even greater degree than in perhaps any other print in this series, the foreground features emerging from the margin virtually fill the print. These are the drying racks of the dyers' quarter, still so named and used today, hung with the typical narrow bands of fabric that were used variously as towels and headbands. In their simplest version they are white with designs in blue indigo dye. The designs

on the bands on the right are the fish character of "Uoei", the publisher of this series, and Hiroshige's own lozenge-shaped mark, familiar from a number of other prints.

The cloth-and-fabric theme of this print is pursued in a number of less obvious ways. The printing includes the use of a fabric texture (*nunomizuri*) on the background of the fabric strips, and the title cartouche is filled with a typical fabric tie-and-dye pattern rather than the cloud-band design that occurs in a variety of color combinations in most of the other prints of the series.

In the background can be seen the unmistakable profile of Mount Fuji, and, slightly closer at hand, the turrets of Edo Castle. Hiroshige certainly knew a very similar scene in Hokusai's series of views of Mount Fuji in which a hooked pole in the hands of an unseen dyer reaches up to detach a length of fabric.

The remarkable strength of this composition depends on the play of the horizontals, of the drying racks and the distant horizon, against the verticals of the hanging cloth, disturbed only by the wafting of the breeze.

"Kanda: The Dyers' District," 1857. *Number 75 of* One Hundred Famous Views of Edo. *Brocade print,* oban *size. Courtesy of the Trustees of the British Museum, London.*

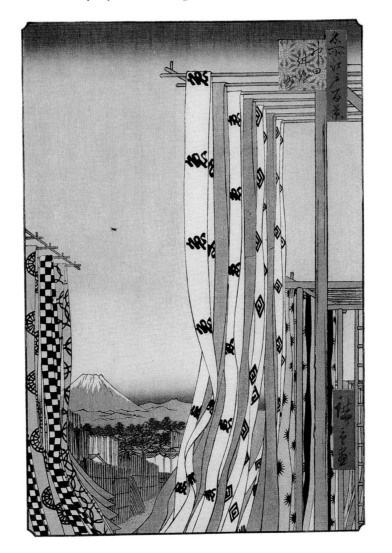

## Kyobashi: The Bamboo Yards

Bamboo is one of nature's strongest and most flexible materials. It is used all over the world for everything from shopping baskets and fishing rods to bridges and house structures. Many varieties of bamboo are indigenous to Japan, and it was (and is still) extensively cultivated as an extremely important and versatile raw material. It was brought into Edo on the rafts that are a familiar feature of this series (page 122) and stacked in the yards near Kyobashi—the Bamboo Bridge—pictured on page 144, which is on the Tokaido highway just south of its start at Nihon-bashi. It too boasts decorative bronze knobs on the rail posts.

It is early evening, and a party of pilgrims carrying festive staffs is crossing the bridge. The full moon tells us that they are probably returning from Mount Omaya, where a festival was held at the full moon during the seventh month of the year. On the lantern that precedes them appears the name of the engraver of the blocks for this print and others in the series. A blockmaker's mark quite often appears beyond the margin of a print, along with the censor's seal and date. This is one of the few occasions in which the block-maker's name appears as part of the image. The reason for this rare exception is that the engraver's name can be read as "bamboo"—like the name of this view.

## Tsuki No Misaki: The Moon-Viewing Point

Even by the standards of this most unusual of Hiroshige's series, this is a very puzzling picture—the image is almost entirely occupied by the virtually empty floor of a room overlooking Edo Bay. In the distance a number of large boats lie at anchor, while smaller ones return to harbor under sail or paddle. A chevron of geese trails across the full moon.

The remains of a meal are scattered about the floor and on the balcony in the foreground: two *sake* flasks (doubtless empty), a tray of used dishes, a washing bowl, a fan, chopsticks, and a pedestal lamp. Just visible behind the screen at the right, the hem of a garment, the neck of a *samisen,* and the box in which it is being put away. To the left, the skirt of an elaborate *kimono,* and the shadow of a courtesan's coiffure all suggest that a party is coming to an end—or at least a turning point.

*"...that is how you must look at Japanese art: in a very bright room, quite bare and open to the country."*

VINCENT VAN GOGH

"Tsuki no Misaki: The Moon-Viewing Point," 1857. *An evening view over Edo Bay, Number 82 of* One Hundred Famous Views of Edo. *Brocade print,* oban *size. Courtesy of the Trustees of the British Museum, London.*

The key to this image lies in a print published a year before in which the same scene appears with the party in full swing, with the principal guest, two *geisha*, another musician, and the courtesan. Whether the guest has left, and this is another of the *One Hundred Famous Views of Edo*'s melancholy farewells, or whether the guest has just slipped out for a moment before enjoying the company of the courtesan in private, we shall never know.

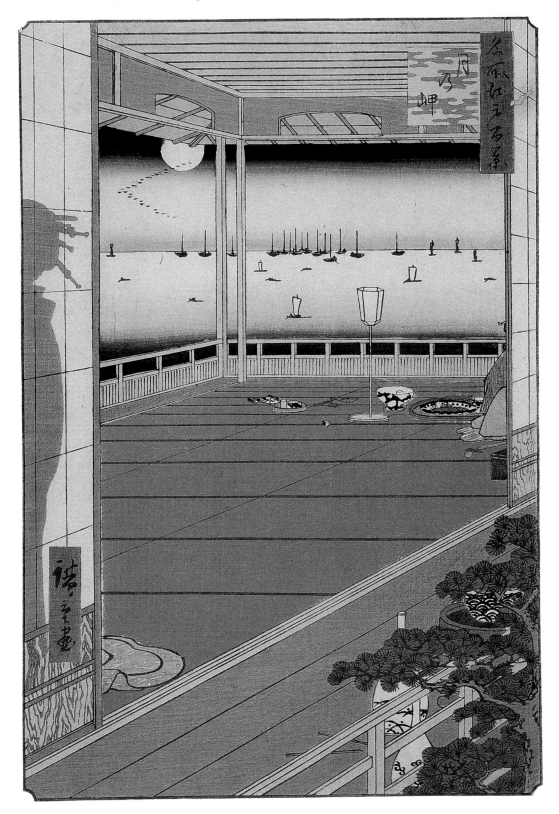

## Surawaka-machi: A Night View

Here is another full moon, this time at the northern end of the city in the licensed theater district, easily identified by the stacks of fire buckets and the gridded frames on the roofs, which would have been decorated with banners were the theaters active. In fact the theaters are closed. It is the eighth month, and the autumn season does not begin for a couple of weeks. There are no placards outside advertising the plays and the actors. The traffic in the street is light, and the ladies in the teahouses on the left are having some difficulty in encouraging customers to step in. It is, after all, evening and most of the traffic is homeward bound.

Hiroshige had depicted this scene many times before, but always alight with activity and color. Again we have an image of melancholy farewell, as though Hiroshige knew it would be his last visit. This melancholia is enhanced by the subtly graduated sky, with its delicate smudge of cloud across the moon, and by the limited range of colors, and the stark shadows—a feature which rarely appears in Japanese prints, and may have been picked up from an increasing knowledge of Western art.

## Ukeji: Inside the Akiba Shrine

We are in the gardens of the Akiba Shrine in early fall (page 64). The maple trees have come into full color, which, with that of the autumnal sky, is reflected in the water. This use of reflections is most unusual in Japanese art. As with the shadows in the previous print, it illustrates the growing knowledge of Western artistic conventions—ironically at the very moment when the Impressionists in Europe were beginning to look for alternatives to that convention.

This print illustrates other differences between the artists, of Japan and Europe. In the foreground at bottom left—the point to which the composition conventionally leads—is an artist, in characteristically Japanese pose, drawing this idylic scene from the vantage of a shaded pavilion. We can imagine that it is Hiroshige himself, and that he may be making the preliminary drawing for this very print.

By following the general intent of the prints of this series, we can interpret his mood—from the composition, subject matter, and coloring. This is a picture of the calm delight and resignation of the mature Hiroshige in this mellow autumnal landscape.

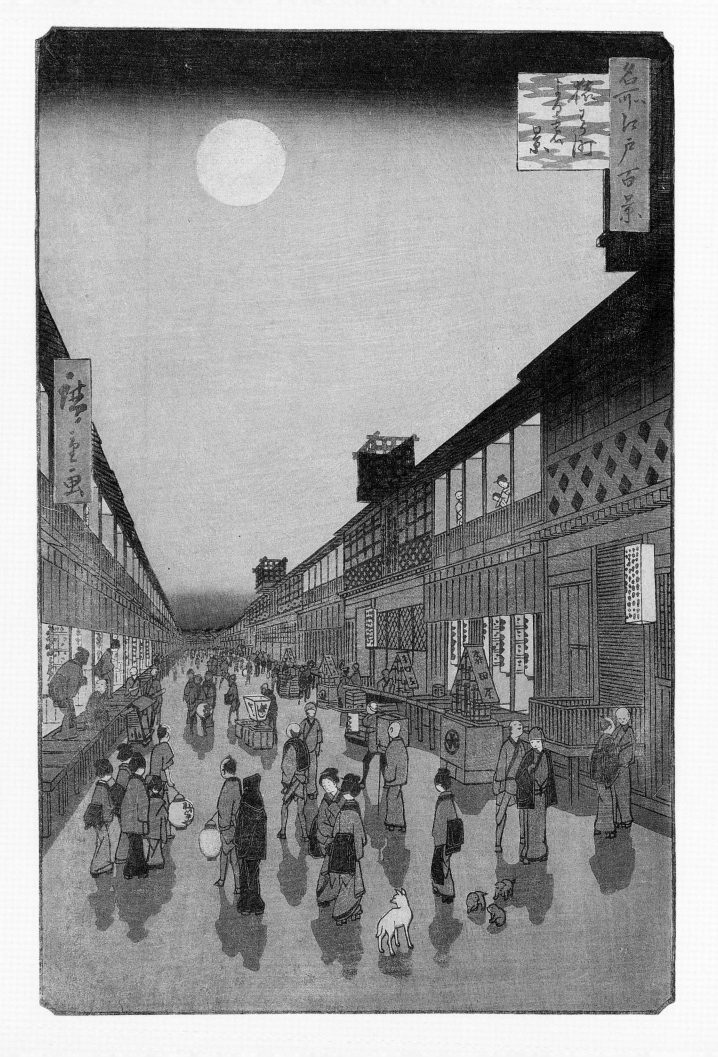

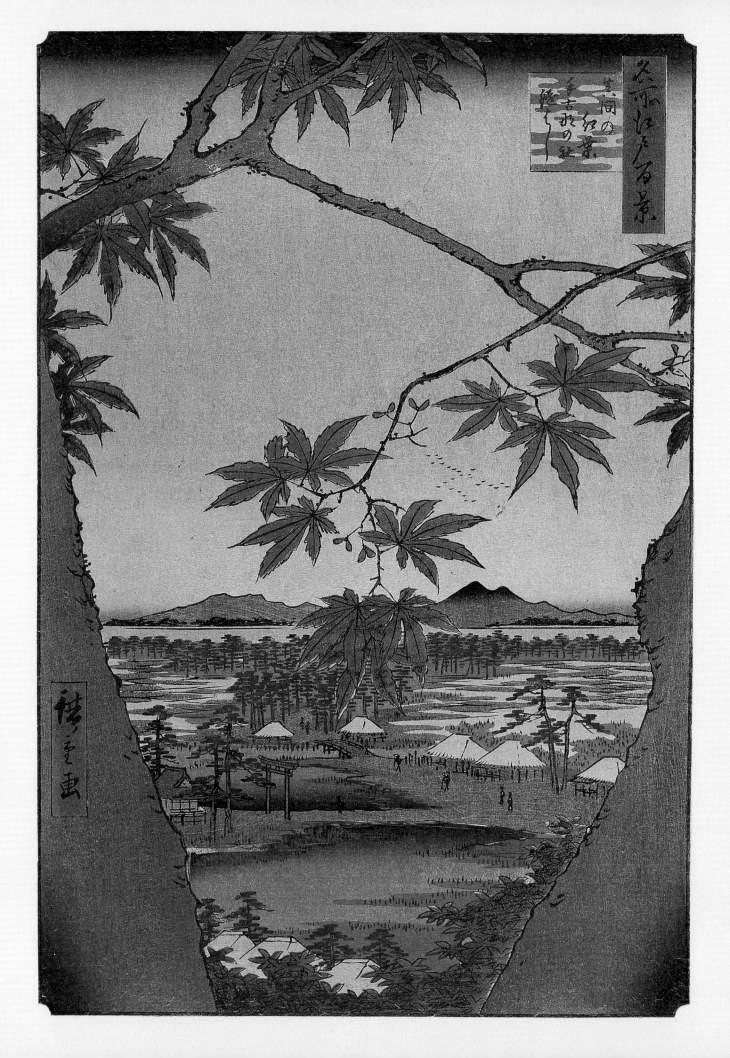

## Mama: The Maple Trees, the Tekona Shrine, and Linked Bridge

Here is yet another image dominated by a close-up view of a plant, this time the foliage of the Japanese maple, whose rich purplish brown is the very archetype of autumnal coloring. The original maple tree at Mama had not survived to Hiroshige's time, but it was nevertheless a popular destination for outings in the fall to see its progeny. The alliteration of the maples at Mama (*Mama-no-momoji* in Japanese) added an extra feature to their charm.

Indeed, the place was famous for other literary associations as well. The shrine is dedicated to Tekona, whose story, appearing in one of Japan's earliest poetry anthologies, the *Man'yoshu*, concerns a beautiful country girl so pursued by unwelcome suitors that she threw herself into the water at this point.

> *She walked unshod, her hair uncombed,*
> *Yet no high-born girl, dressed in rich brocade;*
> *Could match this country girl.*
> *When she stood, smiling like a flower,*
> *Her face like the full moon,*
> *Many suitors sought her,*
> *Like summer moths the fire,*
> *As urgent ships a harbor.*
> *Why did she choose to die*
> *When life is but a breath?*
> *She laid herself in the grave,*
> *The river mouth, under the noisy waves.*

TAKAHASHI MUSHIMARO
(translated by Kokusai Bunka Shinkokai)

In this print, the distinctive coloring of the maples is achieved by the use of red lead or iron oxide that turns black on exposure to light. Fortunately this particular print has been saved that fate.

"Mama: The Maple Trees, the Tekona Shrine, and Linked Bridge," 1857. *Number 94 of* One Hundred Famous Views of Edo. *Brocade print,* oban *size. Courtesy of the Trustees of the British Museum, London.*

133

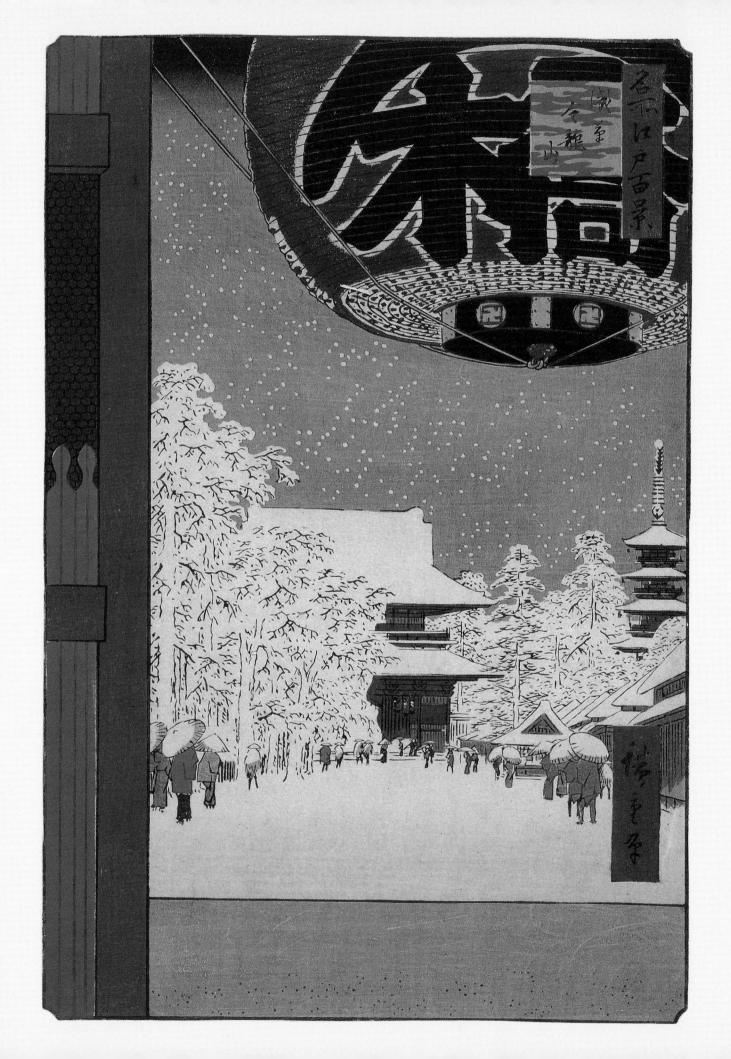

## Asakusa: The Kinryuzan Temple

This is the first print of a new season—winter. The clean white of the first snowfall is set off against the vermilion woodwork of the Asakusa Kannon—the oldest and most venerated of the Buddhist temples of Edo, pre-dating indeed the establishment of the city. The district of Asakusa was, and still is, a vigorous subsidiary center at the northern edge of the old city, along the western bank of the Sumida River, not far from the Yoshiwara and the theater district.

The temple and its precincts are one of the traditional sights of modern Tokyo and are equally popular with tourists and Tokyo residents. The many streets around the precinct boast a host of small shops specializing in traditional goods, such as the exquisite fabrics for *kimono* and brocade sashes (*obi*), traditional towels and headcloths, painted fans, ceramics, decorative paper goods, the hand-carved stamps that the Japanese still use to sign-and-seal official documents, *bonsai* trees, and many other delightful, useful, and curious items.

The view is through the Thunder Gate (*Kaminarimon*) of the temple precincts, marked, as they still are today, by immense red lanterns. On either side of the gate are sculptures of the guardian deities enclosed, then and now, with a picket fence to discourage humans, and a net to prevent pigeons defacing the statues—both of which can be seen at the left-hand margin. The avenue of virgin snow leads to the corner of the principal temple building with the pagoda on the right.

Those who know Asakusa today will recognize all these features but may imagine that Hiroshige has rearranged the elements to his own artistic ends. Today the gate and avenue, lined with booths selling souvenirs, snacks, and various votive items, are aligned on the central bay of the temple, and the pagoda is on the left—not as they appear in this print. However, the originals were destroyed by fire in 1865 and most recently rebuilt in 1960—but in new locations and, sadly, in painted ferroconcrete in place of the original massive timbers.

"Asakusa: The Kinryuzan Temple," 1856. *Number 99 of* One Hundred Famous Views of Edo. *Brocade print,* oban *size. The Whitworth Art Gallery, University of Manchester.*

*The giant lantern, wire mesh, red painted gate posts, and picket fence can still be seen today in one of the side gates to the Asakusa Kinryuzan temple complex.*

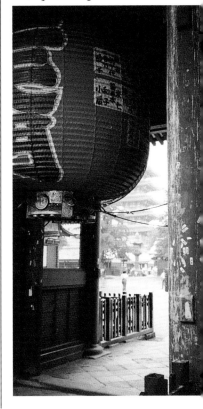

## Yoshiwara: The Nihon Embankment

Right at the edge of the city of Edo, just beyond Asakusa, was the Yoshiwara, the officially sanctioned Pleasure Quarters, separated from the city by this causeway. On the causeway itself were tea stalls sponsored by the various establishments of the Yoshiwara, where those visiting could wait for friends or make an assignation before proceeding to the quarter itself. Many would make the final stages of the journey incognito, protected by a hood or carried in a closed palanquin.

The diagonal composition stresses the remoteness of the Yoshiwara from the city, both in physical distance and in the social conventions that applied in the two very different environments. Hiroshige himself stands with us at some Olympian remove from the frisson of anticipation that doubtless accompanied the journey, but a flight of geese across the beckoning moon suggests a fond nostalgia for past pleasures remembered.

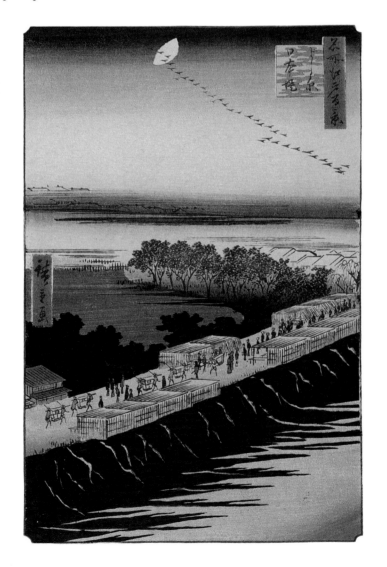

"Yoshiwara: The Nihon Embankment," 1857. *Number 100 of* One Hundred Famous Views of Edo. *Brocade print,* oban *size. The Whitworth Art Gallery, University of Manchester.*

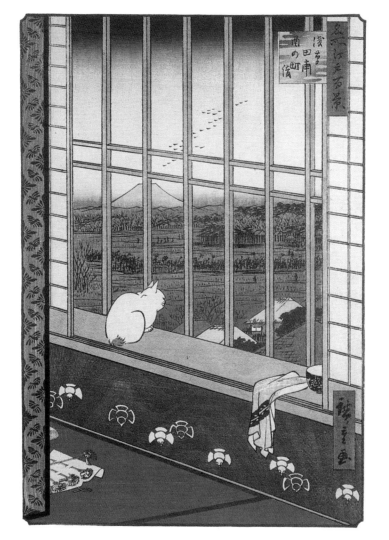

## The Asakusa Rice Fields and the Torinomachi Festival

The scene in the foreground of this print is more closely allied to the festival of the title than may at first be apparent. For we are in an upper room of the Yoshiwara, the official Pleasure Quarter, that adjoin the Asakusa rice fields. From the window can be seen the peak of Mount Fuji, a flight of geese against the sky, and, making its way through the rice fields, the procession of the Torinomachi Festival with its tufted standards.

The set of hairpins in a folded paper packet are miniatures of the hay rakes that are also carried in the procession—symbols of the harvest or, in the commercial world of Edo, the raking-in of the year's profits.

This was an open day at the Yoshiwara—one of the few days of the year when women other than the resident *geisha* and courtesans could visit. All the gates were open and every courtesan was required by tradition to take at least one customer and might do so, against all the usual rules, during the day.

A cat sits in the window, like Hiroshige watching the world with an uncritical but highly observant eye.

137

*"The crane on
one leg at the
waterside—
How still it stays!
But in the ripples
Its reflection
sways."*

KAWADA JUN

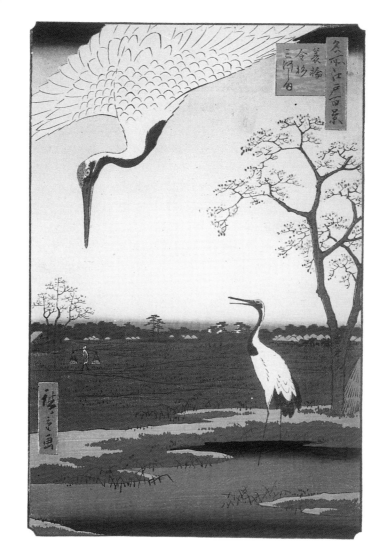

## *Minowa, Kanasugi, and Mikawashima*

This is one of two prints in the series in which a full-scale bird study is combined with a landscape view, the other being the eagle over Fukagawa (page 140). These birds are red-crested cranes (*tancho*), a somewhat rarer cousin of the common cranes and egrets that stalk rice paddies all over Japan, hunting for small frogs and other prey. They were protected even in the Tokugawa period, being regarded as most auspicious birds and tokens of longevity.

In fact, this spot was a sanctuary for them. Each year the *shogun,* with a large ceremonial retinue, came to these marshes to hunt the cranes. The *shogun* himself would release the first hawk, and the first bird taken would be bound to a carrying pole in a specifically decorative way and carried as a gift to the emperor at Kyoto.

At all other times the cranes were protected; in this print the man threading his way along the embankments that separate the rice paddies, carrying two loaded baskets, may well be the keeper appointed to feed them in this winter season.

## Fukagawa: The Timberyards

This is one of Hiroshige's most famous snow scenes. The stark geometrical forms of the propped poles of the timberyards echo the zigzag of the waterway beyond. This, along with the repeated intersection of verticals and diagonals, establishes a strong sense of distance and of the icy openness of the winter sky.

The timberyards of Fukagawa were the clearinghouse for the huge quantities of wood used in the building and maintenance of the world's largest timber city. The logs and poles were delivered to the yards by water, usually in the form of rafts that were poled up and down stream by lumberjacks, like the two seen here in their straw capes.

Humanity is reduced to a few emblematic figures or concealed beneath an umbrella. The fluttering sparrows and the desultory mongrels reinforce the sense of desertion and midwinter's cold.

Such scenes are no longer part of the Tokyo landscape. Concrete, steel, glass, and aluminum have replaced timber as the principal building materials. Only the name of the district—*Kiba* (meaning "wood")—survives as a reminder of this most memorable image.

"Fukagawa: The Timberyards," 1856. *Number 106 of* One Hundred Famous Views of Edo. *Brocade print,* oban *size. Courtesy of the Trustees of the British Museum, London.*

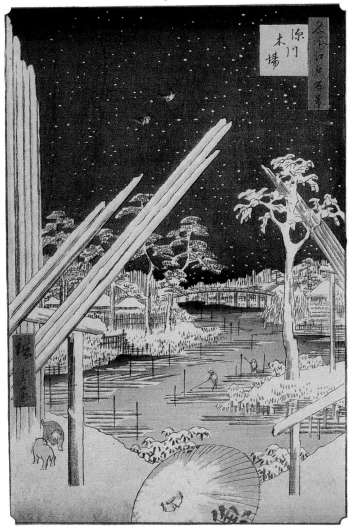

*"Not to mention
The beauty of its
snow
Mount Tsukuba
shines forth
In its purple
robes."*

BASHO

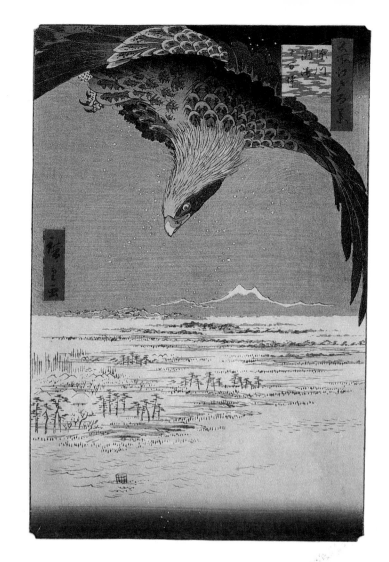

## Fukagawa Susaki and Jumantsubo

This majestic image is frequently referred to as one of the best three of the series. It is indeed the very embodiment of the bird's-eye view, the glittering eye of the voracious eagle looking down on an immense landscape stretching from the seashore to the distant shoulders of Mount Tsukuba. The eagle has caught sight of a tempting morsel, something in the solitary bucket floating in the sea perhaps—or maybe one of the gulls that have gathered around the bucket. He twists in flight, ready to swoop, his outspread wings and glittering claws framing the scene—a stunning compositional device, like that of the cranes at Minowa (page 138).

The landscape is that of the Jumantsubo—"the hundred thousand *tsubo*" (an area of about eighty acres)—a fairly desolate shoreline somewhat to the east of the city. Reeds grow in the brackish water and an isolated handful of houses cluster among the pines. Indeed, every detail of the scene speaks of solitude—the lone eagle, the single floating bucket, the general atmosphere of chill.

In Japanese mythology the eagle was associated with the North Star and the Torinomachi Festival of midwinter. The rendering of the eagle's eye, enhanced by the extra gloss of *nikawazuri,* a special varnished or burnished technique, evokes the unique fixity of the star and its special relationship with the midwinter solstice.

## *Atagoshita and Yabu Lane*

This charming snowscape, with its twittering sparrows and bamboo fronds, borrows from the *kacho* tradition of bird-and-flower pictures. The bamboo thicket on the right was the eponymous feature of Yabukoji (Thicket Lane), an area of *daimyo* mansions to the west of the moats of the *shogun*'s palace.

As in so many prints of this series, the faces of the people are concealed, in this case reinforcing the sense of cold.

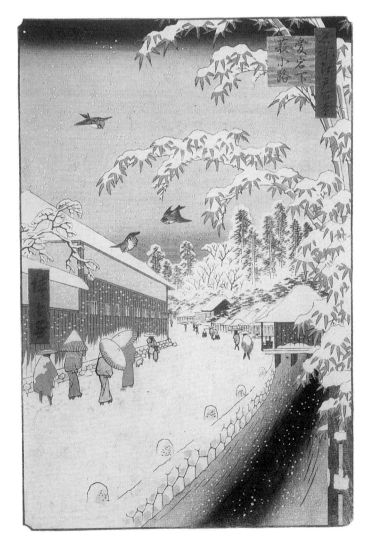

"Atagoshita and Yabu Lane," 1857. *Number 112 of* One Hundred Famous Views of Edo. *Brocade print,* oban *size. Courtesy of the Trustees of the British Museum, London.*

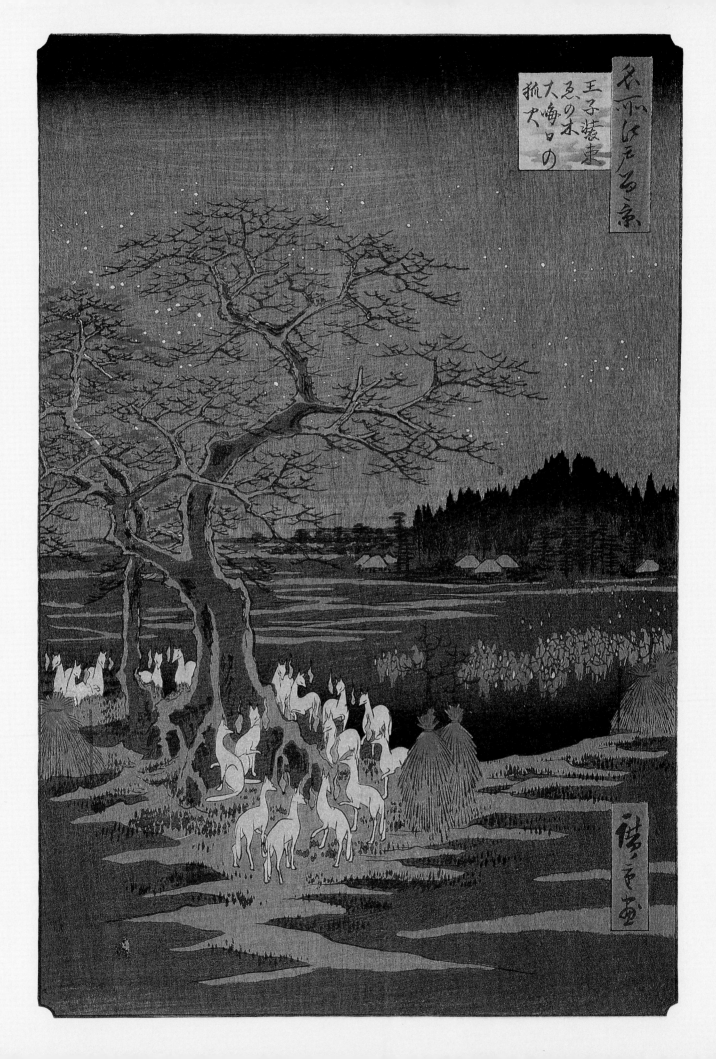

## Oji: The Fox-fires at the Changing Tree on New Year's Eve

Of all the 118 images in the series, this is the only one that portrays a scene of myth or legend. It was said that all the foxes of the Kanto region gathered at the Oji Inari Shrine on New Year's Eve for a ceremony of renewal involving a change of clothing and that, as they came, each one emitted a flame, or "fox-fire." Quite coincidentally, the same term is used in both Europe and Japan to identify unexplained lights at night, in particular the flames of marsh gas known in Britain as "will-o'-the-wisp."

Hiroshige captures the eerie magic of this scene with the most subtle but surprisingly economical combination of grays, browns, and greens balanced against the unexpected pinkish ocher color of the foxes and the orange flames each with its own *bokashi* shading.

The print is rightly regarded as one of the finest of the series, famous for its unusual subject matter, its masterly composition, and its technical brilliance. It also looks forward to the printmaking of the next generation, the more subtle, evocative, and painterly approach of the *Meiji* masters of the woodblock print, such as Yoshitoshi and Kiyochika.

The Changing Tree and its shrine can still be seen today in the northern suburb of Oji, as a reminder both of this most resonant of the *One Hundred Famous Views of Edo* and of a poignant episode of the modern era. The original tree died in the late nineteenth century and remained as a stump until 1945, when a firebombing raid destroyed a large section of the neighboring district. However, the flames stopped short of the Changing Tree itself. After the war, the residents rebuilt the shrine and planted a new tree—invoking, perhaps, the annual ceremony of renewal, the spirits of the foxes, and of their magical fox-fires.

"Oji: The Fox-fires at the Changing Tree on New Year's Eve," 1857. *Number 118 of* One Hundred Famous Views of Edo. *Brocade print,* oban *size. Courtesy of the Trustees of the British Museum, London.*

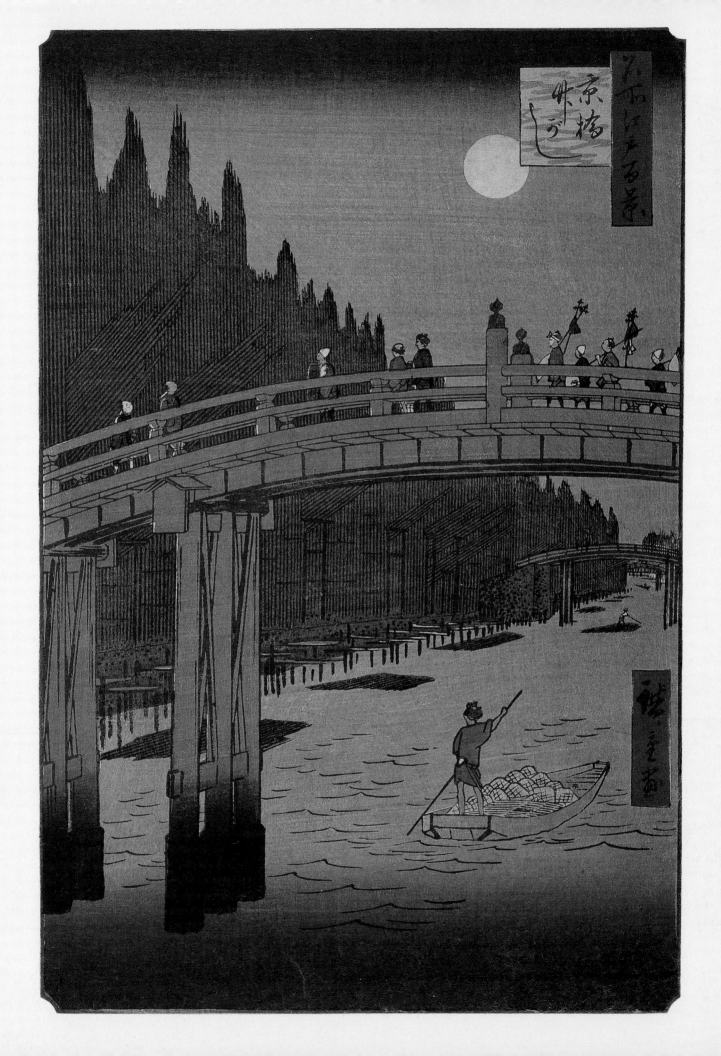

# CHAPTER 8
# HIROSHIGE IN HISTORY

In 1854 there appeared, off the coast of Japan, a flotilla of Black Ships, a naval force under the command of the American Commodore Perry. The objective was to open Japan to trade with the rest of the world. After enjoying 250 years of unquestioned authority, the *bakufu* were completely unprepared for this show of force. The pressures for change were irresistible and within a few years the political and social order collapsed. In 1868 the government was toppled by the virtually bloodless Meiji Revolution. The *shogun's* administration was replaced by a new imperial regime and Japan opened the floodgates to Western trade and technology.

One result of the opening up of Japan was an influx of Japanese art and artifacts to the West, including the prints of Hiroshige. The vogue for all things Japanese swept Europe. As early as 1870, Parisians could pick up copies of his prints in shops and stalls on the left bank of the Seine. The artists of the day were clearly fascinated, collecting the prints, studying their technique and composition, making copies, and developing Japanese ideas in their own work.

One of the most enthusiastic was the young Vincent van Gogh (1853-1890). As a student in Paris in 1870, he decorated the walls of his room with a newly bought collection of Japanese prints, now preserved in the van Gogh Museum in Amsterdam. He made copies in oils of a number of them, including Hiroshige's "Kameido Plum Gardens" and the "Sudden Shower over Atake" (pages 118-119). Van Gogh also included representations of a number of prints (at least one of them Hiroshige's) in the background of the portrait of (Père) Tanguy, the gallery owner who had first shown his paintings (page 148). Van Gogh's work soon began to include ideas drawn from his Japanese studies: the use of strongly asymmetrical compositions and imaginary view-

"Kyobashi: The Bamboo Yards," 1857. *Number 76 of* One Hundred Famous Views of Edo. *Brocade print,* oban *size. The Whitworth Art Gallery, University of Manchester.*

*"A thousand sad thoughts rise in me When I behold the harvest moon, Although to all men Autumn comes, And not to me alone."*

OE NO CHISATO

145

points. Van Gogh's expedition to Arles in 1888 was prompted by a search for these qualities in a natural landscape. Other painters took up the imagery, rather than the techniques, of Hiroshige—Monet's paintings of his garden at Giverny (page 125) and Whistler's nocturnes, for example.

The applied arts also began to reflect Japanese ideas and themes, in fabric design, jewelry, ceramics, metalwork, glassware, and graphic art. There was much new thinking in these fields at that time. It is impossible to distinguish the contribution of Hiroshige from that of Japanese arts and crafts in general—through Art Nouveau, the Arts and Crafts movement, and the many other strands of artistic thinking that led, in the twentieth century, to Modernism.

Until the arrival of photographic color separation, the brocade prints of Edo and Osaka provided one of the most sophisticated and successful media for the mass production of colored pictures the world had ever seen. As such, they mark a unique development in the role of printed images in the history of art and culture worldwide. But the growth of the *ukiyo-e* tradition was contained within Japan, and only became known to the rest of the world at the very moment when more modern technologies were about to displace it. Only since then has the rest of the world responded with the fascination and enthusiasm the genre deserves.

*James Abbott McNeill Whistler,* "**Nocturne: Blue and Gold—Old Battersea Bridge,**" **1872-1873.** *Whistler (1834–1903) painted a series of studies of London and the River Thames which he called "Nocturnes." In both composition and atmosphere several of them echo Hiroshige's images of Edo. Compare Whistler's strongly individual view of Old Battersea Bridge with Hiroshige's view of the Kyobashi Bridge (page 144). Tate Gallery, London.*

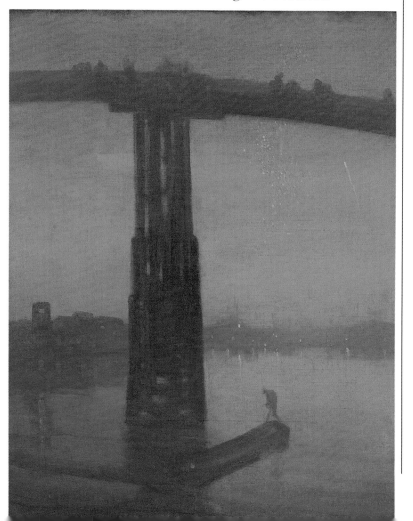

The comparison with photography is of further interest in that photography is tied to the laws of optics. A camera cannot rearrange the component parts of an image to suit some aesthetic ideal (although modern computer and video technologies are now starting to make this increasingly possible). As we have seen, composition—the arrangement of images on the page—is of central interest to the artists of the woodblock print, as it is to any graphic artist or painter. Hiroshige was a master of composition—transposing elements, adjusting view-points and arranging forms on the page to achieve the dynamic or emotional character he wished to convey.

We have also seen that he, of all the *ukiyo-e* masters, developed a particularly direct response to the qualities of the world at large, at every scale and in every circumstance. Appreciation of landscape and topography is universal in that everybody has some firsthand experience of it. Hiroshige therefore engaged with an infinitely wider audience and range of experience than did those artists who specialized in *kabuki* scenes, *bijin,* caricature, *surimono,* and so forth. It is therefore no surprise that he is one of the most popular of all *ukiyo-e* artists, and his images are well known and much loved both in Japan and elsewhere.

Hokusai may have produced more striking images, but they engage the imagination more by their sense of drama than by accurate and sensitive recording of the real world in real circumstances. Hiroshige recalls real memories, Hokusai the images of the imagination.

This special gift of Hiroshige for sympathetic realism is expressed through an artistic and technical mastery that is frequently camouflaged by the simplicity and reticence of his drawing, the delicacy of his coloring, and the charm of the scenes and events he portrays. But behind these apparently simple and simple-minded images stands the full armory of artistic and technical expertise that he and his predecessors in the *ukiyo-e* tradition had developed: the use of line to portray three-dimensional form, the use of color to represent light, the arrangement of forms on the page to lead the eye or evoke an atmosphere, the adaptation of the viewpoint to give a sense of depth, the manipulation of subject matter to evoke a special state of mind in the viewer.

He also exploits all the printers' skills: particularly the use of the *bokashi* shading technique and the exposure of the grain of the block and, to a lesser extent, the use of

*A hand-painted earthenware dish showing the bold coloring, dynamic pattern making, and stylized, asymmetric pictorial composition typical of Japanese applied art. Private Collection.*

*baren* rubbing marks, the high gloss of *sumizuri,* and the use of metallic powders. However, these techniques are never used for their own sakes but only in the service of some specific artistic end.

His images are greatly enriched by the web of literary, historic, mythic, anecdotal, and topographic allusion that is woven into them. They are equivalent, in some ways, to the iconographies of Western art, but in Hiroshige's hands are extended and simplified to include a much less esoteric and exclusive mix of references—references more closely related to the everyday experience of ordinary people than the exotic religious and artistic cross-references of the West.

It is, finally, Hiroshige's ability to record the emotional state of the viewer that is his most special gift. In so many of his finest views he records not only the scene but also the response of those involved—be they the characters portrayed or us, the audience. We can feel those emotions directly: the relief of arriving at the way station after a long day's hike; the chill of the crosswinds in the open marshes; the delight of a magnificent view; the loneliness of the road in winter; the terror and confusion of a sudden rain storm.

*Vincent van Gogh, "Portrait of Père Tanguy," 1887-1888. The artist has placed his old friend and mentor, the gallery owner Père Tanguy, against a background of images drawn from van Gogh's treasured collection of Japanese prints. A typical Hiroshige composition of a cherry tree in bloom beside an irrigation canal appears behind the sitter's left shoulder. Musée Rodin, Paris.*

The fact that he can recall such rich and evocative sentiments simply by the arrangement of colored inks on a piece of paper, the most ephemeral of materials, is a profound and unmatched piece of magic. Given these qualities, it is no surprise that Hiroshige's work is popular with both the uninitiated and the expert, the man in the street and the scholar.

Hiroshige's prints were originally designed for reproduction in small format. They are consequently very suitable for photographic reproduction. The most up-to-date photographic reproduction may not be as faithful to the original prints as one might wish, but Hiroshige's images are now available to a much larger audience, spreading his humanity and charm to a greater and more appreciative public.

Although the arrival of Commodore Perry's Black Ships in 1854 sounded the death knell of the world of Edo that Hiroshige observed with such love and care he was still in full flood, with some of his finest work still before him. He did not live to see the social and political changes that followed, but he would certainly have been aware of the pressures for change during his later years. With the benefit of hindsight, we may look on the melancholy detachment of *One Hundred Famous Views of Edo* as some sort of farewell to the Edo era, but Hiroshige's own advancing years are sufficient explanation. Certainly the newfangled Western ways did not appear in his images. It was in the work of his friend and pupil, Kunisada, that we first see the Western horse-drawn carriages, tailored costumes, iron ships, steam trains, and masonry buildings.

Hiroshige is thus the last of the great *ukiyo-e* masters of the Edo era. The world he has preserved for us is the timeless world of the Tokugawa shogunate—unchanged in essence for 250 years. Though the fashions of the Floating World may have changed season by season, the fundamentals—of culture and commerce, of the mountains, fields, villages, and cities of Japan—remained fixed and permanent. At the same time, Hiroshige's vision is peopled with the endless variety of humankind and with many of nature's other creatures, all part of a cycle of death and rebirth. In Hiroshige's eye the city of Edo, too, is a work of nature, ebbing and flowing with the seasons, changing and renewing itself year by year, but in a way that is constant and predictable—a city in a veritable Golden Age.

*"I hope that later on other artists will rise up in this lovely country and do for it what the Japanese have done for theirs. I have no fear but that I shall always love this countryside. It is rather like Japanese art; once you love it, you never go back on it."*

VINCENT VAN GOGH

# GLOSSARY OF JAPANESE TERMS AND NAMES

| | |
|---|---|
| *Amaterasu* | Goddess of the Sun; mother of the imperial family |
| *Ando* | Family name of Hiroshige |
| *Bakufu* | The shogunal administration |
| *Baren* | The pad covered with bamboo leaves used by the *ukiyo-e* printers to press the paper onto the block |
| *Bashi* | A bridge |
| *Bijin* | "Beauty"—referring to pictures of courtesans, *geisha,* and serving girls in the Pleasure Quarters and elsewhere |
| *Biwa* | Sacred lake above Kyoto |
| *Bokashi* | Printing technique in which color is shaded off |
| *Bonsai* | Specially cultivated miniature trees |
| *-cho* | Word ending denoting district |
| *Chonin* | Townsfolk |
| *Daimyo* | Feudal lords of Japan; the class of noble families and the *shogun*'s administration |
| *-e* | Word ending denoting a picture or image |
| *Edo* | The *shogun*'s capital city, renamed Tokyo after the Meiji Restoration of 1868 |
| *Eisen* | *Ukiyo-e* artist of Utagawa school, specializing in *bijin* pictures, worked with Hiroshige on *Sixty-Nine Stations of the Kisokaido* |
| *Fuji* | The sacred mountain of Japan |
| *Futon* | Sleeping mattress |
| *-gawa* | Word ending denoting a river |
| *Geta* | Raised wooden clogs |
| *Geisha* | Professional female entertainers specializing in serving at table, singing, dancing, and the art of conversation—not to be confused with courtesans |
| *Gen-emon* | Hiroshige's father's given name |
| *Gohei* | Cut paper strips; sacred emblems hung on shrines |
| *Haiku* | Favored verse form of seventeen syllables in three lines |
| *Hiroshige* | (1797–1858) Artistic name of Ando Tokutaro, given him on completion of his training; subsequently conferred on his son-in-law, Hiroshige II and a third artist, Hiroshige III |
| *Hoiedo* | Publisher of *Sixty-Nine Stations of the Kisokaido* |
| *Hokaido* | Northern island of the Japanese archipelago |

| | |
|---|---|
| *Hokusai* | (1760–1849) One of the most prolific and influential of the *ukiyo-e* masters of the generation before Hiroshige, responsible for the most popular series of views, *Thirty-Six Views of Mount Fuji* |
| *Hototogisu* | Japanese cuckoo, symbolic of summer rain and unrequited love |
| *Ichiryusai* | One of a number of names used by Hiroshige to sign his prints |
| *Kabuki* | Popular theater of the *chonin,* or townsfolk, as distinct from the highly formalized traditional *Noh* style of theater |
| *Kacho* | The tradition of "bird-and-flower" prints |
| *Kamakura* | The twelfth-century capital of Japan, superseded by Kyoto |
| *Kanji* | Ideogram of the Japanese writing system |
| *Kanto* | The province in which Edo lies |
| *Kara-zuri* | "Blind" printing technique similar to embossing or *gaufrage* used to produce a raised image on paper |
| *Kento* | Marks incorporated in the master *(sumi)* block and reproduced on the color blocks to ensure the correct alignment of successive color printings |
| *Kimono* | Traditional untailored gown with full-length sleeves and coat worn by men and women in a variety of designs and qualities of cloth for different purposes |
| *Kisokaido* | The more direct but mountainous road running from Edo (Tokyo) to Kyoto (as distinct from the Tokaido which is the seaside route); the subject of Hiroshige's famous series of prints, *Sixty-Nine Stations of the Kisokaido* |
| *Koku* | Unit of measurement for rice (approximately 5 bushels), used as a measure of wealth of the *daimyo* estates and as salary for *samurai* and others |
| *Kunisada* | (1786–1865) *Ukiyo-e* artist of Utagawa school, colleague of Hiroshige |
| *Kyoto* | Ancient capital of Japan, and home of the emperor and his court |
| *Kyushu* | Southern island of the Japanese archipelago |
| *Matsuri* | Festival |
| *Meiji* | Family name of the line of emperors restored in 1868, giving their name to the succeeding period |
| *Meisho* | Literally, "famous places" or "views" associated with the tradition of prints and paintings of well-known locations at different seasons of the year |
| *Mitsu-* | Counting word for "three" |
| *Netsuke* | Toggle used to retain carrying-pouches in the belt or sash of traditional Japanese costumes, often exquisitely carved |
| *Nihon* | Japanese name for Japan |

| | |
|---|---|
| *Nikawa-zuri* | Printing technique involving the sprinkling of mica or metallic powders onto a glue to give a sparkling effect |
| *Nishiki* | Brocade |
| *Nishiki-e* | "Brocade image" meaning the elaborate polychrome prints of the *ukiyo-e* |
| *Noh* | Highly formalized traditional style of theater associated almost exclusively with the courts of the emperor and *shogun* and often performed in the precincts of temples |
| *Nomi-zuri* | Special printing technique used to give a fabric-like texture |
| *Noren* | Printed fabric hanging over the door of restaurants and other buildings announcing the name of the establishment and forcing a bowing of the head on entry |
| *Norimono* | Closed sedan chair (palanquin) with a single carrying pole used by high officials, ladies, and those who wished to travel incognito; the more open "mountain palanquin" was a favored vehicle for the lazy or infirm on cross-country journeys |
| *Nunomezuri* | Printing technique for obtaining a fabric-like texture |
| *Oban* | The most often used standard size for *ukiyo-e* prints, about 10" x 15$\frac{1}{2}$" |
| *Obi* | Elaborate brocade sash used by women to hold a kimono in place, usually tied with a formal fold behind, but in the case of courtesans tied in a florid bow in front |
| *Osaka* | Port on the Inland Sea serving the emperor's capital at Kyoto |
| *Samisen* | Japanese three-stringed lute of plaintive tone—the favored instrument for accompanying song and dance—its mastery was one of the most important accomplishments of the *geisha* |
| *Samurai* | The traditional warrior class, mostly employed as retainers of the *daimyo* lords, the *shogun* and the emperor |
| *Sake* | Japanese rice wine |
| *Shinto* | The most ancient religion of Japan; centered on celebration of the seasons, the spirits associated with individual locations, and the myths of creation |
| *Shogun* | De facto ruler of Japan during the Edo period (1600–1868) |
| *Shunga* | Literally "spring pictures"—erotic images |
| *Sumi* | Japanese black ink, traditionally available as a block which was wetted with the brush for writing and drawing |
| *Sumida* | Principal river flowing through the city of Edo |
| *Sumo* | Traditional Japanese wrestling |
| *Surimono* | Genre of high-quality prints produced as special editions for connoisseurs, poetry clubs, and others |
| *Taisho* | Central compartment of a *Shinto* shrine—the home of the god |

| | |
|---|---|
| *Tatami* | Woven rice straw mat used as flooring in traditional Japanese interiors, corresponding with a single sleeping space 6 feet by 3 feet |
| *Temno* | Generic title for the emperor and his immediate family |
| *Tokaido* | "The Great Eastern Road"—the most important road in Japan following the coastal route from Edo to Kyoto, illustrated in Hiroshige's famous series *Fifty-Three Stations of the Tokaido* |
| *Tokonoma* | Ceremonial niche in the principal room of every Japanese house, usually featuring a painted scroll and/or an appropriate flower arrangement |
| *Tokugawa* | Family name of the *shogun;* also the name given to the period 1600–1868 |
| *Tokutaro* | Hiroshige's given name at birth |
| *Toyohiro* | Utagawa Toyohiro (1793–1828), *ukiyo-e* master to whom Hiroshige was apprenticed |
| *Torii* | Symbolic gateway at the entrance to a *Shinto* shrine |
| *Toto* | The "Eastern Capital"—alternative name for Edo (Tokyo) |
| *Tsukuba* | Mountain to the north of Edo (Tokyo) with characteristic double peak that features in many of Hiroshige's views of Edo |
| *Toyokuni* | (1769–1825) *Ukiyo-e* artist, specializing in *bijin* pictures and portraits of actors |
| *Ueno* | Large recreational park in the northeastern section of Edo |
| *Uki-e* | "Floating images"—referring to the use of illusory perspective in the European manner |
| *Ukiyo* | The "floating world"—referring to the ephemeral world of entertainment, theater, poetry, and so forth |
| *Ukiyo-e* | "Images from the Floating World"—the world of the Japanese woodblock print |
| *Utagawa* | Leading school of printmakers (1760–1860) including Hiroshige; his master, Toyohiro; his successors, Hiroshige II and Hiroshige III; and many other notable artists |
| *Utamaro* | (1750-1806) *Ukiyo-e* artist |
| *Waka* | Popular verse form of 31 syllables in 5 lines |
| *-yama* | Word ending denoting a mountain |
| *Yayosu* | Name of the barracks where Hiroshige was born |
| *Yoshiwara* | Officially sanctioned Pleasure Quarter just beyond Asakusa, to the north of the city of Edo |
| *Yukata* | Lightweight, short-sleeved kimono, usually with a blue design on white ground, used as a sleeping garment |
| *-zuri* | Word ending denoting a printing method or technique |

# Acknowledgments

The author and publishers wish to thank the following for permission to reproduce copyright material: The Trustees of the British Museum, London for pages 16, 18-19, 38, 42, 50, 52, 58, 63, 64, 71, 73, 78, 80 both, 81, 84, 85, 87, 88, 89, 90, 92, 103 above, 106, 111, 113, 114, 115, 116, 117, 119, 120, 122, 123, 124, 127, 129, 132, 137, 138, 139, 141, 142 and front cover (new photography by Kevin Lovelock); The Board of Trustees of the Victoria & Albert Museum, London for pages 25, 44, 51, 68, 69 both, 70-71 and 94 (photographer Ian Thomas), 4, 5, above, 12, 13, 16, 26, 27, 29, 40-41, 44-45, 46, 48, 55, 56, 56-57, 59, 60-61, 66, 67, right, 69, 70, 72, 74, 97, 98-99 both, 100-101 both, 104-105, 121, 122, 123, 124 and 131; The Whitworth Art Gallery, University of Manchester for pages 31, 62, 79, 82 both, 83, 86, 91, 110 below, 118, 134, 136, 140 and 144; The Ashmolean Museum, Oxford for pages 15 and 108-109; The Tate Gallery, London for page 146; The Musée Rodin, Paris for page 148; page 125 is reproduced by courtesy of the Trustees, The National Gallery, London; pages 34 both, 54, 67 left, 93, 103 below, 147 and the back cover are from private collections, photographed by Alex Saunderson; pages 5 below, 20-21 all, 22, 23 both, 30, 32, 33, 35 both, 36, 37 both, 53, 109, 110 above and 135 are courtesy of the author.

The marginal decorations are Japanese heraldic crests reproduced in *Japanese Design Motifs,* Compiled By The Matsuya Piece-Goods Store (1913), Translated by Fumie Adachi (Dover Publications, New York, 1972). The horizontal text decorations are border designs from *Kodai Moshiki Zuko* (Picture Album of Traditional Patterns) reproduced in *Japanese Border Designs,* Selected and Edited by Theodore Menten (Dover Publications, New York, 1975).

---

The marginal quotations come from the following sources with grateful acknowledgement: pages 9, 43, 47, 51, 65 and 95 from *Art and Illusion,* Ernest Gombrich (Phaidon Press, London, 1960); pages 17, 128 and 149 from *Dear Theo, The Autobiography of Vincent van Gogh* edited by Irving and Jean Stone (Grove Press, New York, 1960). Marginal poetry not translated from reproduced *kacho* prints comes from the following sources; pages 13, 18, 71, 73, 75, 107, 126 and 140 from *The Narrow Road to the Deep North, and Other Travel Sketches,* Matsuo Basho, Translated by Nobuyuki Yuasa (Penguin Books, London, 1966); pages 41 (R.H. Blythe), 77 (JCTC), 89, 138 and 145 (Miyamori Asataro) from *Hiroshige's Tokaido in Prints and Poetry,* edited by Rieko Chiba (Charles E. Tuttle, Vermont and Tokyo, 1992).

---

## Woodblock print sizes used in the book:

| | inches | centimeters |
|---|---|---|
| *aiban* (intermediate) size | 13 x 9 | 34 x 22.5 |
| *chuban* (medium) size | 10 x 7 | 26 x 19 |
| *hosoban* (narrow) size | 13 x 5½ | 33 x 14.5 |
| large *hosoban* size | 16 x 7 | 39 x 17 |
| *oban* size | 15 x 10½ | 39 x 26 |
| large *oban* size | 22 x 12 | 58 x 32 |
| *o-tanzaku* (large poem card) | 15 x 7 | 38 x 17 |
| *chu-tanzaku* (medium poem card) | 15 x 5 | 38 x 13 |
| large *surimono* (privately commissioned print) | 14 x 8 | 35 x 20 |
| *koban*-size *surimono* | 4-7 x 3½-5 | 12-19 x 9-13 |
| *uchiwa-e* (fan) | 12 x 8 | 29 x 21 |

**Note:** Sizes are approximate and based on the size of the sheet before printing.

# Select Bibliography

Basho, Matsuo. *The Narrow Road to the Deep North and Other Travel Sketches*. Translated by Nobuyuki Yuasa. Penguin Books: London, 1966.

Chiba, Rieko, ed. *Hiroshige's Tokaido in Prints and Poetry*. Charles E. Tuttle: Vermont and Tokyo, 1992.

Clark, Timothy. *Ukiyo-e Paintings in the British Museum*. British Museum Press: London, 1992.

Earle, Joe, ed. *The Toshiba Gallery: Japanese Art and Design*. Victoria & Albert Museum: London, 1986.

Faulkener, Rupert. *Masterpieces of Japanese Prints: The European Collections: Ukiyo-e from the Victoria & Albert Museum*. Kodansha International: Japan, 1991.

Goldman, Israel, Cynthea Bogel, and Alfred H. Marks. *Hiroshige: Birds and Flowers*. George Braziller: New York, 1988.

Gombrich, Ernst. *Art and Illusion*. Phaidon Press: London, 1960.

Gunji, Masakatsu. *Kabuki*. Translated by John Bester and Janet Goff. Harper & Row: New York, 1985.

Illing, Richard. *Japanese Prints from 1700 to 1900*. Phaidon Press: Oxford, 1976.

Impey, Oliver. *Hiroshige's Views of Tokyo*. Ashmolean Museum, University of Oxford: Oxford, 1993.

Kikuchi, Sadao. *Ukiyo-e*. Translated by Fred Dunbar. Hoikusha: Japan, 1964.

Kobayashi, Tadashi. *Ukiyo-e: An Introduction to Japanese Woodblock Prints*. Translated by Mark A. Harbison. Kodansha International: Japan, 1992.

Kyodo National Museum, Tokyo National Museum and The Kyoto Shimbun. *Ukiyo-e from Matsukata Collection*. Tokyo, 1991.

Lane, Richard. *Images from the Floating World: The Japanese Print*. Alpine Fine Arts Collection (UK): London, 1978.

Morse, Edward S. *Japanese Homes and Their Surroundings*. Charles E. Tuttle: Vermont and Tokyo, 1972.

Newland, Amy, ed; Chris Uhlenbeck, ed. *Ukiyo-e to Shin hanga: The Art of Japanese Woodblock Prints*. Magna Books: Leicester, 1990.

Oka, Isaburo. *Hiroshige: Japan's Great Landscape Artist*. Translated by Stanleigh H. Jones. Kodansha International: Japan, 1992.

Reischauer, Edwin O. *Japan: The Story of A Nation*. Charles E. Tuttle: Vermont and Tokyo, 1972.

Smith, Henry D. II, Robert Buck, and Amy G. Poster. *Hiroshige: One Hundred Famous Views of Edo*. Thames and Hudson: London, 1986.

Stone, Irving and Jean, ed. *Dear Theo, the Autobiography of Vincent van Gogh*. Grove Press: New York, 1960.

Suzuki, Takashi. *Hiroshige*. Elek Books: London.

Watson, Professor William, ed. *The Great Japan Exhibition: Art of the Edo Period 1600-1868*. Royal Academy of Arts/Weidenfeld and Nicholson: London, 1981.

# Index

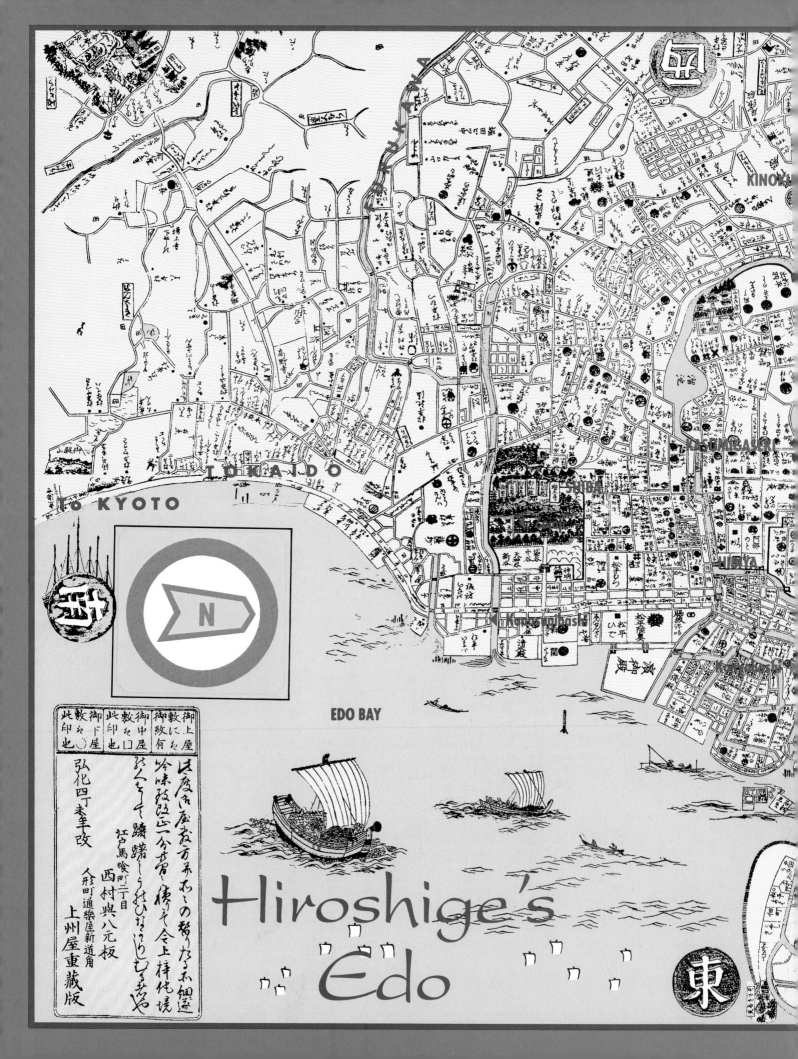

Hiroshige's
Edo